TYPOGRAPHY 15

# TYPOG RAPHY

THE ANNUAL OF THE

# TYPE
## DIRECTORS
# CLUB

*Watson-Guptill Publications    New York*

## acknowledgments

The Type Directors Club gratefully acknowledges the following for their enthusiastic support in the success of TDC40:

Judging facilities: The School of Visual Arts
Paper: Simpson Paper Company
Printer: MacNaughton Einson Graphics
Design: ReVerb and Rick Vermeulen (Hard Werken, L.A. desk)
Exhibition facilities: The Arthur A. Houghton Jr. Gallery at The Cooper Union

First published in 1994 by Watson-Guptill Publications, a division of BPI Communications, Inc., 1515 Broadway, New York, N.Y. 10036

The Library of Congress has cataloged this serial title as follows:

Typography (Type Directors Club [U.S.])
Typography: the annual of the Type Directors Club.—I—
New York: Watson-Guptill Publications, 1980—
v.ill.; 29 cm.

Annual.
ISSN 0275—6870 = Typography (New York, N.Y.)
I. Printing, Practical—Periodicals. 2. Graphic arts—periodicals.
I. Type Directors Club (U.S.).
Z243.A2T9a 686.2'24 81—640363
AACR 2 MARC-S
Library of Congress [8605]

Distributed outside the U.S.A. and Canada by RotoVision, S.A., Route Suisse 9, CH—1295 Mies, Switzerland

Manufactured in Italy
First printing, 1994

1 2 3 4 5 6 7 8 9 10 / 98 97 96 95 94

| | |
|---|---|
| senior editor | Marian Appellof |
| associate editor | Dale Ramsey |
| design | ReVerb, Los Angeles & Rick Vermeulen (Hard Werken, L. A. desk) |
| page makeup | Jay Anning |
| production manager | Ellen Greene |
| judges' photographs | Mara Kurtz |

# contents

For this year's competition, prospective entrants were asked to assess their work from an unusual point of view. What's that buzzzzzzzzzzzzzzzzzzzzzzzzzzzzzzzzzzing? The question is used as the driving concept in the design of the Call for Entries and the cover of this volume. Simple and enigmatic, this question was originally posed in 1967 by Marshall McLuhan and Quentin Fiore in *The Medium is the Message*. In the context of a design competition the question is compelling. Competitions like this have often proceeded on vague notions of quality and value.

Although ambiguous at first, the word "buzzing" could be set up as a clear metaphor for two issues that are generating notable work in typography and graphic design: *Identity* and *Authority* and the buzzing (the change) going on in each. *Identity:* What is our function and responsibility as visual communicators? *Authority:* What is right and wrong about the way we communicate? What is good design and bad design? Who decides these things and under what conditions are these judgments made?

Buzzing can be thought of as the sound that accompanies the emergence of a more complex and diversified world. A world where monolithic, centralized authorities that dispense standards of practice are shown to be inadequate, if not entirely irrelevant. Famously, digital technology has in the last few years empowered designers to allow their work to reflect this diversity. The scope of typographic approaches available is less limited now by the house styles of type shops, the proprietary inventories of font manufacturers. The imagination and sensibility of the designer have been given a wider opening through which ideas can flow. Digital technology and cultural diversity blend well in typography and graphic design. If a designer feels she wants to enact her work in a more vernacular and culturally specific manner, she has the tools to do it. If she wants to get closer to her audience, she is now technically more capable of exploring a range of pathways before selecting the most effective approach. Her energy, insight, and ingenuity can become the authorities. Designers are much freer now to experiment with ways to redefine their roles. But

Dirk Rowntree is a graphic designer and type director. His graphic design projects include books and book covers. He is currently working with Jean Foos on an *Aperture* monograph concerned with the work of artist David Wojnarowicz. He is type director at Young & Rubicam New York. As art director of *Shiny* magazine he received a Society of Publication Designers Merit Award for cover design.

control over production tools is not enough. Typographers, for their work to remain significant, will have to learn to think like designers. Designers will have to think along with the writers on the project, to internalize the message and empathize with the audience. Those areas generally known as the humanities—literature, art, history, philosophy—will become important sources for the designer. Certainly not a brand new idea, this discipline melding was well demonstrated almost thirty years ago by McLuhan (writer) and Fiore (designer). It means we have to become not scholars but simply more curious and aware, to recognize the broader social context of our work.

A successful design piece creates its own authority and has a convincing sense of identity. Standards of quality, like everything else, change. None are permanent and universal. The demonstration of a change in values at the expense of a beloved traditional quality standard should not impact negatively on the judgment of a piece. Rather than judge the TDC40 entries solely on their formal characteristics or on their level of obedience to conventional quality standards, the jury was asked to recognize those pieces that effectively demonstrate an enthusiastic cooperation between idea and form—that work which assumes that the audience is alert, intelligent, and sensitive enough to respond positively to ambitious visual messages.

It was my pleasant duty to fill the jury with people who have been practicing this kind of work. People I've admired and been inspired by, they were generous with their time and stingy with their praise. They sifted through 2,574 entries with a scrutiny that amazed me as the hours wore on. A new category, font design, added a special twist, with some ninety fonts entered. The selections showcased in this annual represent some of the most successful, challenging, and exciting work being done with typography today. Have fun browsing through it as a survey. Enjoy it, steal from it, be motivated. Don't think of it as authority so much as an invitation, an enticement, and a challenge to do work that emanates its own authority and establishes its own identity.

8 **judges** (LEFT TO RIGHT)

carol devine carson

graham clifford

jonathan hoefler

carl lehmann-haupt

ellen lupton

rebeca méndez

lisa nugent

Carol Devine Carson, a designer and art director in New York City for the past twenty-one years, studied fine arts and art history in her home state at the University of Tennessee. She has taught graphic design at the School of Visual Arts and has served on the board of directors for *American Illustration*. As an art director, she has worked for Scholastic, *Savvy* magazine, and at Time, Inc. Currently, Carson is a vice president of the Knopf Publishing Group and art director of Alfred A. Knopf.

Graham Clifford was born near London and in his teens was trained by his father as a type director. He worked as a type director in a number of London advertising agencies for seven years before being head-hunted to New York City to work for Chiat/Day as a typographic designer. After a hiatus during which he rode by motorcycle from London to Nairobi, he spent a year at Ogilvy and Mather, New York, as design director. He currently works for Chiat/Day, New York.

Jonathan Hoefler is a type-face designer and an arm-chair type historian. His New York studio, The Hoefler Type Foundry, has created such award-winning original type-face designs as the Champion Gothic family for *Sports Illustrated*, the Ziggurat family for *Rolling Stone*, and the popular Didot family for *Harper's Bazaar*. His latest project is Hoefler Text, a four-thousand-character family of text faces designed for Apple.

In each of his designs, Hoefler attempts to interpret the critical and aesthetic theories which precipitated a particular style of letter, and to spin this internal logic into the foundation for a family of original designs.

Hoefler's interest in contemporary critical typography is satisfied by serving as creative director of *Typo* magazine, and by sharing his office with antipodal designer Barry Deck.

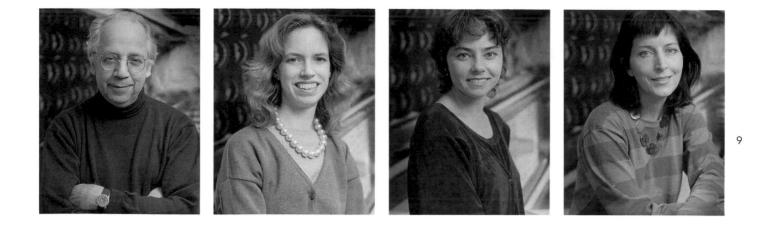

Carl Lehmann-Haupt was born and educated in New York City, where he has worked all his life. At the age of eleven, he pulled his first proofs on an old Columbia press in the Library School at Columbia University, where his father was a professor of graphic arts history. He has been co–art director of *Metropolis* magazine since 1990.

Ellen Lupton is a curator, writer, and graphic designer. As curator of contemporary design at the Cooper-Hewitt National Museum of Design in May 1992, she produced the book and exhibition *Mechanical Brides: Women and Machines from Home to Office*. She was curator of the Herb Lubalin Study Center at the Cooper Union from 1985 through 1992, where she organized many exhibitions on graphic design. In collaboration with J. Abbott Miller, she has created exhibitions and books such as *The ABCs of ●■▲: The Bauhaus and Design Theory* (1991). She and Miller received the Chrysler Design Award in 1993. Lupton's essays have appeared in journals and in books such as *Graphic Design in America* (ed. Mildred Friedman). In 1993, *I.D.* magazine named her one of America's forty design innovators.

Rebeca Méndez was born and raised in Mexico City and educated at Art Center College of Design in Pasadena, California, where she became design director in 1991. A teacher of typography and graphic and packaging design, she has also worked as a freelance designer and on the staffs of Robert Miles Runyan and Associates and Carl Seltzer Design. She was partner and creative director of Vianu Design from 1987 to 1989. Méndez is the recipient of many awards, including Designer of the Year, for both 1991 and 1992, from the Council for the Advancement and Support of Education, and her work has been honored or published by *I.D.* magazine, *AIGA Journal of Graphic Design, Communication Arts*, The 100 Show (American Center for Design, 1992 and 1993), and many others. Her work has been exhibited in numerous museums and galleries.

Lisa Nugent is a partner of ReVerb, a design studio in Los Angeles. Her work has been published in *The Graphic Edge, I.D.* magazine's "New & Notable" department, and *Studio Voice*, and has been included in The 100 Show (American Center for Design) for the past three years. The range of her work includes print, signage, and digital imagery for corporate clients as well as cultural institutions.

Nugent has taught for four years at Otis College of Art and Design and has been instrumental in developing communication arts courses, most recently "Typography and the Computer."

She received a B.F.A. in illustration in 1982 from California State University at Long Beach; in 1989, she received an M.F.A. from California Institute of the Arts, where she was awarded a merit scholarship.

Two posters designed for the Fells Point Corner Theatre—one by Paul Sahre and Dave Plunkert (shown here), the other by Paul Sahre—appeared to me to have a strong sensitivity and a sincere interest in the subject of drama. Each has a subtle and inherent wit and use of typography that help to realize this. The velvety screenprinting of these posters will have to be imagined.

DESIGNERS: Paul Sahre and David Plunkert, *Baltimore, Maryland* LETTERER: Paul Sahre and David Plunkert TYPO-GRAPHIC SOURCE: In-house CLIENT: Fells Point Corner Theatre PRINCIPAL TYPE: Futura Bold DIMENSIONS: 13½ x 20 in. (34.5 x 50.8 cm)

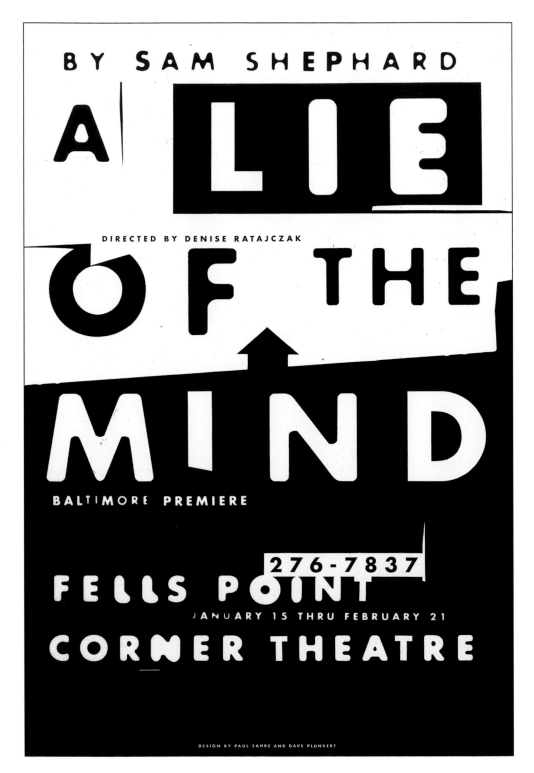

# graham clifford

Vance Studley is administrator of Archetype Press at Art Center College of Design in Pasadena, California. In 1986, the school purchased a type collection made up entirely of foundry type, which includes many faces from Europe and even 4,000 units of wood type. The Archetype program, which has sixteen presses for the use of these types, is a complement to the large Macintosh program that all the students take. The metal type affords a fresh, direct experience and physicality for the students as they acquire a link to the past; it's a whole new medium to them. Each term Vance selects a theme based on humanistic concerns, often from literature— never from a commercial product or an event—and one that has appeal for an ethnically diverse student population. "On Typography" enabled the students to research and interpret quotes in metal and on paper. Vance has encouraged the students to look for a hidden voice in the message, to arrange the type as they respond to the image rather than trying to presume what the author had in mind.

book

DESIGNERS: Vance Studley and various student designers, *Pasadena, California* LETTERER: Various TYPOGRAPHIC SOURCE: Archetype Press AGENCY: Art Center College of Design STUDIO: Archetype Press CLIENT: Art Center College of Design PRINCIPAL TYPE: Various foundry types DIMENSIONS: 11¼ x 7¼ in. (28.6 x 18.4 cm)

15

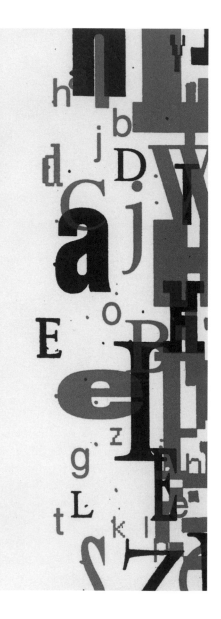

# jonathan hoefler

Depending on where you stand, typography is either in flux or in crisis. Diehard Modernists, obsessed with connoisseurship and inveterate notions of beauty, are becoming increasingly alarmed by a new generation of deconstructivist designers who have dedicated themselves to deflating the authoritarian canons of Modernism. Their battles are waged in the editorial columns of *Emigré* and *Eye*; their fallout fills these pages.

While critics repeatedly play the trump card of legibility, the more progressive members of both camps are asking some potent questions about readership. *What is the nature of design? Is the reader a passive receptacle, or an active participant in the design? Does a design have fixed or multiple readings? Are all aesthetic vocabularies inherently tainted?* To recovering Modernists, it is of paramount importance that these profound critical issues be reconciled with the supposedly outmoded aesthetics of classical typography.

This poster, designed for Nike by Guido Brouwers, seems to me representative of an emerging breed of design, which participates in the meaningful dialectic of deconstruction without relying on the shopworn visual clichés of deconstructivism. It adopts the conventions of a traditional poster, but invites the reader's involvement through subtle ironies. Foremost is its use of braille, a language which is at once familiar and largely indecipherable. Only arguably is it primarily intended for the blind: its use of a luxurious, pristine paper suggests sighted readers; its display-size braille is a witty yet imponderable typographic contrivance, unfamiliar to readers of braille; the very choice of the poster as a medium implies visual rather than tactile interaction. The usual hierarchy of design and text is subverted by its message, which can be inferred without decrypting the code: from the Nike swoosh, even nonreaders of braille can anticipate the ubiquitous Nike slogan, *Just Do It.*

Whenever a design appropriates a specific graphic vernacular, there is speculation about the intentions of the designer, and the motives of the client. In this case, these motives remain ambiguous. One wonders whether the poster was designed to evoke a warm response among the blind or the sighted politically correct, whether the piece was constructed to sell sneakers or to engender the image of a benevolent and sensitive corporation. That the piece both upholds and subverts typographic convention makes it interesting, but by provoking a discussion about visual language, it is of critical value.

The braille translates: Just Do It. This poster designed for those whose inspirations are felt and not merely seen.

DESIGNER: Guido Brouwers, *Beaverton, Oregon* LETTERER: Guido Brouwers TYPOGRAPHIC SOURCE: Schlagel Typesetting STUDIO: Nike Design CLIENT: NIKE, Inc. PRINCIPAL TYPES: Braille Regular and Braille Extra Bold DIMENSIONS: 22 x 34 in. (55.9 x 86.4 cm)

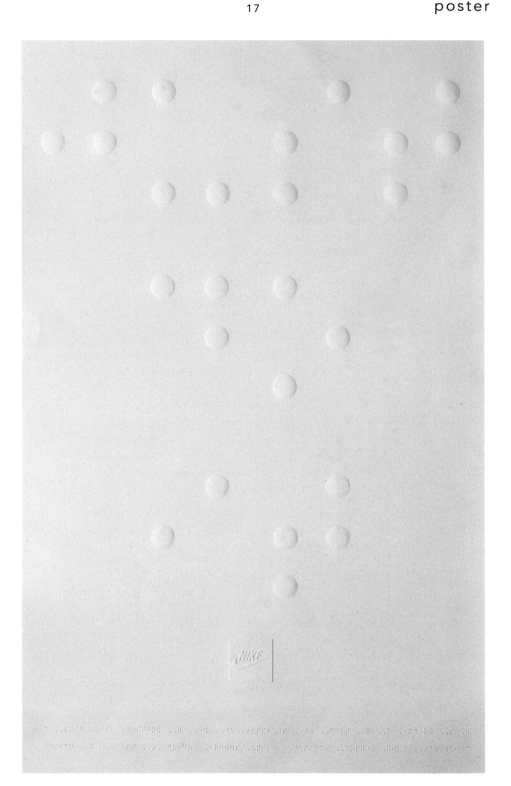

It was the title *Etaoin shrdlu* that hooked me. A note on the title page explained that the two words are produced by "lightly tapping the first twelve keys of a Linotype machine keyboard." If the operator has erred, (s)he can't make a correction, but, by quickly completing the line with "etaoin shrdlu," can discard the line.

A phrase signifying *mistake* stands alone on the title page. No author. Only at the end do we find it is the collaborative work of thirteen graduate students and their professor at the University of Illinois at Urbana.

The book's theme is sleep: sleep's periodicities, dreams, the language of the unconscious. On each verso page appear excerpts from a scientific text on sleep. On the facing recto the work of one designer, a composition in type which presents a poetic text. There is nothing here that one hasn't seen before, but there is no display. Each composition is challenging in a different way, and what each challenges is the way we read. When the text fails to read smoothly—as it always fails (etaoin shrdlu)—something in it gives me pause. I don't skip forward. I stare blankly. And then, miraculously, a new perception stirs. A shift in my spatial sense. The *line* is cancelled. The *plane* appears. I am reading the whole page. Several texts merge. The meaning sparks at the edges, where matter-of-fact language strikes the language of dreams, just as at waking.

One such composition gives us the first sentence of a story of Kafka's, and by simply varying the line breaks, the letter and word spacing, that first sentence is rendered perspicuous and alarming. In another, the voices of Rilke and Dickinson are intertwined with a scientific text on dreaming so as to make madness seem almost palpable. And in a third, voices emerge from sleep and speak with one another so beautifully that the too-long lines and serried leading act to force attentiveness on the reader.

At the end I begin to understand something. I see that texts do not exist except as they are embodied in sound or script, and their embodiment inevitably colors one's reading even of familiar texts. When experimental typography uncovers the transparency of type, the words become palpable and interpretation can begin from new ground.

Judging the entries was painful. So much rhetoric, so many clichés. But it was really satisfying to see the final selections, the choices that reflect the temper of our time. Even so, choosing *Etaoin shrdlu* reflects a question. Why choose a work of poetry, done in graduate school, over work done in "real world" conditions? The voice coming from the other side of sleep speaks to us. It tells of an impoverishment in the air we breathe, the air of consumerism and technology. One has to look to the margins of our profession for something that the profession fails for the most part to provide—the voice that answers, "the voice that is great within us."

DESIGNERS: Fred Daab, Brian Curry, Gregg Synder, Nan Goggin, Mark Fetkewicz, Elizabeth A. Postmus, Paula J. Curran, Christina Nordholm, Karen Cole, Jeff Clift, Fanky Chak, Vince Parker, Joe Kukella, and Chris Waegner, *Champaign, Illinois* ART DIRECTOR: Nan Goggin TYPOGRAPHIC SOURCE: University Printing Services, University of Illinois at Urbana-Champaign STUDIO: Graduate Graphic Design Studio Art GD 467 PRINCIPAL TYPE: Baskerville DIMENSIONS: 8 x 8 in. (20.3 x 20.3 cm)

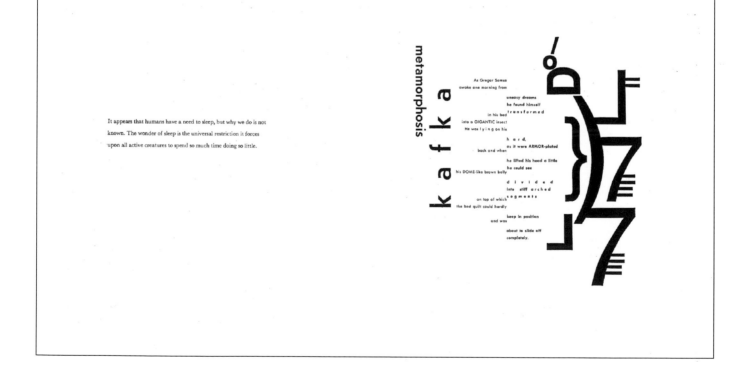

Designer Susan Silton, artist Kim Abeles, and editor Karen Moss collaborated on the concept of *Encyclopedia Persona*, a book that stands out among the stuffy, self-aggrandizing publications typical of museums and art galleries. The book's format, production values, typography, layout, and literary style all contribute to the meaning and experience of the overall object. More than just a parody, *Encyclopedia Persona* explores a familiar publishing genre in a manner rich with cultural associations and design and content possibilities. The leatherette binding, shiny paper, and process tints invoke the material quality of elementary school textbooks while avoiding the sentimentality and nostalgia so prevalent in recent vernacular appropriations. Holding back on the desire to "push" the publication's look toward a trendy retro caricature, the designer has successfully invoked the ominous anonymity of the libraries and family rooms of our girlhood.

DESIGNER: Susan Silton, *Los Angeles, California* TYPO-GRAPHIC SOURCE: In-house STUDIO: SOS, Los Angeles CLIENT: Santa Monica Museum of Art, Fellows of Contemporary Art PRINCIPAL TYPES: Futura, Bembo, Clarendon, and Univers DIMENSIONS: 7½ x 10 in (19.1 x 25.4 cm)

catalog

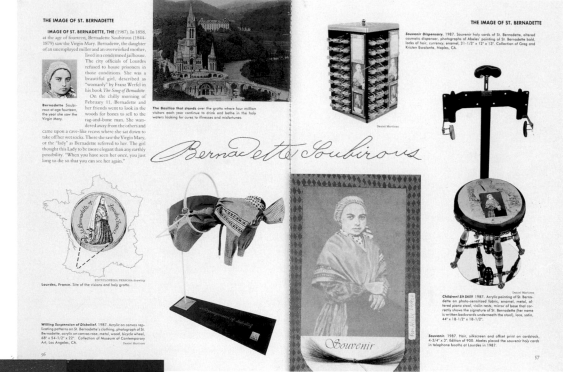

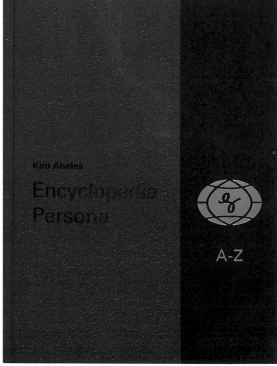

# rebeca méndez

This poster conveys a sense of the tenuous nature of the whole—specifically, the body of human rights as indivisible and inviolable—on the verge of fragmentation. The poster is perforated and divided into a set of thirty-two detachable postcards, each describing a violation of human rights. The ease of separating the postcards suggests the fragility of these rights. The moment one right is violated or taken away, the human being is no longer whole. The layering of allusions to the body works on several levels. Not only is the perforated grid covering the image of the body an obvious metaphor for violation, it also resembles and points to a skeletal structure or circulatory system, while infusing an organic quality into the poster's materiality. The words "human rights abuse," violently and contemptuously stamped over the surface of the poster—and the skin of the body—works at the level of a scar, a tattoo, or a burn, and effectively contrasts with and heightens the effect of sensing the deeper violation of basic human values, dignity, and propriety. For me this poster penetrates at a rational and at a sensory level simultaneously, giving me a glimpse of that threat by which we are made abject through suffering.

DESIGNERS: Hal Wolverton, Alicia Johnson, Adam McIsaac, and Kat Saito, *Portland, Oregon* LETTERER: Hal Wolverton PHOTOGRAPHER: Rafael Astorga TYPOGRAPHIC SOURCE: In-house AGENCY: Johnson & Wolverton CLIENT: Amnesty International USA PRINCIPAL TYPES: Garage Gothic and Monotype Grotesk DIMENSIONS: 24 x 34 in. (61 x 86.4 cm)

poster                    23

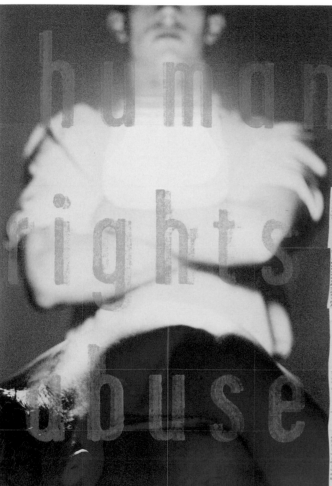

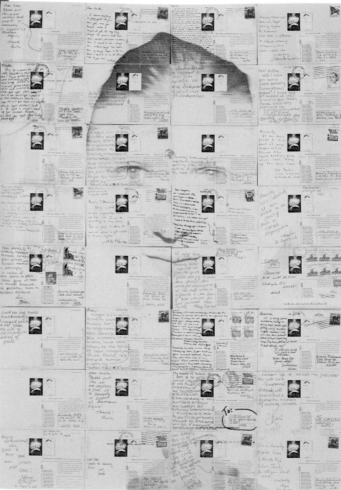

Initially I selected *105 Minutes* for its quirky stylization of classical typography: however, later it became clear that the more intriguing aspect was its omission of the film title and the hostile response that omission evoked. A quick read is highly valued in a consumer society and as a result the reader (or consumer) expects a title of a work (or name of a product) to be easily found and read—anything less is cause for annoyance. Even so, innovative designers have experimented with shifts in typographic hierarchy, thereby subverting messages and creating alternative readings of a text, but it is rare for a designer to edit out a title. Is the intervention a violation of Hal Hartley's *Trust* and readers' expectations, or is it an insightful interpretation of information specific to the concerns of a small community?

The designer employs the power of style by speaking in two authoritarian voices. (1) He reinforces its own believability by making reference to 15th-century manuscripts, a book form that emerged from the intellectual centers in Europe. (As a comparison, imagine the poster styled after a tabloid and consider its credibility.) Also, the font Charlemagne, used in all capitals, mimics the studies of constructed letters by Renaissance scholars. (2) While the movie was running, he taped an addendum on each of the posters with the words "trust" and, in very small letters, "design." The first reading is the title of the film, *Trust*, and the second reading a request to trust design. The type style, lower-case sans-serif, makes the association with Bauhausian authority and speaks in a modern voice—"Didn't I tell you what the movie was about?"

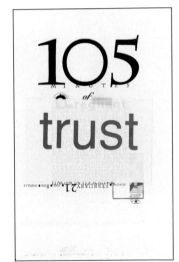

Style is a device often underestimated in its ability to persuade, and Brian Schorn has used it well to reinforce his message. I commend him for reassessing our conventions and trying a new tactic. The negative response indicates how some artists, willing to challenge conventions in their own work, are unwilling to accept the same challenges in design. In order to better understand Brian's strategy, I've included his statement of intent.

*105 Minutes* is a poster announcement for a feature-length movie which is part of a weekly series on campus of Cranbrook Academy of Art. The poster is constructed around the fact that it contains no title. The reason for this is quite simple: The title of the film, *Trust*, is, for all practical purposes, an abstract word, and therefore carries no significant meaning, especially in reference to what the film is actually about. This reminds me of a quote stressed in beginning poetry writing workshops, "Go in fear of abstraction" (Ezra Pound). Fear acts as a measure to prevent one from saying nothing by using abstract words. Here, I am thinking specifically of those who are not familiar with the movie and would be using the poster as a means of making a decision about what they should do with their time on Sunday night. With this in mind, I decided that the standard description found in a Movie Guide would communicate the movie's content far more clearly than the title itself. This description became the body of the text. What appears, at first glance, to be the title (*105 Minutes*) is an intentional flipping of hierarchy based on the fact that graduate art students tend to have tight schedules and find it necessary to budget their time. In other words, tonight's movie is 105 minutes long: Do I have time for that or should I work in the studio instead? In addition to the above reasoning, both the flipped hierarchy and the lack of a title are direct responses to previous movie posters done by other designers where a gradual loss or veiling in information was evident. The progressive, weekly dialogue (a new designer each week) that was established between each designer's response provided a fresh level of graphic communication evident not only to the Design Department but to the entire school as well. Some posters were taken down and put in flat files or even framed, while others were bitterly defaced by graffiti.

DESIGNER: Brian Schorn, *Bloomfield Hills, Michigan*
TYPOGRAPHIC SOURCE: In-house
STUDIO: Cranbrook Academy of Art Design Department
CLIENT: Cranbrook Academy of Art Sunday Night Film Series
PRINCIPAL TYPES: Charlemagne and Avenir DIMENSIONS: 11 x 17 in. (27.9 x 43.2 cm)

25

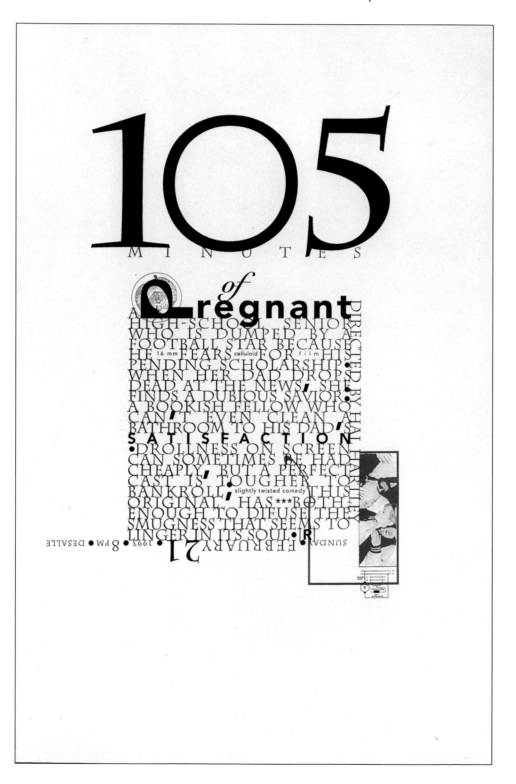

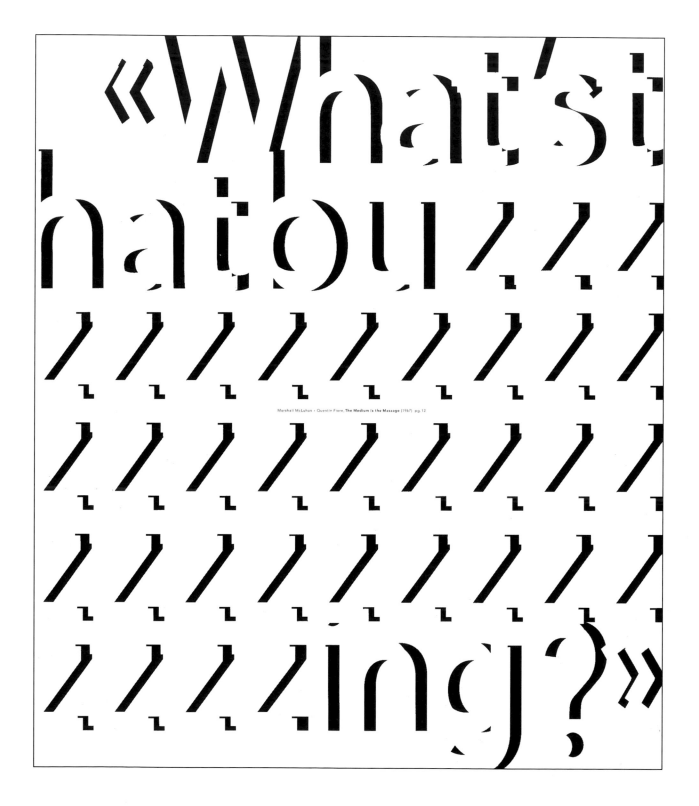

«What's that you /// ///// ////ing?»

Marshall McLuhan - Quentin Fiore, **The Medium is the Massage** (1967) pg.12

DESIGNERS: ReVerb and Hard Werken, L.A. Desk, with Chris Haaga, *Los Angeles* OUTPUT: Digital Pre-Press International, *San Francisco* PAPER: Simpson Satin-Kote Recycled 60-lb. Book, Simpson Paper Company PRINTER: MacNaughton Einson Graphics PRINCIPAL TYPE: Avenir DIMENSIONS: 38 x 33½ in. (96.5 x 85 cm)

Buzzing is the sound of change. What is changing? The world. For designers and typographers, the way we express ideas is changing. Also changing (gasp) is our understanding of the terms excellence and quality. Some adjusted attitudes we're starting to see are: 1. Quality is not necessarily bound up with the idea that value, beauty and legibility are embedded in ideal form. 2. The best guide to excellence might not be white, male, Eurocentric design history. 3. Invisibility: the idea that typography and design can be transparent and devoid of meaning might not always apply. Typographic standards that have been around for 500 years are now coming under fresh scrutiny from creative, resourceful designers.

Creative people are buzzing. It's their job. There are more of them buzzing and they're buzzing louder than ever before. Boundaries between high and low, good and bad, beautiful and ugly are disappearing as fast as traditional type shops. The buzzing is difficult to ignore.

With all this, how do we judge the quality of a designer's work? That's up to the panel of accomplished practitioners and observers I've assembled to do just that. Some things they'll be looking for are: a high level of commitment to a project, its content and its audience; careful attention to detail; relevance; a command of the tools whether technical or theoretical; innovation; willingness to explore; and thoughtfulness. To award excellence in typography, we must now access a wider range of approaches, take another look at the traditional along with the excluded, the forbidden, the overlooked.

The Type Directors Club celebrates the expansion of typography's reach.

We love type.

We enthuse over a heightened awareness of type's design potential, its vitality and its power.

With this call I encourage you to participate in the fortieth annual Type Directors Club international competition. Let us see the pieces you're most excited about.

Which ones are those? Pick them up. Put them to your ear. Is there a buzz? We can't wait to hear from you.

—Dirk Rowntree, Chairperson

Type Directors Club
60 East 42 Street, Suite 721
New York, NY 10165-0721
USA

Bulk Rate
U.S. Postage
PAID
Permit No. 1470
Ronkonkoma, NY

## 40th Annual Type Directors Club Exhibition

Call for Entries
Deadline January 7, 1994

Please Post

# Call for Entries

### THE CONTEST

The Type Directors Club, founded in 1947, is a professional organization of typographic designers and users of typography. For the 40th year, the Type Directors Club (TDC) announces an open call for entries in an international competition to measure excellence in the use of typography, calligraphy, handlettering and other letterforms. The winners of this competition will be exhibited and published in *Typography 15*, the all-color annual of the competition, designed by ReVerb and Hard Werken/L.A. Desk (Rick Vermeulen). ReVerb consists of Somi Kim, Whitney Lowe, Susan Parr, Lisa Nugent and Lorraine Wild. The annual is published by Watson-Guptill and over 20,000 copies are sold worldwide.

### CATEGORIES AND ENTRIES

Work is judged for typographic excellence in the following categories: advertising, announcements, annual reports, books, book jackets, brochures, calendars, catalogs, compact disk and video cassette packaging, corporate identity, dimensional design, magazines, menus, newspapers and newsletters, packaging, point-of-purchase, posters, programs, record albums, architectural and urban signage, and film and television titles. Digital type on CD as well as multi-media and interactive works on CD will also be judged. The categories are endless.

This year, for the first time, we have included a special category, Typeface Design. Typefaces designed in 1992 and 1993 will be judged. To enter this new category, see instructions below.

### ENTRY RULES:

•Actual piece must be published or produced in 1993 and may be submitted by anyone associated with the work.

•If the actual piece is not available or its size is unmanageable (signage, outdoor advertising, dimensional design, etc.), a photographic print (8 x 10 inches/approximately 20.3 x 25.4 cm) is acceptable. A transparency or slide, is NOT acceptable.

•Pieces designed for or on behalf of the TDC may not be submitted.

•It is not necessary to mount the work.

•Videos (1/2 in. VHS/NTSC only) will be accepted for judging, but winners will be asked to submit individual frames from each video as photographic prints for the exhibition and annual book.

*Some categories require special information:*

•Logotypes must include firm or institution name and a one-sentence description on the front bottom of the entry. Photostats, computer prints and printed versions of the work may be submitted in a minimum size of 8 x 10 inches (20.3 x 25.4 cm) and maximum 11 x 17 inches (27.9 x 43.2 cm) format.

•Stationery, which may include a letterhead, billhead, envelope and one business card, will be considered as a single entry. If other items are included, the stationery will be considered a series entry. A logotype associated with the stationery must be

submitted as a separate entry. If the logotype and stationery are submitted together, it will be considered a series entry.

•Corporate identity is considered a campaign entry (at least two but not more than six pieces) and may contain letterhead, stationery items, identity materials, signage, etc.

•Packaging and point-of-purchase material may be submitted as an actual piece or in a photographic print (8 x 10 inches or approximately 20.3 x 25.4 cm). If the photograph contains more than one item, it will be considered a campaign/series and require the appropriate fee.

•Invitations may include the invitation, response card and envelope. The inclusion of additional pieces will be considered a campaign/series entry.

•Brochures and catalogs that are multiples, distributed in a single envelope, constitute a series entry.

•Typeface designs done in 1992 and 1993 will be accepted. These must be submitted on a 11 x 17 in. (27.9 x 43.2 cm) sheet. Please show all the characters in the character set. Also, include the word *Hamburgefonstiv* on the page. The designers of the winning entries will be asked to design a showing of their font for a full page in the annual. Each font will be considered a single entry and a family of fonts will be considered a series.

*NO ENTRIES WILL BE RETURNED.*

•Remember the following are NOT accepted:
  •Transparencies
  •Slides
  •Pieces designed for or on behalf of the TDC
  •Pieces produced or published prior to 1993, except typeface design entries.

### AWARDS

Only winners will be notified the week of January 24, 1994.

Entries selected by the jury will receive Certificates of Typographic Excellence. The work will be exhibited and published in *Typography 15*, the annual of the 40th TDC Exhibition, and published by Watson-Guptill Publications. Last year, twenty-thousand copies sold internationally.

The opening of TDC40 will be held in the Houghton Gallery at The Cooper Union and will be on display in June 1994. Winners will be asked to supply five additional copies of the winning entries for use in exhibitions outside New York. These shows travel throughout North America, South America, Australia, New Zealand, Europe, and Eastern Asia. Credits for individuals and firms that contributed to each entry will be included in the exhibition and in *Typography 15*.

### FEES

Payment must be submitted with entries. The fees are as follows:

Single entry – US$15.

Series/Campaign entry – US$40.
Two but not more than six typographically and/or conceptually related items such as posters, advertisements, booklets, packages, or pieces used in corporate identity programs.

Videotapes (1/2 in. VHS/NTSC only) – US$15. Each video must be entered on a separate cassette.

Winners will be charged a US$80 hanging fee for each individual entry and US$130 for each series/campaign entry to be included in the annual exhibition, traveling shows and *Typography 15*.

The hanging fee for TDC members is US$25 for each individual entry and US$40 for each series/campaign.

Fees from all countries outside the U.S. must be in the form of drafts drawn on a New York bank, payable in U.S. dollars. Travelers checks in U.S. dollars are acceptable. No credit cards please.

### JUDGES

All entries will be judged early in 1994 by this select group of graphic arts professionals:

Carol Devine Carson
    Art Director Alfred A. Knopf Inc.
Graham Clifford
    Type Director Chiat/Day inc. Advertising
Jonathan Hoefler
    Typographic Designer
B. W. Honeycutt
    Art Director Details
Ellen Lupton
    Curator Cooper-Hewitt National Museum of Design
Rebeca Méndez
    Designer Art Center College of Design
Lisa Nugent
    Designer ReVerb

Carol Wahler
    Executive Director Type Directors Club
Dirk Rowntree
    TDC 40 Chairperson

### SHIPPING INSTRUCTIONS

All entries, together with the fees, are to be sent to:

TDC40, Type Directors Club
60 East 42 Street, Suite 721
New York, NY 10165-0721
USA

Unfortunately, no entries can be returned.

If more than one package is shipped, indicate this on the outside of each package.

Packages must be delivered prepaid. Non-US contestants should mark each package, "Material for contest entry. No commercial value." No provision will be made by TDC for US Customs or airport pickup. Therefore, international entries should be sent by mail, not by air freight.

Entries must be received by January 7, 1994.

For further information, please call the TDC office: 212-983-6042 or FAX 212-983-6043.

Copyright 1993 Type Directors Club
Printer: MacNaughton Einson Graphics
Paper: Simpson Satin-Kote Recycled 60 lb. Book,
    Simpson Paper Company
Output: Digital Pre-Press International, San Francisco
Typeface: Avenir/Adobe
Design: ReVerb & Hard Werken/L.A. Desk with Chris Haaga

### ENTRY FORMS

Each entry form must contain a title for identification of the piece and an indication of whether it is a single, series or campaign entry. Indicate number of pieces. An entry form is printed on this poster. If additional forms are needed, make photocopies. An entry form must be attached to the back of each entry. If it is a series or campaign, one entry form is sufficient, and should be placed on one of the items. Fasten only at the top of the form. The lower portion will be removed prior to judging.

PLEASE TAPE AT TOP ONLY TO THE BACK OF THE ENTRY. TDC WILL REMOVE LABEL PRIOR TO JUDGING.

FOR OFFICE USE

CHECK ONE: ............single entry ...........series/campaign entry ............(number of pieces)

CATEGORY                                   TITLE OF WORK

SUBMITTED BY

COMPANY

ADDRESS

CITY, STATE, ZIP CODE

COUNTRY

TELEPHONE                              FAX

Credits will be requested for selected pieces. Entry is declared to be a 1993 production and permission is granted to reproduce selected pieces in the annual, *Typography 15*, and in publications reporting the exhibition.

DO NOT FASTEN THIS EDGE. TAPE THE TOP OF THIS FORM ONLY.

MUST BE ATTACHED TO PAYMENT:
    Number of single entries.............@ US$15
    Number of series/campaign...........@ US$40
            Total payment due
    Make checks payable to: Type Directors Club

NAME
COMPANY
ADDRESS
CITY, STATE, ZIP CODE
COUNTRY
TELEPHONE                         FAX

CHECK HERE IF YOU WISH TO RECEIVE TDC MEMBERSHIP INFORMATION

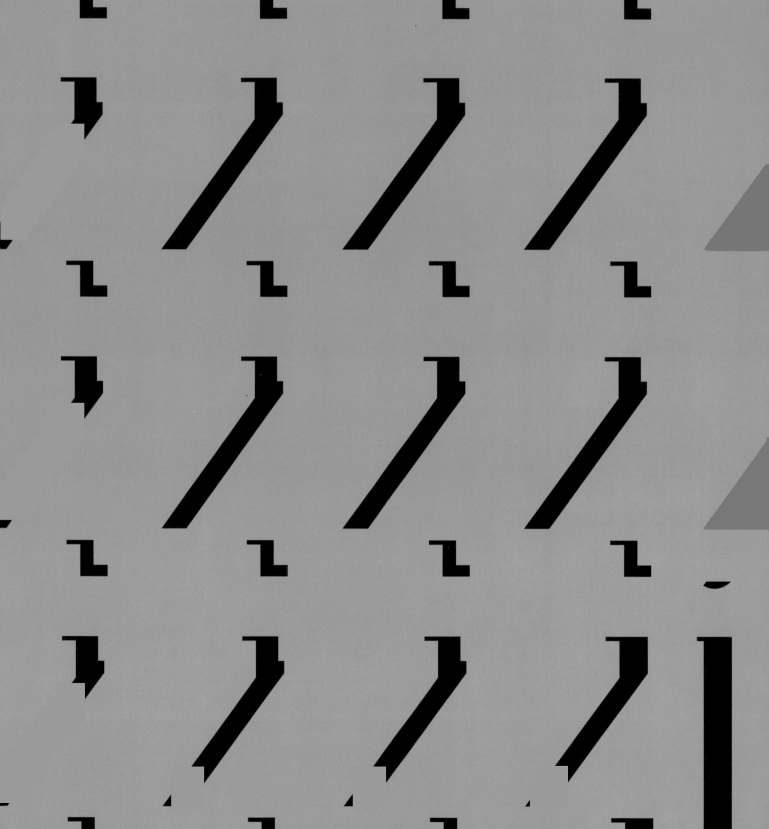

DESIGNER: Paul Sahre, *Balti-more, Maryland* STUDIO: GKV
Design PRINCIPAL TYPE: Fur
Extra Rounded

# Fur Extra Rounded

a b c d e f g h i j k l m
n o p q r s t u v w x y z

! @ $ % & ( ) ' " ' " ; " ' , . ?

A B C D E F G H I J K L M
N O P Q R S T U V W X Y Z

0 1 2 3 4 5 6 7 8 9

## Ff What's that buzzing?

This is a showing of the font Fur Extra Rounded.
It was selected by the TDC40 jury as
an outstanding achievement in font design.

DESIGNERS: Andréas Nettho-
evel and Urs Mühlheim, *Biel,
Switzerland* ART DIRECTOR:
Andréas Netthoevel STUDIO:
second floor south CLIENTS:
Spörri Optik AG, Urs Brassel
and Kuno Cajacob PRINCIPAL
TYPES: Franklin Gothic Demi,
Futura Bold, and Helvetica
Heavy DIMENSIONS: 35⅝ x 50⅖
in. (90.5 x 128 cm)

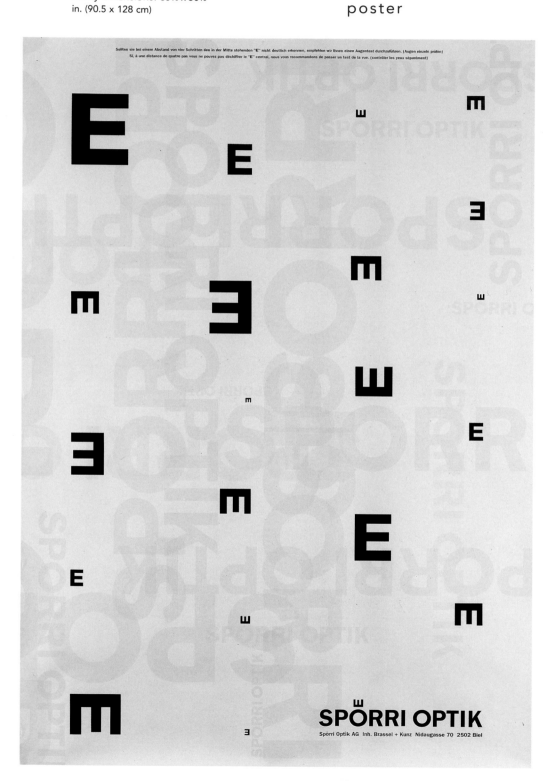

DESIGNER: David Carson, *Del Mar, California* TYPOGRAPHIC SOURCE: In-house AGENCY: Wieden & Kennedy STUDIO: David Carson Design CLIENT: NIKE, Inc. PRINCIPAL TYPE: Canadian Photographer DIMENSIONS: 17 x 10 ¾ in. (43.2 x 27.3 cm)

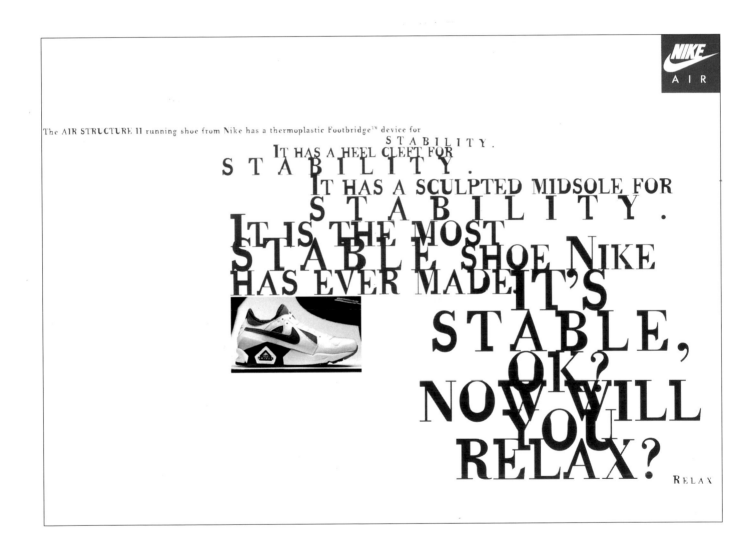

DESIGNER: David Carson, *Del Mar, California* TYPOGRAPHIC SOURCE: In-house AGENCY: Wieden & Kennedy STUDIO: David Carson Design CLIENT: NIKE, Inc. PRINCIPAL TYPE: Eve DIMENSIONS: 17 x 10¾ in. (43.2 x 27.3 cm)

advertisement                    33

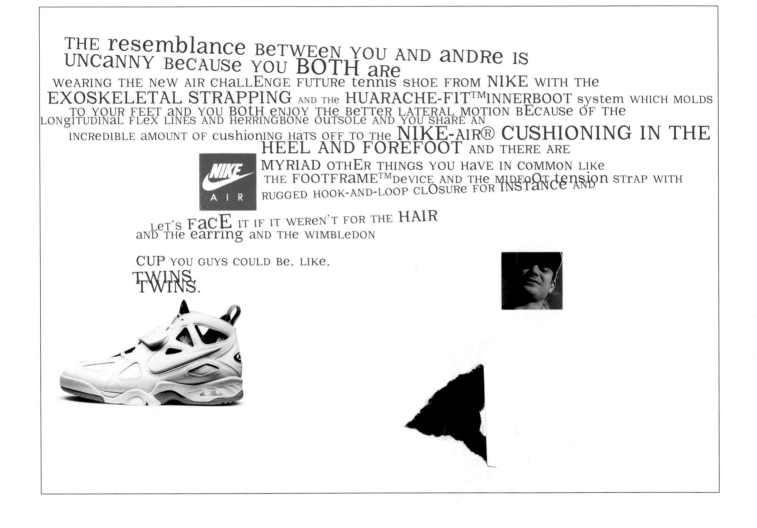

DESIGNER: Robert Bergman-Ungar, *New York, New York*
TYPOGRAPHIC SOURCE: In-house
AGENCY: Art w/o Borders Co.,
New York   CLIENT: Mâp Pub-
lications Inc., Zurich   PRINCIPAL
TYPE: Helvetica   DIMENSIONS:
9 x 13 in. (22.9 x 33 cm)

34                                                                                                   magazine

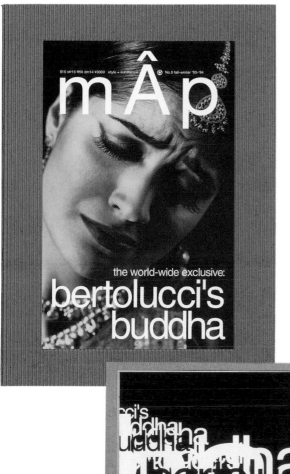

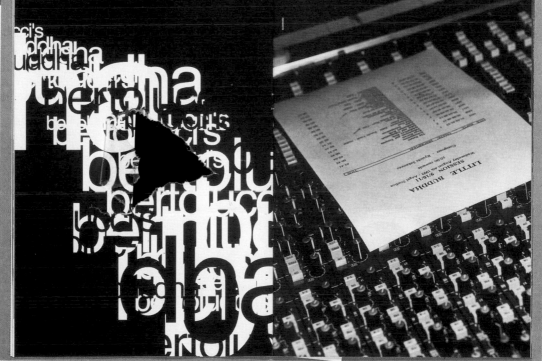

DESIGNERS: Carlos Segura and
Scott Smith, *Chicago, Illinois*
TYPOGRAPHIC SOURCE: In-house
STUDIO: Segura, Inc. CLIENT:
[T-26] PRINCIPAL TYPE: Tema
Cantante DIMENSIONS: Various

DESIGNERS: Theseus Chan and Jim Aitchison, *Republic of Singapore* TYPOGRAPHIC SOURCE: In-house AGENCY: Chan/Aitchison Partnership CLIENT: D Corner PRINCIPAL TYPES: Baskerville, Times Roman, Caslon, and Clarendon DIMENSIONS: 15 x 10⁷/₁₆ in. (38 x 26.5 cm)

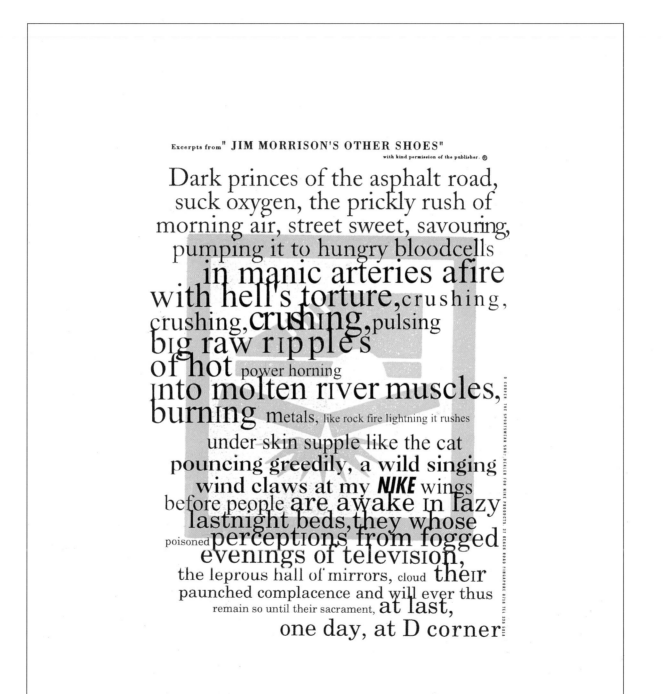

DESIGNERS: Theseus Chan and Jim Aitchison, *Republic of Singapore* TYPOGRAPHIC SOURCE: In-house AGENCY: Chan/Aitchison Partnership CLIENT: D Corner PRINCIPAL TYPE: Courier DIMENSIONS: 15 x 10⁷/₁₆ in. (38 x 26.5 cm)

advertisement

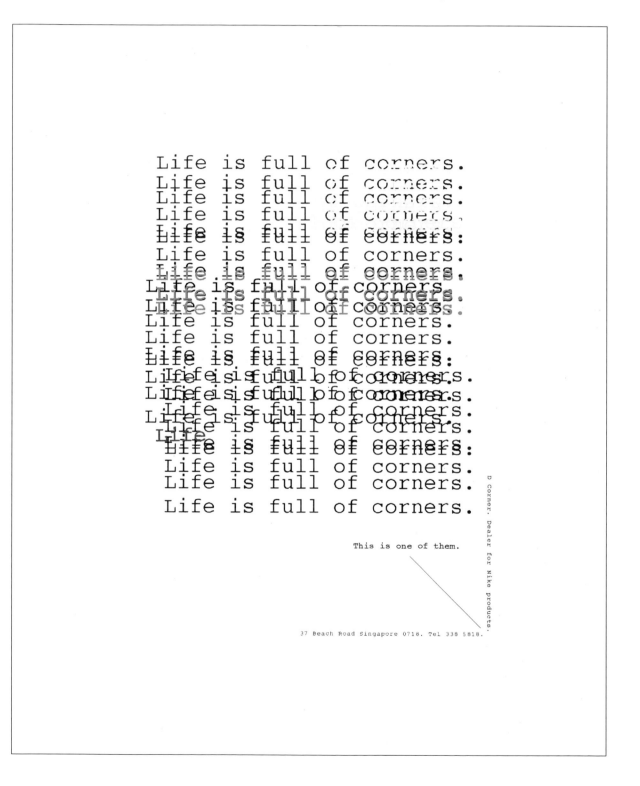

DESIGNER: Robert Wong, *New York, New York* JUNIOR DESIGNER: Matt Rollins CREATIVE DIRECTOR: Aubrey Balkind and Kent Hunter TYPOGRAPHIC SOURCE: In-house AGENCY: Frankfurt Balkind Partners CLIENT: The Limited, Inc. PRINCIPAL TYPES: Trixie and Dot Matrix DIMENSIONS: 6 x 11 in. (15.2 x 27.9 cm)

Questioning is good business. A year ago, we responded to more than 10,000 questions from our associates.

# Questioning ThinkingActing
The process continues.

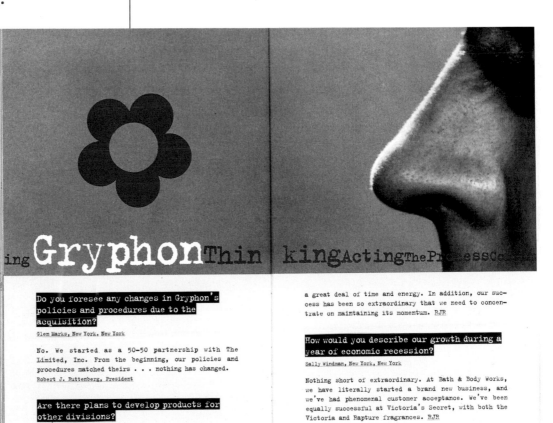

ing **Gryphon** Thin  kingActingTheProcessCo

**Do you foresee any changes in Gryphon's policies and procedures due to the acquisition?**
Glen Marks, New York, New York

No. We started as a 50-50 partnership with The Limited, Inc. From the beginning, our policies and procedures matched theirs . . . nothing has changed.
Robert J. Ruttenberg, President

**Are there plans to develop products for other divisions?**
Steve McCammon, Aberdeen, New Jersey

We believe we have to focus on serving the divisions we originally started with — Victoria's Secret and Bath & Body Works — and on building significant fragrance and toiletry businesses for them, to make them true destination stores for personal care products. These are still start-up businesses, and they require

a great deal of time and energy. In addition, our success has been so extraordinary that we need to concentrate on maintaining its momentum. RJR

**How would you describe our growth during a year of economic recession?**
Sally Windman, New York, New York

Nothing short of extraordinary. At Bath & Body Works, we have literally started a brand new business, and we've had phenomenal customer acceptance. We've been equally successful at Victoria's Secret, with both the Victoria and Rapture fragrances. RJR

Gryphon develops and supplies fragrances and toiletry products for our retail divisions.

DESIGNER: John Ball, *San Diego, California* LETTERER: David Quattrociochi TYPO-GRAPHIC SOURCE: In-house STUDIO: Mires Design, Inc. CLIENT: Communicating Arts Group PRINCIPAL TYPE: Letter Gothic DIMENSIONS: 12 x 12 in. (30.5 x 30.5 cm)

mailer

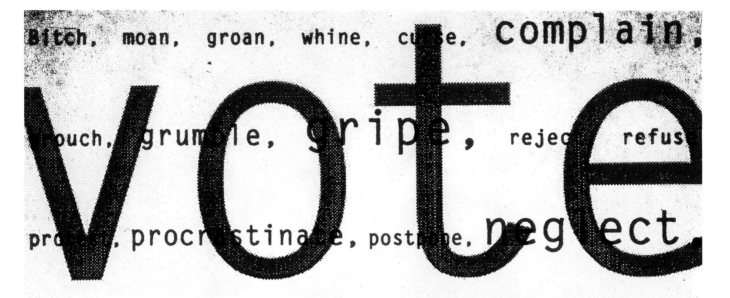

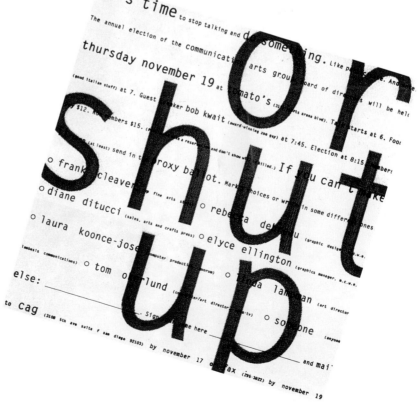

DESIGNER: P. Scott Makela, *Minneapolis, Minnesota* DIRECTOR: Jeffrey Plansker TYPOGRAPHIC SOURCE: In-house STUDIO: P. Scott Makela Words and Pictures for Business and Culture CLIENT: Vans Shoes PRINCIPAL TYPES: Dead History and Carmela

40                                              video

DESIGNER: P. Scott Makela, *Minneapolis, Minnesota* DIRECTOR: Jeffrey Plansker TYPOGRAPHIC SOURCE: In-house STUDIO: P. Scott Makela Words and Pictures for Business and Culture CLIENT: UTV, British Columbia PRINCIPAL TYPES: Dead History and Barmeno

video

DESIGNERS: Thekla Halbach
and Thomas Hagenbucher,
*Düsseldorf, Germany* TYPO-
GRAPHIC SOURCE: In-house
CLIENT: Akademie der Archi-
tektenkammer NRW and
Fachhochschule Düsseldorf
PRINCIPAL TYPE: Futura Bold
DIMENSIONS: 23⅜ x 33¹⁄₁₆ in.
(59.4 x 84 cm)

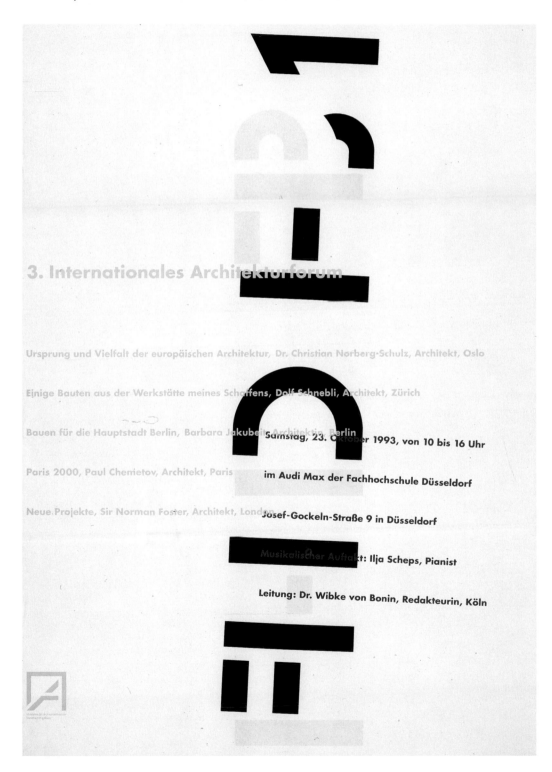

DESIGNER: P. Scott Makela, *Minneapolis, Minnesota* TYPOGRAPHIC SOURCE: In-house STUDIO: P. Scott Makela Words and Pictures for Business and Culture CLIENT: Walker Art Center PRINCIPAL TYPES: Dead History and Tempo DIMENSIONS: 17 x 23 in. (43.2 x 58.4 cm)

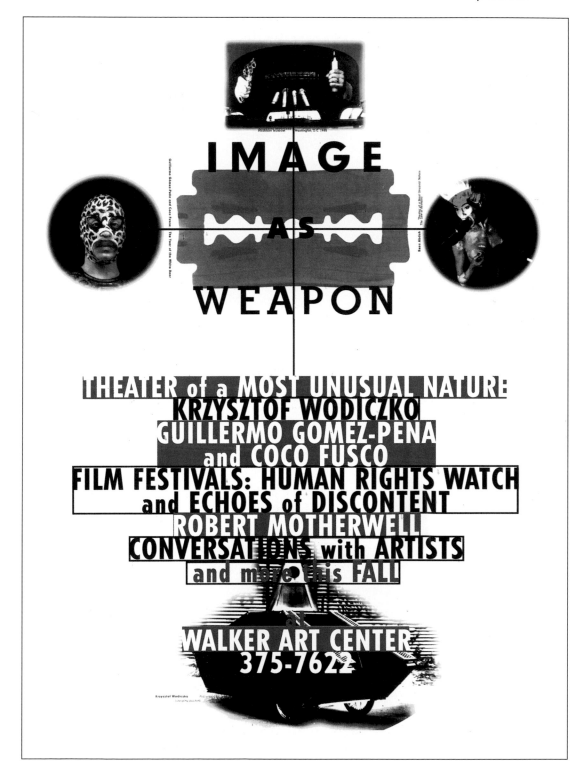

DESIGNERS: Thekla Halbach and Thomas Hagenbucher, *Düsseldorf, Germany* TYPO-GRAPHIC SOURCE: In-house CLIENTS: Thekla Halbach and Thomas Hagenbucher PRINCI-PAL TYPE: Frutiger DIMEN-SIONS: 23⅖ x 33¹⁄₁₆ in. (59.4 x 84 cm)

poster

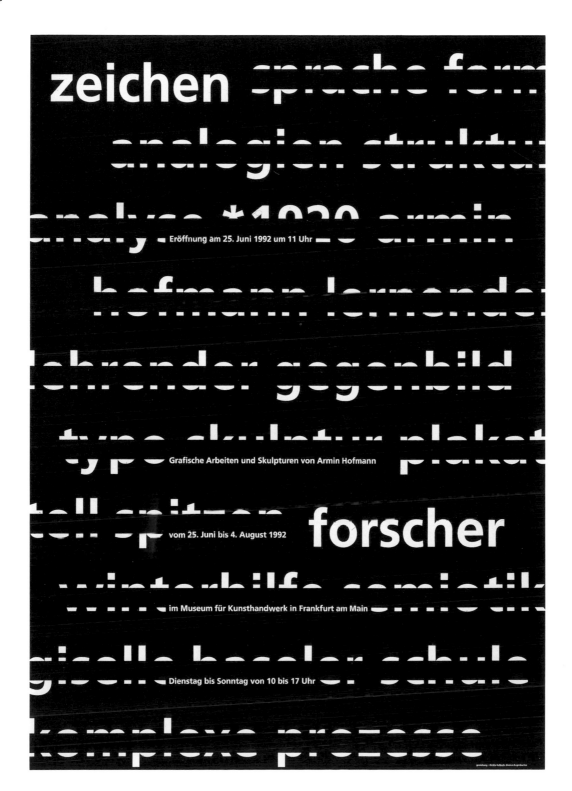

poster and postcard

DESIGNER: Uwe Loesch, *Düsseldorf, Germany* LETTERER: Uwe Loesch TYPOGRAPHIC SOURCE: In-house STUDIO: Uwe Loesch CLIENT: Museum für Kunsthandwerk, Frankfurt am Main PRINCIPAL TYPE: Franklin Gothic Oblique DIMENSIONS: Poster: 33 1/16 x 46 7/8 in. (84 x 119 cm) Postcard: 8 1/4 x 5 13/16 in. (21 x 14.8 cm)

45

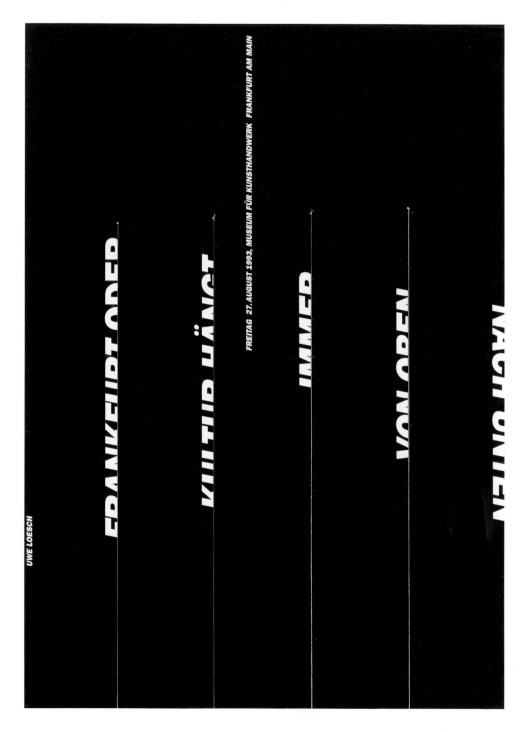

DESIGNER: Susan Randine Lally, *Oak Park, Illinois* TYPOGRAPHIC SOURCE: In-house STUDIO: Lally Design CLIENT: Design by Wirth PRINCIPAL TYPES: Futura, Goudy, Franklin Gothic, and Garamond DIMENSIONS: 8⅜ x 11 in. (21.25 x 27.9 cm)

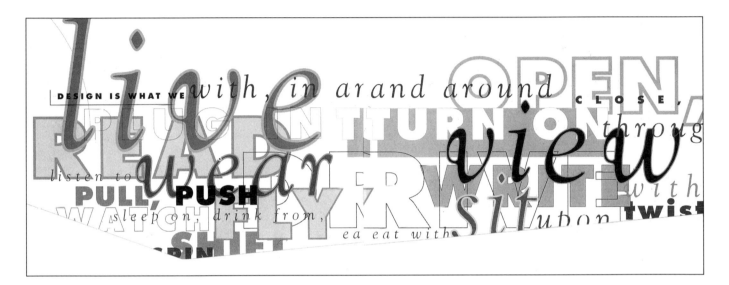

DESIGNERS: Thekla Halbach and Thomas Hagenbucher, *Düsseldorf, Germany* TYPO-GRAPHIC SOURCE: In-house CLIENTS: Thekla Halbach and Thomas Hagenbucher PRINCI-PAL TYPE: Frutiger DIMEN-SIONS: 23⅖ x 33¹⁄₁₆ in. (59.4 x 84 cm)

poster 47

ballett buch schnee
weiß s/ w rhythmus
design laboratory a
Grafische Arbeiten vo
brodov itch harper's
im Museum für Kunst
bazaar fremd *1898
vom 6. August bis 3. S
rußlan d filmischer
Dienstag bis Sonntag
fluß fo tomontage
Eröffnung am 6. Augu
n Alexey Brodovitch
observ ations †1971
handwerk in Frankfurt am Main
portfo lio intuition
eptember 1992

von 10 bis 17 Uhr

st 1992 um 11 Uhr

DESIGNERS: Steve Farrar and Kirk James, *Burlington, Vermont* ART DIRECTOR: Steve Farrar CREATIVE DIRECTOR: Michael Jager TYPOGRAPHIC SOURCE: In-house STUDIO: Jager DiPaola Kemp Design CLIENT: TDK PRINCIPAL TYPES: Din and ITC Officina DIMENSIONS: 24 x 24 in. (61 x 61 cm)

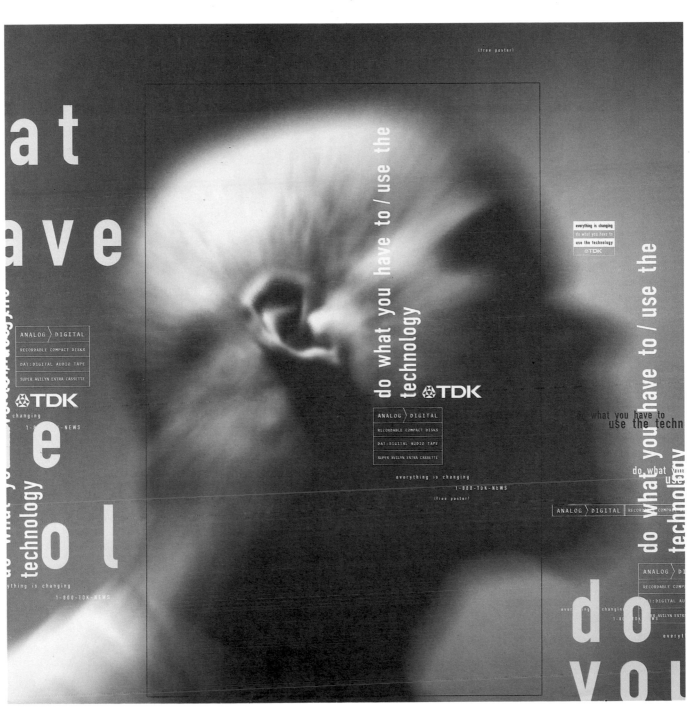

DESIGNERS: **Michel Mallard** and
**Liza H. Enebis,** *Paris, France*
TYPOGRAPHIC SOURCE: In-house
STUDIO: Michel Mallard
Studio/Paris CLIENT: *L'Autre*
*Journal* PRINCIPAL TYPES:
OCR-B and Times DIMENSIONS:
11¼ x 16⅛ in. (28.5 x 41 cm)

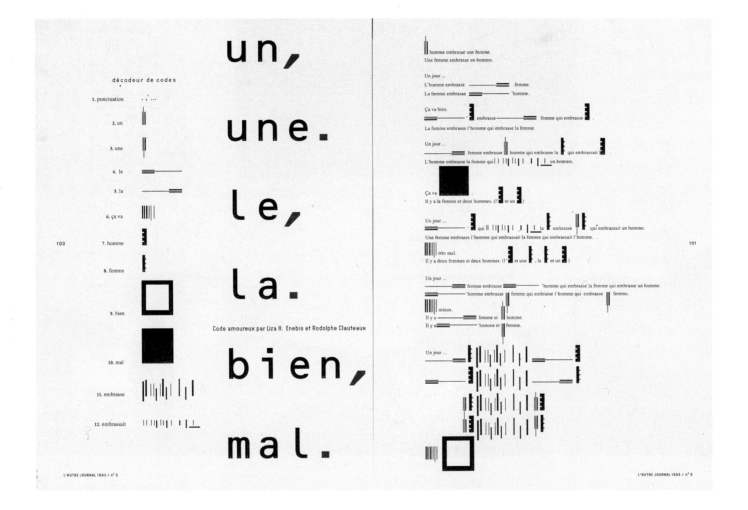

DESIGNER: Koeweiden/Postma,
*Amsterdam,      Netherlands*
TYPOGRAPHIC SOURCE: In-house
STUDIO:   Koeweiden/Postma
CLIENT: Paul Joosten PRINCIPAL
TYPES: Eurostile and Matrix
Script DIMENSIONS: 13 x 9½ in.
(33 x 24.1 cm)

brochure                50

DESIGNERS: Sandra Carla Lütze and Tobias Strebel, *Düsseldorf, Germany* TYPOGRAPHIC SOURCE: Fachhochschule für Design PRINCIPAL TYPE: Univers Condensed DIMENSIONS: 23½ x 35 in. (60 x 88.9 cm)

poster/catalog

DESIGNERS: Paul and Carolyn Montie, *Boston, Massachusetts* TYPOGRAPHIC SOURCE: In-house STUDIO: Fahrenheit Design CLIENT: Harvard University Graduate School of Design PRINCIPAL TYPES: Gill Sans, Univers, Meta, Garamond, and Futura DIMENSIONS: Various

campaign

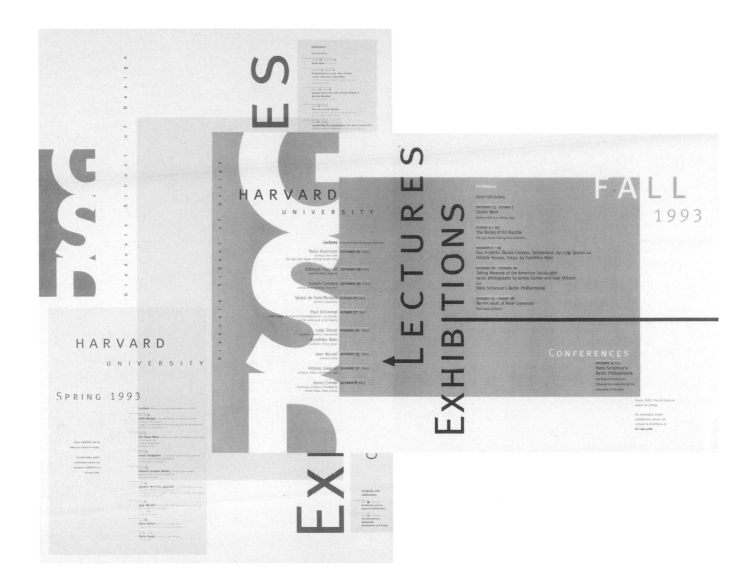

DESIGNER: P. Scott Makela, *Minneapolis, Minnesota* TYPOGRAPHIC SOURCE: In-house STUDIO: P. Scott Makela Words and Pictures for Business and Culture CLIENT: Walker Art Center PRINCIPAL TYPES: Dead History and Carmela DIMENSIONS: 8½ x 11 in. (21.6 x 27.9 cm)

DESIGNER: Lucille Tenazas, *San Francisco, California* PHOTOGRAPHER: Richard Barnes TYPOGRAPHIC SOURCE: In-house STUDIO: Tenazas Design CLIENT: Center for Critical Architecture, Art and Architecture Exhibition Space PRINCIPAL TYPES: Adobe Garamond and DIN Schrift DIMENSIONS: 18 x 25 in. (45.7 x 63.5 cm)

poster          54

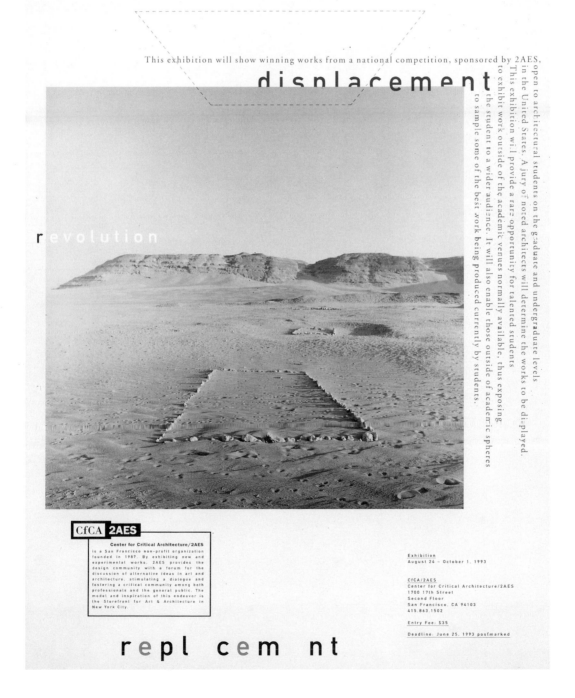

DESIGNER: Thomas Ullrich, *Düsseldorf, Germany* TYPO-GRAPHIC SOURCE: In-house AGENCY: Ullrich Grafik Design CLIENT: Gesellschaft der Musik-freunde Donaueschingen PRIN-CIPAL TYPE: Frutiger DIMEN-SIONS: Various

corporate identity                    55

programm

1993

27

1

*donaueschinger*

*musiktage*

15. bis 17. Oktober

26

brauerei/sudhaus

Eingang Haldenstraße
Freitag von 18.30 Uhr - 21.00 Uhr,
Samstag von 10.00 Uhr - 21.00 Uhr,
Sonntag von 10.00 Uhr - 17.30 Uhr

Christina Kubisch
"KREISLÄUFE"
Vier Licht-Klang-Räume        Uraufführung

Entstanden im Auftrag des Südwestfunks

Mit Unterstützung der Fürstlich
Fürstenbergischen Brauerei KG

Sendung:
Dienstag, 2. November 1993,
19.05 Uhr über S2 Kultur

KREISLÄUFE
Vier Licht-Klang-Räume im ehemaligen Sudhaus der Fürstlich
Fürstenbergischen Brauerei Donaueschingen.

Bevor man auf eine computergesteuerte Anlage
umstieg, wurden im alten Sudhaus der Fürsten-
bergischen 'Brauerei in vier großen Kupfer-
behältern die gekeimte Gerste verarbeitet und
die Würze mit Hopfen gekocht.

Maischebottich, Maischepfanne Läuterbottich,
Würzepfanne, Stärke, Enzyme; filtern, läutern,
rasten, lösen, gerinnen, verdampfen - Vorgänge
aus der Welt des Brauens, die einen natürlichen
Prozeß des Wachsens, sich Veränderns und Um-
wandelns beschreiben.

Die Installation *KREISLÄUFE* bezieht sich eng
auf diese zeitlichen Prozesse.
Zum permanent an- und ab-
schwellenden Grundgeräusch,
das in jedem Gefäß erklingt
und durch den durchziehen-
den Luftstrom erzeugt wird,
kommen andere Klänge hinzu,
die im Bottich selbst entstehen.

biographie

Christina Kubisch
wurde1948 in
Bremen geboren

DESIGNER: Rebeca Méndez, *Pasadena, California* CALLIGRAPHER: Nakajima Kosho, *Kyoto, Japan* TYPOGRAPHIC SOURCE: In-house STUDIO: Art Center College of Design, Design Office CLIENT: KYOTO/ACCD: An International Design Conference Committee PRINCIPAL TYPES: Univers and Trajan DIMENSIONS: 40 x 18½ in. (101.6 x 47 cm)

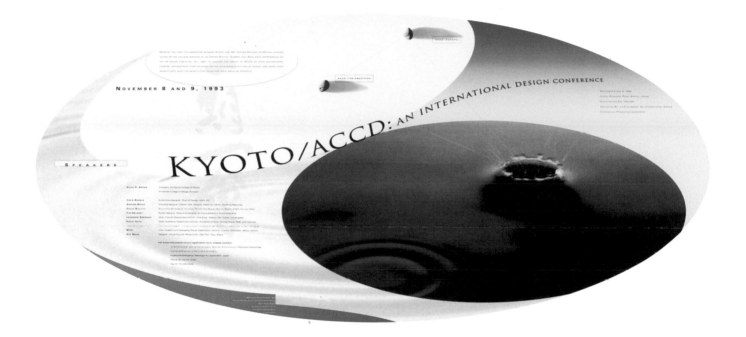

DESIGNERS: Tara Carson and Rebeca Méndez, *Pasadena, California* LETTERER: Martin Ledyard TYPOGRAPHIC SOURCE: In-house STUDIO: Art Center College of Design, Design Office CLIENT: Art Center College of Design PRINCIPAL TYPE: Gill Sans DIMENSIONS: 14⅞ x 39½ in. (37.8 x 100.3 cm)

57          poster

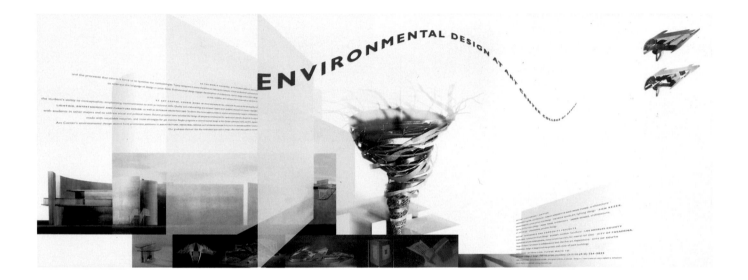

DESIGNERS: Kian Huat Kuan and Ann Gildea, *Columbus, Ohio* PHOTOGRAPHER: Peter Rice, *Boston, Massachusetts* WRITER: Mike Mooney TYPOGRAPHIC SOURCE: In-house STUDIO: Fitch Inc. CLIENT: Harman Consumer Group PRINCIPAL TYPES: Gill Sans, Industria, and Helvetica Black DIMENSIONS: 9¼ x 3½ in. (23.5 x 8.9 cm)

58

invitation

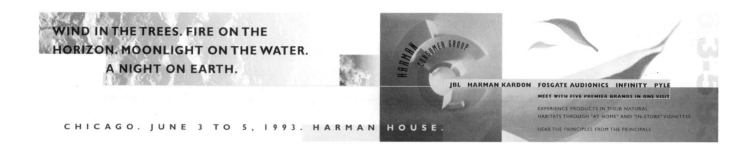

DESIGNER: Rebeca Méndez, *Pasadena, California* TYPO-GRAPHIC SOURCE: In-house CLIENT: The Getty Center for the History of Art and the Humanities PRINCIPAL TYPES: Trajan and Franklin Gothic DIMENSIONS: 34½ x 19 in. (87.6 x 48.3 cm)

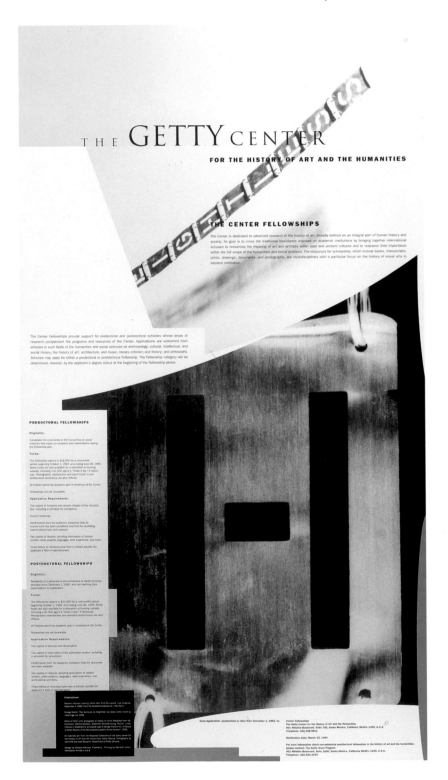

DESIGNER: William T. Kochi, *New York, New York* TYPOGRAPHIC SOURCE: In-house STUDIO: KODE Associates, Inc. CLIENT: LinoGraphics Corporation PRINCIPAL TYPES: Meta and Snell Roundhand DIMENSIONS: 3½ x 4⅞ in. (8.9 x 12.4 cm)

60   brochure

DESIGNERS: Steven Tolleson
and Jennifer Sterling, *San
Francisco, California* TYPO-
GRAPHIC SOURCE: In-house
STUDIO: Tolleson Design
CLIENT: Escagenetics, Inc.
PRINCIPAL TYPE: Frutiger
DIMENSIONS: 8½ x 11 in. (21.6 x
27.9 cm)

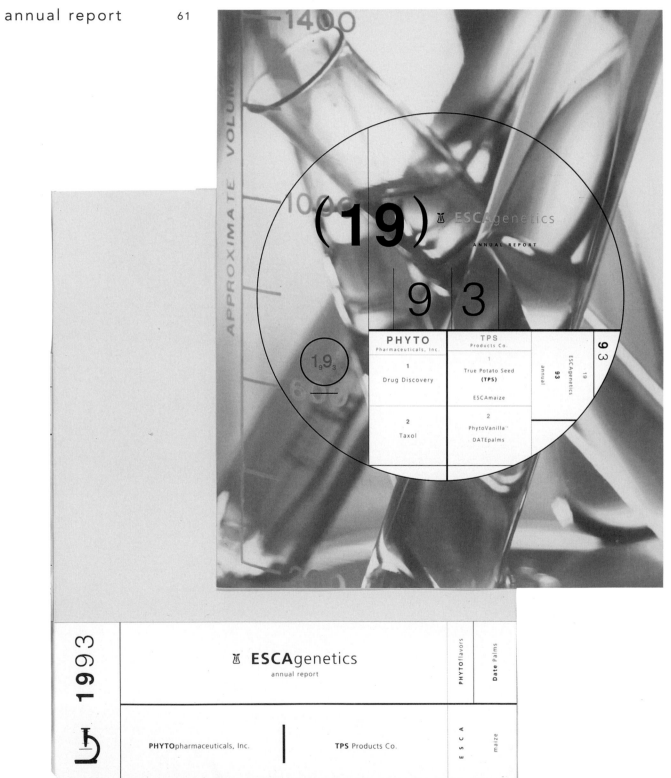

DESIGNER: Greg Lindy, *Los Angeles, California* ART DIREC-TORS: Jeri Heiden and Michael G. Rey TYPOGRAPHIC SOURCE: In-house STUDIO: Rey International CLIENT: Warner Bros. Records, Archives Series PRIN-CIPAL TYPES: Syntax and Akzidenz Grotesk

logotype                                     62

DESIGNERS: Dan Olson and Haley Johnson, *Minneapolis, Minnesota* TYPOGRAPHIC SOURCE: In-house STUDIO: Olson Johnson Design Co. CLIENT: Cabell Harris, Work PRINCIPAL TYPE: Futura DIMENSIONS: 8½ x 11 in. (21.6 x 27.9 cm)

63 **stationery**

DESIGNER: Todd Waterbury, *Portland, Oregon* TYPO-GRAPHIC SOURCE: LinoTypographers STUDIO: Todd Waterbury, Wieden & Kennedy CLIENT: Stanley Bach PRINCIPAL TYPES: Alternate Gothic and News Gothic DIMENSIONS: 22 x 35 in. (55.9 x 88.9 cm)

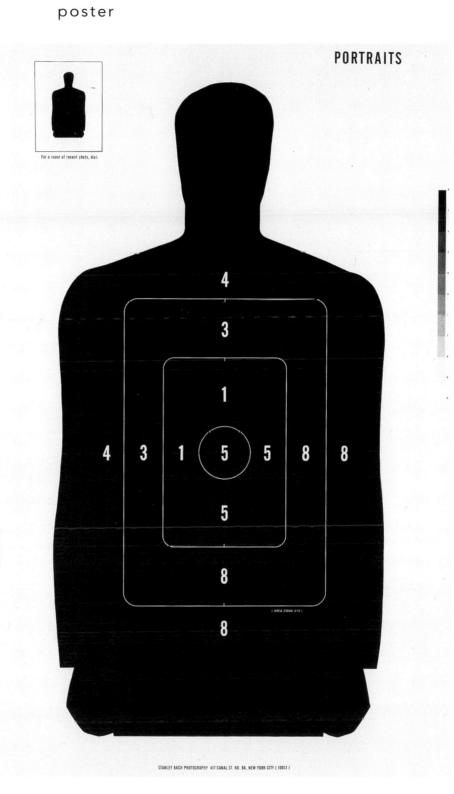

DESIGNERS: Steve Pattee, Kelly Stiles, and Cindy Poulton, *Des Moines, Iowa* TYPOGRAPHIC SOURCE: Typographics Two STUDIO: Pattee Design CLIENT: Metro Waste Authority PRINCIPAL TYPES: Franklin Gothic and Times Roman DIMENSIONS: 9 x 12 in. (22.9 x 30.5 cm)

65 brochure

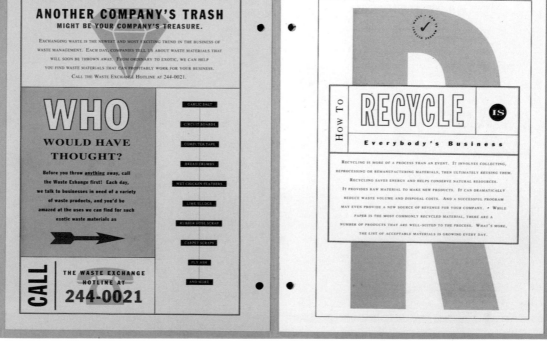

DESIGNERS: Rüdiger Götz and Olaf Stein, *Hamburg, Germany* LETTERERS: Rüdiger Götz and Olaf Stein TYPOGRAPHIC SOURCE: In-house STUDIO: Factor Design CLIENT: Font Shop International PRINCIPAL TYPES: Alternate Gothic and hand-lettering DIMENSIONS: Various

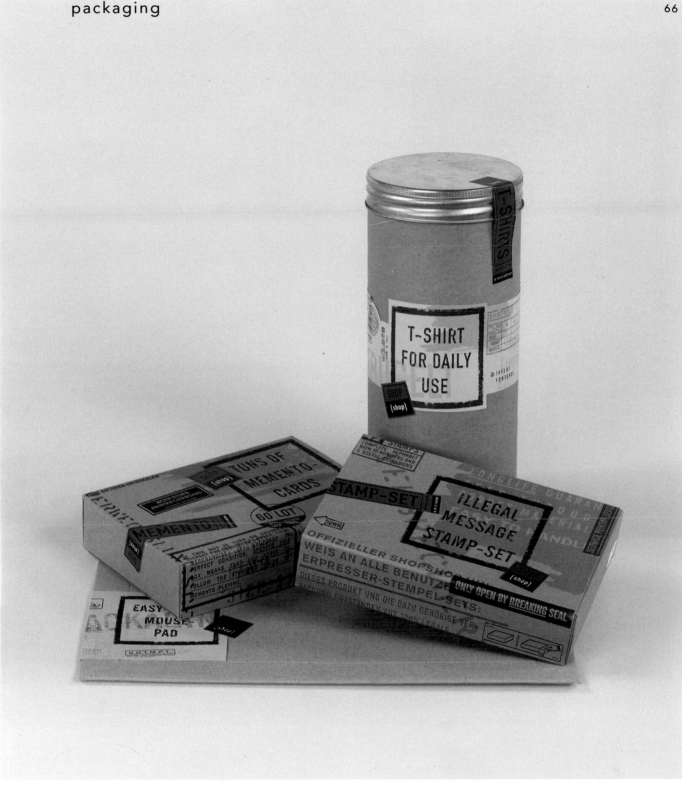

DESIGNERS: Charles S. Anderson, Todd Hauswirth, and Paul Howalt, *Minneapolis, Minnesota* TYPOGRAPHIC SOURCE: In-house STUDIO: Charles S. Anderson Design Company CLIENT: French Paper Company PRINCIPAL TYPES: 20th Century, Gothic 13, Alternate One, Garamond, and Franklin Gothic DIMENSIONS: 4¼ x 7 x ½ in. (10.8 x 17.8 x 1.3 cm)

DESIGNER: Heather van Haaften, *Los Angeles, California* TYPOGRAPHIC SOURCE: Personal collection STUDIO: Let Her Press CLIENT: Columbia Records PRINCIPAL TYPE: Various wooden block types DIMENSIONS: 11 x 8½ in. (27.9 x 21.6 cm)

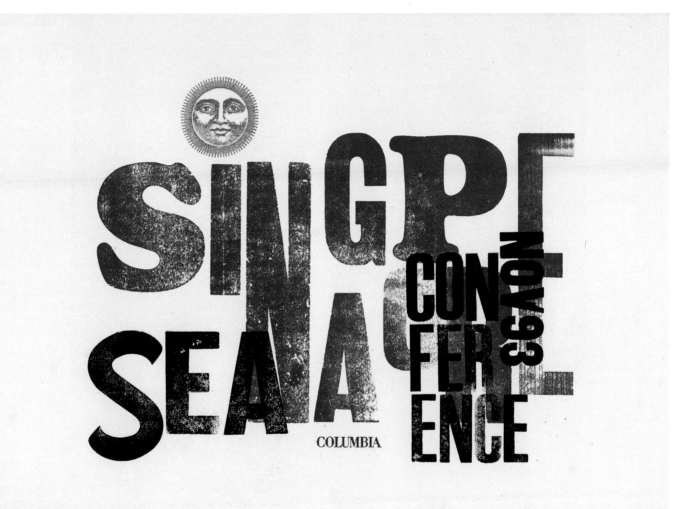

DESIGNER: Heather van Haaften, *Los Angeles, California*
LETTERER: Heather van Haaften
ILLUSTRATOR: Howard Baker
TYPOGRAPHIC SOURCE: In-house
STUDIO: Let Her Press CLIENT: Isabelle Miller PRINCIPAL TYPES: Black Oak, Franklin Gothic Condensed, and various wooden block types DIMENSIONS: 5½ x 5⅜ in. (14 x 13.6 cm)

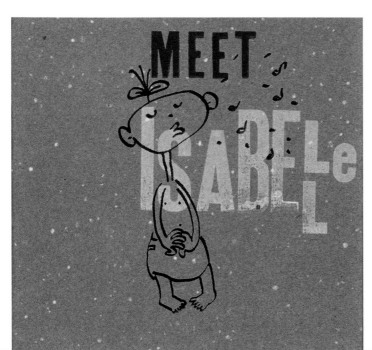

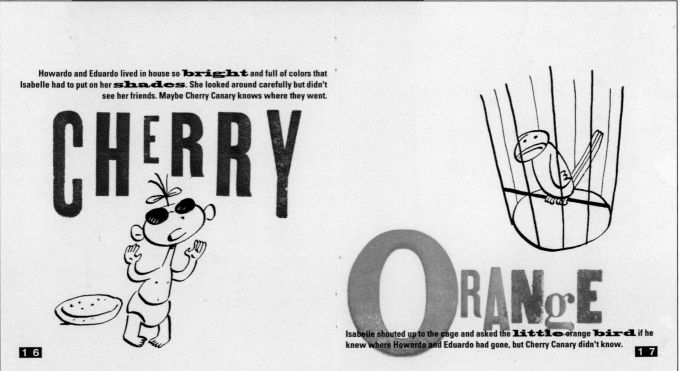

DESIGNER: Stephen Coates, *London, England* TYPOGRAPHIC SOURCE: In-house CLIENT: *Eye* magazine, Wordsearch Limited PRINCIPAL TYPES: Monotype News Gothic and Monotype Sabon DIMENSIONS: 11¹⁄₁₆ x 9⅛ in. (29.7 x 23.2 cm)

magazine

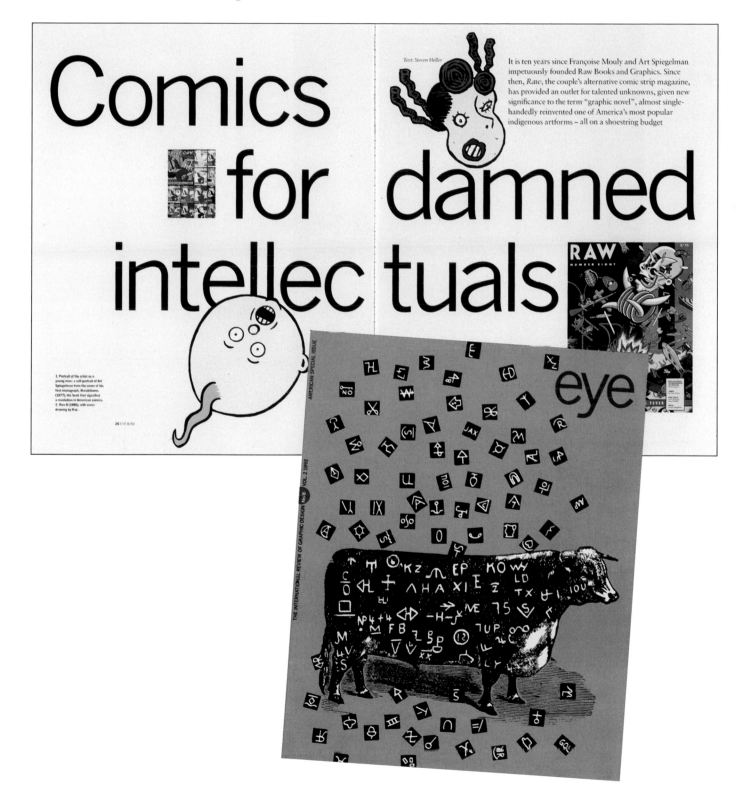

DESIGNER: John Gall, *New York, New York* TYPOGRAPHIC SOURCE: In-house STUDIO: John Gall Graphic Design CLIENT: St. Martin's Press PRINCIPAL TYPE: Arbitrary Sans DIMENSIONS: 14⅝ x 7 in. (37.1 x 17.8 cm)

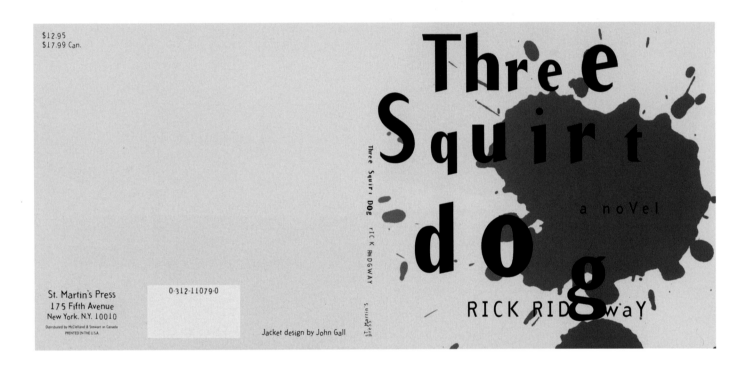

$12.95
$17.99 Can.

St. Martin's Press
175 Fifth Avenue
New York, N.Y. 10010
Distributed by McClelland & Stewart in Canada
PRINTED IN THE U.S.A.

0-312-11079-0

Jacket design by John Gall

Three Squirt Dog
rICK RIDGWAY
St. Martin's

Three
Squirt
dog
a noVel
RICK RIDGwaY

DESIGNER: Sharon Werner, *Minneapolis, Minnesota* PROJECT MANAGER: Mark Materowski ART DIRECTOR: Laurie Kelliher CREATIVE DIRECTOR: Lisa Judson TYPOGRAPHIC SOURCE: In-house STUDIO: Werner DesignWerks Inc. CLIENT: Nick at Nite/MTV Networks PRINCIPAL TYPES: Nuezit and Clarendon Bold DIMENSIONS: 9 x 12 in. (22.9 x 30.5 cm)

media kit 72

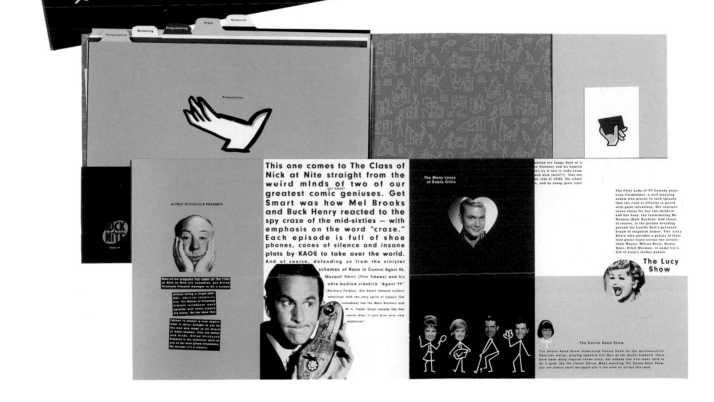

DESIGNER: Paul Sahre, *Baltimore, Maryland* LETTERER: Paul Sahre TYPOGRAPHIC SOURCE: In-house STUDIO: GKV Design CLIENT: Catacomb Brewery (Home Brew) PRINCIPAL TYPES: Fur Extra Rounded and Futura Heavy DIMENSIONS: 7¾ x 3½ in. (19.7 x 8.9 cm)

73

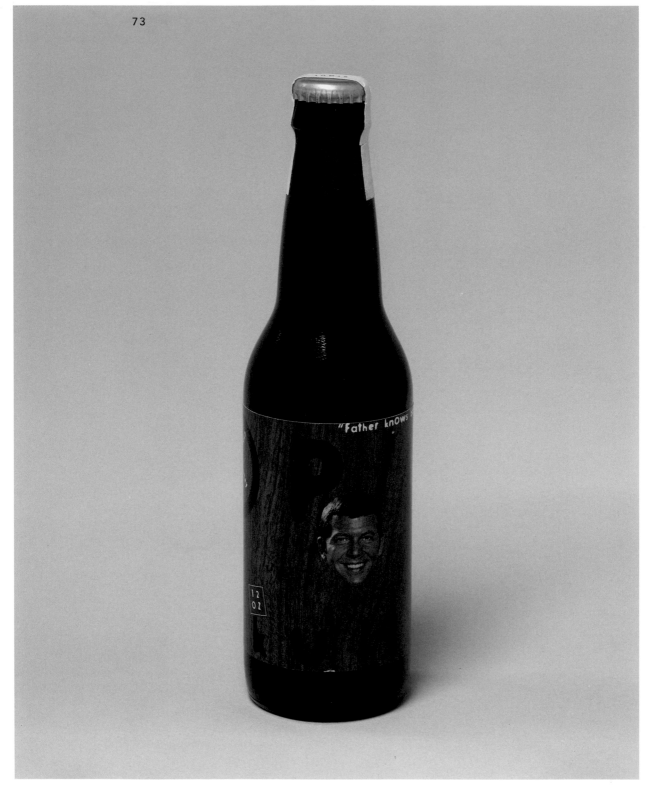

DESIGNERS: Elizabeth Kaney and James Prendergast, *Chicago, Illinois* ILLUSTRATOR: Tony Griff TYPOGRAPHIC SOURCE: In-house STUDIO: Summit Consulting Group, Inc. CLIENT: Clyde Battón PRINCIPAL TYPE: Bell Gothic DIMENSIONS: Various

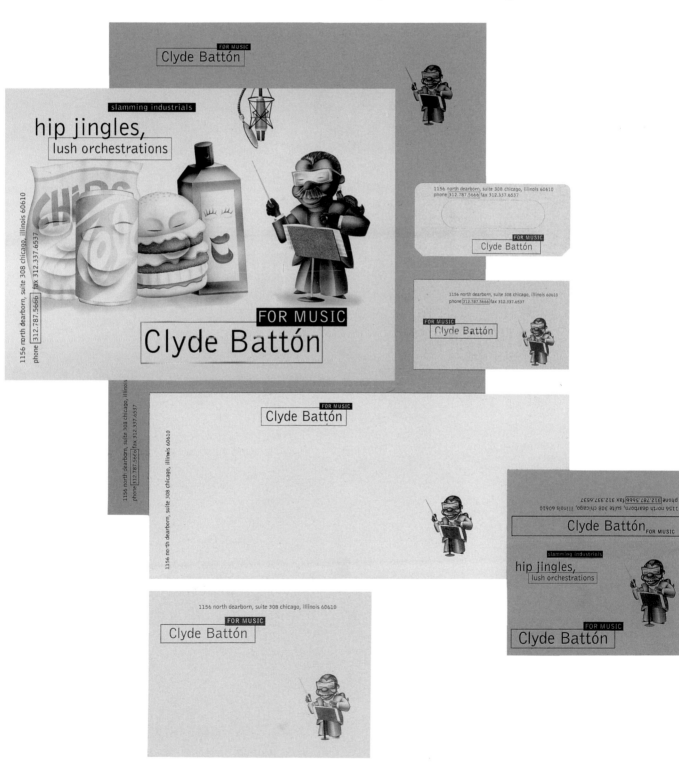

DESIGNER: Bob Aufuldish, *Mill Valley, California* FONT DESIGN-ERS: (Big Cheese) Eric Donelan and Bob Aufuldish TYPO-GRAPHIC SOURCE: In-house STUDIO: Aufuldish Warinner CLIENT: *Emigré* PRINCIPAL TYPES: Big Cheese and Triplex DIMENSIONS: 32¾ x 22½ in. (83.2 x 57.2 cm)

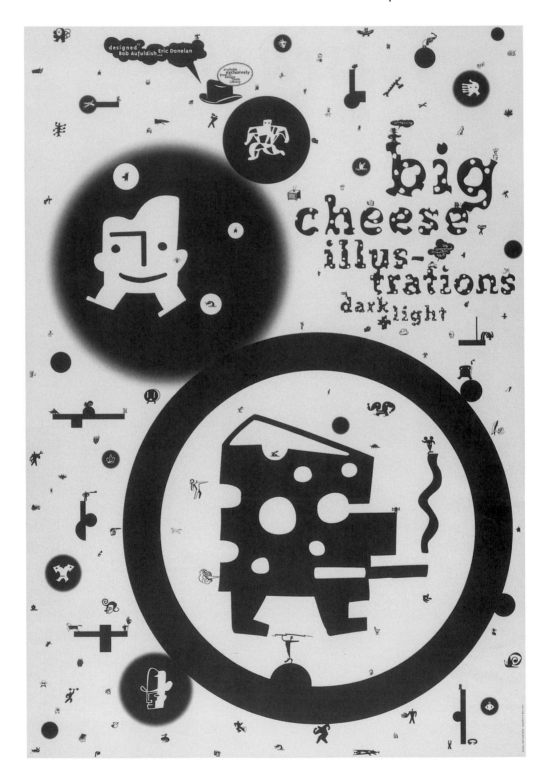

DESIGNER: Todd Waterbury, *Portland, Oregon* ILLUSTRA-TOR: Gary Baseman, *New York, New York* TYPOGRAPHIC SOURCE: LinoTypographers STUDIO: Todd Waterbury CLI-ENT: Gary Baseman PRINCIPAL TYPES: Tempo Italic and News Gothic DIMENSIONS: 8½ x 11 in. (21.6 x 27.9 cm)

stationery                    76

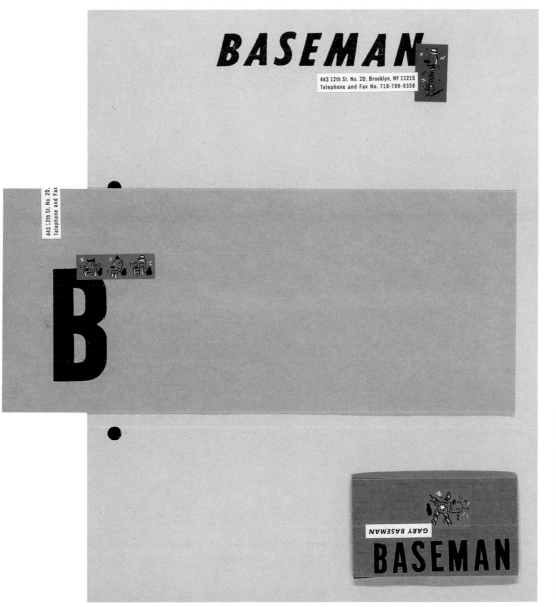

DESIGNER: Wade Koniakowsky, *Irvine, California* TYPOGRAPHIC SOURCE: In-house AGENCY: dGWB CLIENT: Vans PRINCIPAL TYPE: Distressed Futura Bold DIMENSIONS: 11 x 14 in. (27.9 x 35.6 cm)

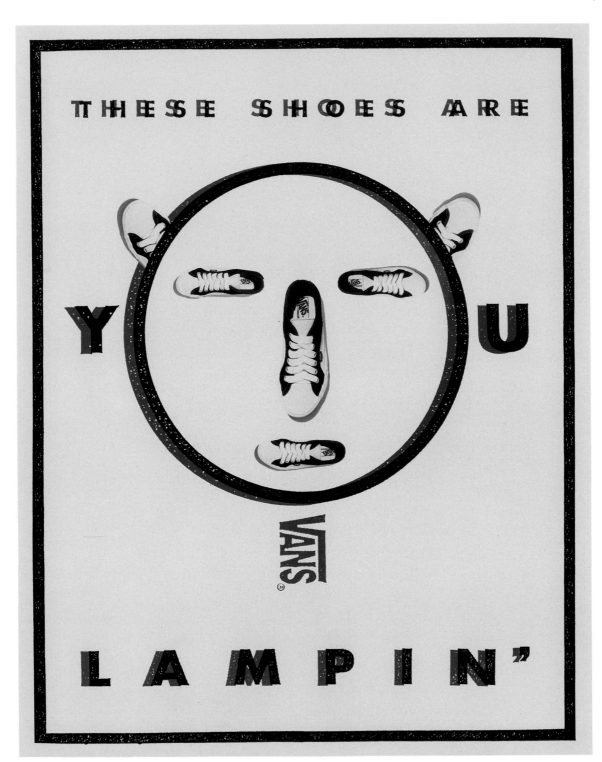

DESIGNERS: Kobe and Alan Lensink, *Minneapolis, Minnesota* LETTERERS: Kobe and Alan Lensink TYPOGRAPHIC SOURCE: In-house STUDIO: Duffy Inc. CLIENT: Chums Ltd. PRINCIPAL TYPES: Gill Sans, Trade Gothic, and Futura DIMENSIONS: Various

DESIGNERS: Peter Saville, Brett Wickens, and Howard Wakefield, *London, England* ART DIRECTORS: Jeff Gold, Steven Baker, and Peter Saville TYPOGRAPHIC SOURCE: In-house STUDIO: Pentagram Ltd., London CLIENT: Qwest/Warner Bros. Records PRINCIPAL TYPE: "New Order" News Gothic DIMENSIONS: 6 x 5 x ¾ in. (15.2 x 12.7 x 1.9 cm)

packaging

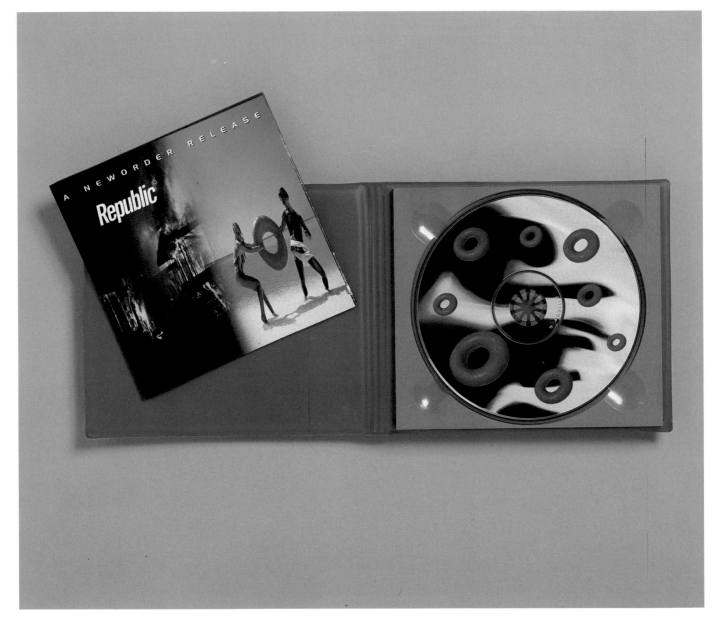

DESIGNERS: Sonja Wood-Frick and Stephen Hutchinson, *London, England* ART DIRECTOR: John Sorrell and Frances Newell TYPOGRAPHIC SOURCE: In-house AGENCY: Newell and Sorrell CLIENT: CFX Associates DIMENSIONS: Various

corporate identity

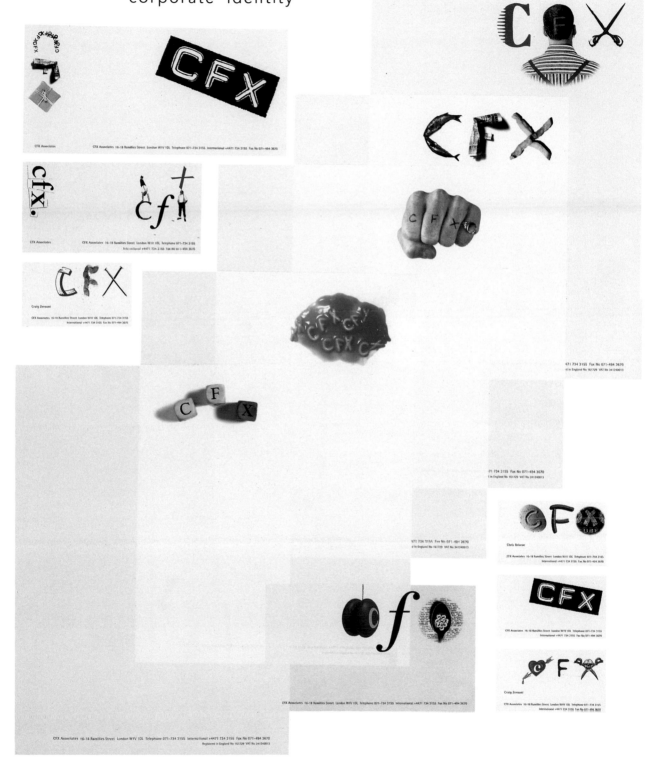

DESIGNER: Dann De Witt,
*Northampton, Massachusetts*
TYPOGRAPHIC SOURCE: In-house
STUDIO: De Witt Anthony Inc.
CLIENT: De Witt Anthony Inc.
PRINCIPAL TYPE: Bastardville
DIMENSIONS: 15½ x 9½ in. (39.4
x 24.1 cm)

announcement

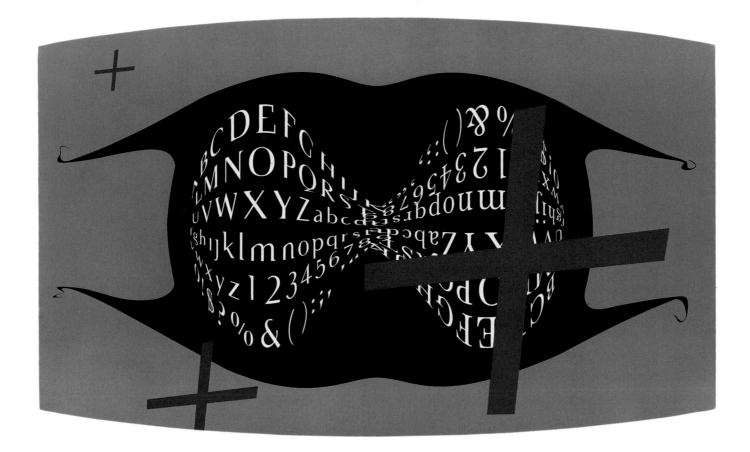

DESIGNER: Ruth Diener, *New York, New York* PHOTOSHOP ILLUSTRATOR: Johan Vipper CREATIVE DIRECTOR: Kent Hunter TYPOGRAPHIC SOURCE: In-house AGENCY: Frankfurt Balkind Partners CLIENT: American Illustration PRINCIPAL TYPES: Blur and various others DIMENSIONS: 9½ x 12½ in. (24.1 x 31.6 cm)

book

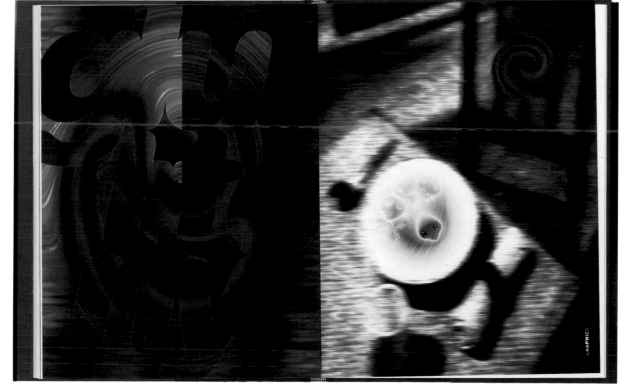

DESIGNER: Paul Sahre, *Balti-more, Maryland* LETTERER: Paul Sahre TYPOGRAPHIC SOURCE: In-house CLIENT: Fells Point Corner Theatre PRINCI-PAL TYPE: Fette Fraktur DIMEN-SIONS: 13½ x 20 in. (34.5 x 50.8 cm)

DESIGNER: Fritz Klaetke, *Boston, Massachusetts* TYPO-GRAPHIC SOURCE: In-house STUDIO: Visual Dialogue CLI-ENT: The Program in Cell and Developmental Biology, Harvard Medical School PRINCIPAL TYPES: Trade Gothic Condensed and Adobe Garamond DIMENSIONS: 14 x 20 in. (35.6 x 50.8 cm)

poster

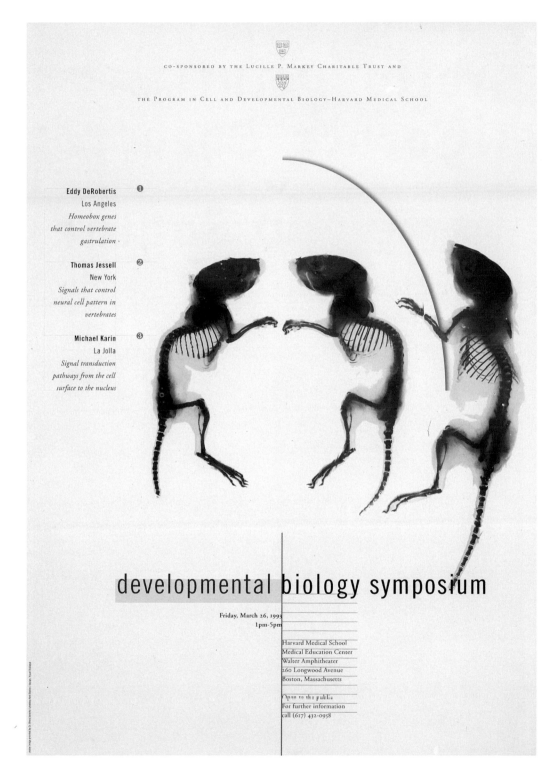

DESIGNERS: Thomas Anger-meier, Eva Becker-Stähle, Sabine Bock, Rosita Fraguele, Babsi Frisch, Gerlinde Godel-mann, Matthias Heitzer, Katja Hilberg, Christof Jörg, Ole Kleffmann, Gabriele Kreidel, Silvia Lenz, Mini Misra, Ellen Padusch, Katrin Rändel, Eva Reichmann, Monika Schrimpf, Rainer Schmidt, Angela Seel-mann, Simone Stenger, Karin Theilmeier, Eike Thiel, Karin Wichert, and Prof. Christof Gassner, *Darmstadt, Germany* TYPOGRAPHIC SOURCE: In-house STUDIO: FH Darmstadt, Department of Design CLIENT: FH Darmstadt PRINCIPAL TYPE: Various DIMENSIONS: 4⅛ x 5¹³⁄₁₆ in. (10.5 x 14.8 cm)

DESIGNER: Vittorio Costarella,
*Seattle, Washington* LETTERER:
Vittorio Costarella TYPO-
GRAPHIC SOURCE: In-house
STUDIO: Modern Dog CLIENT:
Seattle Repertory Theatre
PRINCIPAL TYPE: Univers (modi-
fied) DIMENSIONS: 22⅛ x 29¾
in. (56.2 x 75.6 cm)

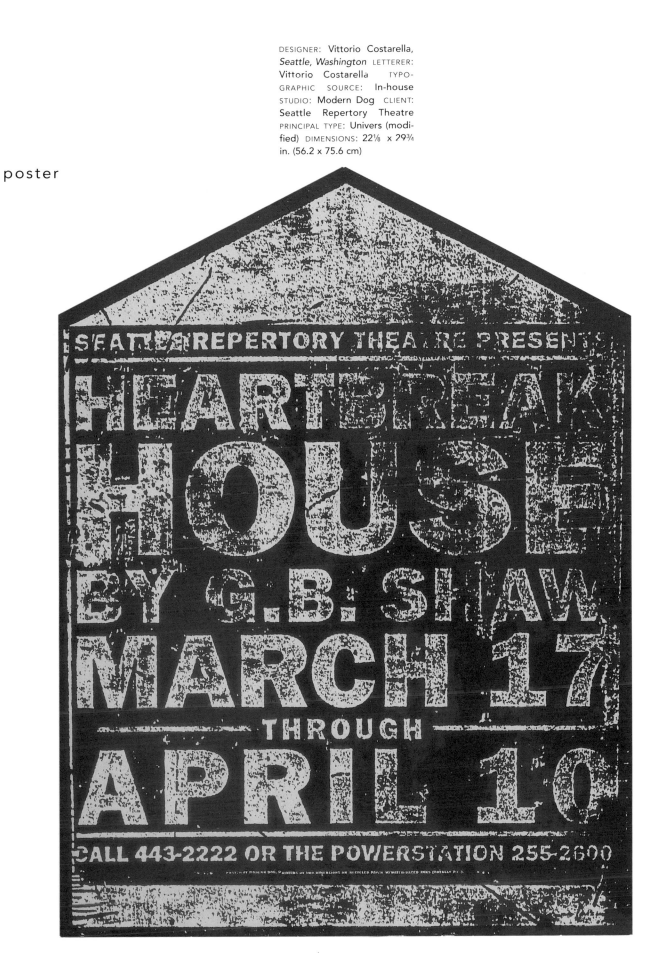

DESIGNERS: Todd Gallentine, Roger Richards, and Susan Treacey, *Atlanta, Georgia* TYPOGRAPHIC SOURCE: Southern Poster AGENCY: Two Drink Minimum CLIENT: Portfolio Center PRINCIPAL TYPE: Franklin Gothic DIMENSIONS: 30 x 40 in. (76.2 x 101.6 cm)

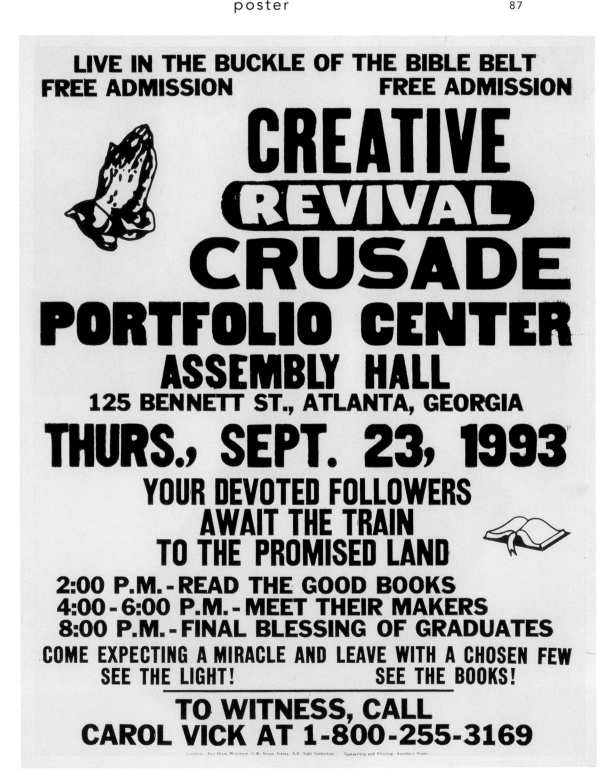

DESIGNERS: Paul Sahre and Gregg Heard, *Baltimore, Maryland and San Francisco, California* TYPOGRAPHIC SOURCE: In-house STUDIO: GKV Design CLIENTS: Gregg and Laura Heard PRINCIPAL TYPE: Clarendon DIMENSIONS: 4 x 5¼ in. (10.2 x 13.3 cm)

invitation

88

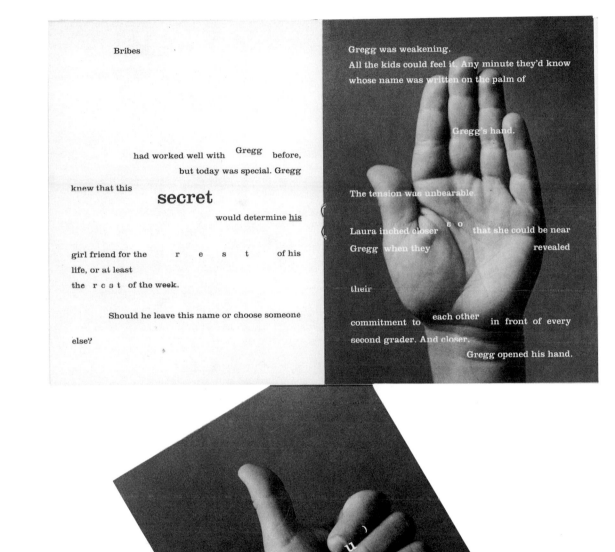

DESIGNER: Uwe Loesch, *Düssel-dorf, Germany* LETTERERS: Iris Utikal and Michael Gais TYPO-GRAPHIC SOURCE: In-house AGENCY: Uwe Loesch, Arbeits-gemeinschaft für visuelle und verbale Kommunikation CLIENT: Goethe-Institut, Brussels PRINCIPAL TYPE: Rotis DIMENSIONS: Poster: 33¹⁄₁₆ x 46⁷⁄₈ in. (84 x 119 cm), Catalog: 8¼ x 11¹¹⁄₁₆ in. (21 x 29.7 cm)

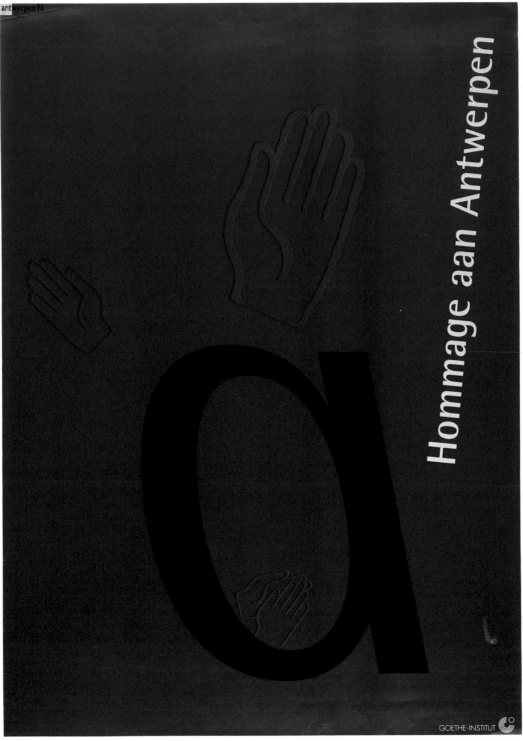

DESIGNER: Stephen Farrell, *Chicago, Illinois* LETTERER: Stephen Farrell TYPOGRAPHIC SOURCE: In-house STUDIO: Stephen Farrell Design CLIENT: *Confetti* magazine PRINCIPAL TYPES: Missive, Entropy, and Osprey DIMENSIONS: 8½ x 11 in. (21.6 x 27.9 cm)

90 promotion

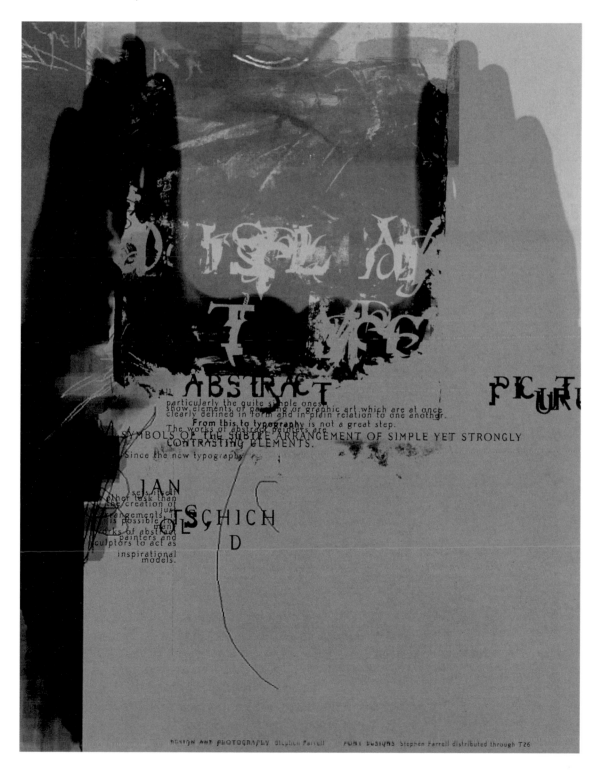

DESIGNER: Stephen Farrell,
*Chicago, Illinois* STUDIO:
Stephen Farrell Design PRINCI-
PAL TYPE: Entropy

typeface

# ENTROPY

A B C D E F G H I J K L M
N O P Q R S T U V W X Y Z

0 1 2 3 4 5 6 7 8 9

! # $ % & * { } ' ' " " ¢ ¶ • ; " ' , - ?
' © ' ^ ° ¬ ® ß F ¨ √ ¡ ™ § § Æ Ø Œ ß Ç ¥ ¿ ¡
Ä Á À Â Å Ã Ë É È Ê Ï Í Ì Î
Ö Ó Ò Ô Õ Ü Ú Ù Û Ÿ Ï Í Ì Î Ñ Ü Ú Ù Û Ñ Ÿ

THIS IS A SHOWING OF THE FONT ENTROPY.
IT WAS SELECTED BY THE TDC40 JURY AS
AN OUTSTANDING ACHIEVEMENT IN FONT DESIGN.

DESIGNER: Matthew Carter,
*Cambridge, Massachusetts*
TYPOGRAPHIC SOURCE: In-house
CLIENT: Carter & Cone Type
Inc. PRINCIPAL TYPES: Mantinia
and ITC Galliard DIMENSIONS:
8½ x 11 in. (21.6 x 27.9 cm)

brochure

## CAPS & SUPERIORS
SHIFT KEYS    UNSHIFT KEYS

AABBCCDD

EEFFGGHHIIJJ

KKLLMMNNOOPPQQ

RRSSTTUUVVWWXX

YY&&ZZÆÆŒŒ

## FIGURES ON FIGURE KEYS

1234567890

## SMALL CAPS

HACEHIORSTUWYZH

## INTERPOINTS ♠ ♀ ▾

## TALL CAPITALS
CB AN OVERLAPPING COMBINATION LIKE
THIS IS AUTOMATICALLY POSITIONED
BY THE KERNING TABLE

HIHTHLHYH

## LIGATURES

HVCTHUPLATIC

TUTWTYMEMPMDMBE

## ALTERNATIVES

AOT&YRRQQ

## ACCENTS &C
[ACCENTED SUPERIOR CAPITALS ARE IN THE
CORRESPONDING LOWERCASE LOCATIONS]

ÀÁÂÄÃÅÇÐÈÉÊËÌÍ

ÎÏŁÑÒÓÔÖÕØÞ

ŠÙÚÛÜÝŸŽ

SET AT 42 POINT, LETTERSPACED

DESIGNER: Matthew Carter,
*Cambridge, Massachusetts*
CLIENT: Carter & Cone Type
Inc. PRINCIPAL TYPE: Mantinia

# MANTINIA

A B C D E F G H I J K L M
N O P Q R S T U V W X Y Z

O I 2 3 4 5 6 7 8 9

A B C D E F G H I J K L M
N O P Q R S T U V W X Y Z

! $ $ & ❖ { } ( ) ' ' " " ₵ & ♠ ; " ' , . ?
Æ Œ Ø ø Œ Æ A O O T TT CT I L Y I S £ ¥ ƒ i i
Ä Á À Â Å Ã Ç Ë È É Ê Ï Í Ì Î Ñ
Ö Ó Ò Ô Õ Ü Ú Ù Û Ÿ Ä Á À Â Å Ã Ç Ë É È Ê Ï Í Ì Î Ñ Ö Ó Ò Ô Õ Ü Ú Ù Û Ÿ
A C E R S W Y Z ´ ` ^ ° ˜ ¨ LA MB MD ME MP TH ET TY VY i Ç Ç ♠ & ♠ A O

MTDC

specimen book

DESIGNER: James Young, *Mountain View, California* ART DIRECTOR: Laurie Szujewska TYPOGRAPHIC SOURCE: In-house AGENCY: Adobe Systems Incorporated Marketing Communications Department CLIENT: Adobe Systems Incorporated PRINCIPAL TYPES: Viva Multiple Master and Adobe Caslon DIMENSIONS: 5⅝ x 9 in. (14.3 x 22.9 cm)

Viva

*a two-axis multiple master typeface*

### Primary Fonts

A set of *primary fonts* is supplied with each multiple master typeface, comprising a collection of ready-to-use variations of the design. In addition to the thousands of custom fonts that can be generated along the weight and width axes, Viva includes the nine primary fonts highlighted on the right.

Primary fonts are named according to their position along each design axis in the typeface. Viva's weight and width axes have been assigned a specific numerical range that is relative to other Adobe multiple master typefaces. Although relative numeric ranges are most useful when comparing the weights and widths of typefaces designed specifically for text composition, to maintain consistency among multiple master typefaces, the same relative numeric system has been applied to Viva's design axes.

*Below are the primary font name abbreviations and a key to the primary instances highlighted in the matrix to the right. The numbers along the top and down the left side of the matrix refer to the width and weight values respectively, of each instance in the matrix. This matrix shows only a small sample of the possible variations that can be generated from Viva.*

**Primary font name abbreviations**  **Design axis abbreviations**

| WEIGHT | WIDTH | | |
|---|---|---|---|
| LT *light* | CN *condensed* | wt *weight* |
| RG *regular* | NO *normal* | wd *width* |
| BD *bold* | XE *extra-extended* | |

**Primary font names**

| A | D | G |
|---|---|---|
| 250 LT 400 CN | 250 LT 600 NO | 250 LT 1500 XE |
| *light condensed* | *light normal* | *light extra-extended* |
| B | E | H |
| 385 RG 400 CN | 385 RG 600 NO | 385 RG 1500 XE |
| *regular condensed* | *regular normal* | *regular extra-extended* |
| L | J | |
| 700 BD 400 CN | 700 BD 600 NO | 700 BD 1500 XE |
| *bold condensed* | *bold normal* | *bold extra-extended* |

WEIGHT  WIDTH ▶ 400
▼

250  A  tango

320  tango

385  B  tango

430  tango

475  tango

520  tango

565  tango

610  tango

655  tango

700  C  tango

28-point 250 wt 650 wd
LANGUOROUS MAIDEN

44-point 325 wt 650 wd
Savoy Theatre

55-point 420 wt 650 wd
LEATHERY

77-point 500 wt 650 wd
Vigilant

110-point 600 wt 650 wd
flight

161-point 700 wt 650 wd
Eye

DESIGNER: Jerry Ketel, *Port-
land, Oregon* TYPOGRAPHIC
SOURCE: In-house AGENCY:
Cyrano STUDIO: Bang Bang
Bang CLIENT: Oregon Shake-
speare Festival PRINCIPAL TYPE:
Centaur

DESIGNER: Sonja Wood-Frick, *London, England* ART DIREC-TORS: John Sorrell and Frances Newell TYPOGRAPHIC SOURCE: In-house AGENCY: Newell and Sorrell CLIENT: Newell and Sorrell PRINCIPAL TYPES: Franklin Gothic, Gill Sans, Trajan, and Adobe Sabon DIMENSIONS: 7¹¹⁄₁₆ x 9¹¹⁄₁₆ in. (19.5 x 24.5 cm)

# THE TROUBLE WITH WORDS

John Simmons

*Newell~Sorrell*

For example, let's take these two versions of a Penguin classic, *Nostromo* by Joseph Conrad. The version below shows the front cover and part of the blurb of the edition published in 1967.

Below are shown the front cover and blurb of the edition published in 1990.

Amid the grandiose scenery of South America, against the exciting events of a revolution, Conrad ironically displays men, not as isolated beings, but as social animals.

The novel captures the tragic and brutal essence of Latin-American politics as each character's potential for good is turned to corruption or defeat.

In 1967 we thought of South America in terms of its grandiose scenery. Revolution (or the idea of revolution) was exciting, and people (although no doubt individuals) were seen within the context of society.

By 1990 South America is seen somewhat less romantically. Politics - closely associated with corruption - can defeat the individual and the individual's potential for good.

DESIGNER: Carter Weitz, *Lincoln, Nebraska* TYPOGRAPHIC SOURCE: In-house AGENCY: Bailey Lauerman & Associates CLIENT: Lincoln Foundation PRINCIPAL TYPES: Antiqua and Goudy Old Style DIMENSIONS: 8½ x 11 in. (21.6 x 27.9 cm)

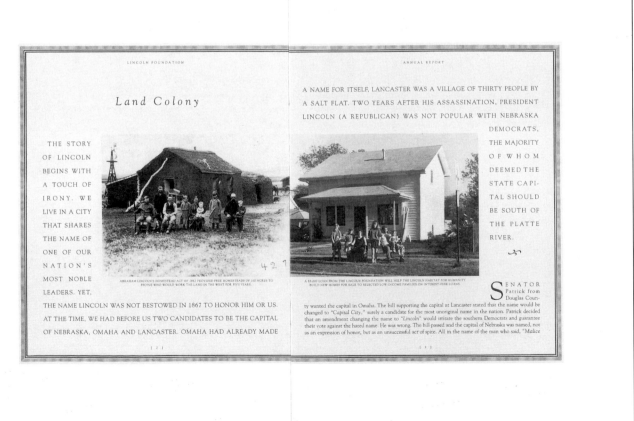

DESIGNER: Lorraine Wild, *Los Angeles, California* TYPO-GRAPHIC SOURCE: Wilsted & Taylor STUDIO: ReVerb CLIENT: The Getty Center for the History of Art and the Humanities PRINCIPAL TYPES: Century Old Style and Garamond No. 3 DIMENSIONS: 7½ x 10¼ in. (19.1 x 26 cm)

ORDONNANCE
FOR THE FIVE KINDS
*of* COLUMNS
AFTER THE METHOD
*of* THE ANCIENTS

PART TWO
Things Proper to Each Order

Chapter 1
The Tuscan Order

THE ORDERS OF ARCHITECTURE invented by the Greeks were only three in number: that is to say, the Doric, the Ionic, and the Corinthian. To these, the Romans added the Tuscan and the Composite, which some have called the Italic. Properly speaking, however, the characters of these two orders do not differ essentially from the characters of the Greek orders, for the characters of the Tuscan are almost the same as those of the Doric and those of the Composite resemble those of the Corinthian very closely. This is not so in the three Greek orders, where the things that distinguish them from one another are very considerable and very obvious, as the first chapter of part one explains in greater detail.

The Tuscan is, in fact, nothing but the Doric strengthened by the shortening of the shaft or stalk of the column and simplified by diminishing the number of moldings that usually ornament the orders and making them more massive, for the base and cornice of its pedestal have few moldings and most of these are very massive. This base and cornice have fewer moldings than do those in the other orders, although their height by proportion is as great. In addition, the base of the column has only a single torus and no scotia; the abacus of the capital has no ogee at the top;

DESIGNER: Ed Colker, *New York, New York* PRINTER: Mary Phelan TYPOGRAPHIC SOURCE: Kent Kasuboske CLIENT: Haybarn Press PRINCIPAL TYPES: Italian Oldstyle, Caslon, Bulmer, and Garamont DIMENSIONS: 12 x 9 in. (30.5 x 22.9 cm)

*for Michal*

Our mother is always awake
and her baby is always asleep
Are they both wrapped in gold after all
Or is it just paint: a veil

She is ordinary in ordinary mourning
and her baby is not going to live
She leans her curls against his skull
because she is awake but he is thought

Her big hands were cut by stone-cutters
when the world was rich and brown
Her eyes are tired because he is an old man
a little corpse in ghostly swaddling

You say it is all for the love of a child
but she would like to sob with her beautiful neck
and her ornamental uneconomical curls
the beautiful that could not save this child

At the foot of the Cross
That has grown within her
she will remember his loud rebuke
and infinitesimal fingers curled together without end

The historians have applied the X-rays
and they found nothing
They were searching for gold and haloes and dates
She was offering the ordinary meal again

She is awake and in trouble and he is dreaming
of riots, earthquakes, cut flesh, fire, open graves
and a lion on its discontented path
and his blood dripping into his mother's cup

Our mother's eyes are open but he has turned away
in a dream of cities and palms, victories
that look like catastrophe, and indestructible fury
and silence which he will maintain his whole life

And silence in which he will maintain our life

DESIGNER: Andréas Netthoevel, *Biel, Switzerland* ART DIRECTOR: Andréas Netthoevel TYPOGRAPHIC SOURCE: In-house STUDIO: second floor south CLIENT: Agathe Rytz PRINCIPAL TYPES: Stone Sans and Stone Serif DIMENSIONS: 5½ x 8⅝ in. (14 x 21.8 cm)

editorial 100

### LILI BOULANGER (1893-1918)

Grande et belle jeune fille à l'allure noble et distinguée, au regard mélancolique et rêveur, aux gestes harmonieux et mesurés, Lili Boulanger est une personnalité attachante tout à fait exceptionnelle. Je ne l'ai pas connue, mais sa soeur Nadia était si proche d'elle qu'à travers elle, je pense pouvoir vous la présenter sans beaucoup me tromper.

Dès sa naissance (21 Août 1893) Lili Boulanger se trouve entourée de musique et de musiciens: son père compositeur et professeur de chant, sa mère cantatrice amateur, sa soeur (de six ans son ainée) élève au Conservatoire et travaillant avec zèle à la maison: solfège, harmonie, piano. La petite fille écoute tout avec une attention extraordinaire, cherchant ensuite à reproduire ce qu'elle a entendu et compris à sa manière. Curieuse des sonorités instrumentales, elle prend des leçons de violon, violoncelle, harpe et piano, sans toutefois s'attacher plus à l'un qu'à l'autre. Dès l'âge de six ans elle chante des mélodies de Fauré qui se plaît à les lui faire déchiffrer en l'accompagnant; elle improvise facilement au piano; mais, malgré l'extrême emprise de la musique sur elle, ses études musicales restent sporadiques. En réalité, elle est souvent malade et ne peut pas fournir un travail suivi et régulier.

En 1904, lorsque Lili a onze ans, Nadia (qui en a seize) remporte pour sa sortie du Conservatoire, simultanément, quatre premiers prix: orgue, fugue, composition, accompagnement au piano. C'est une réussite magistrale: elle va pouvoir commencer à donner des leçons! Madame Boulanger et ses deux filles (Monsieur Boulanger est mort en 1900) déménagent pour s'installer 36 Rue Ballu, où trônent bientôt dans le salon, un orgue et deux pianos, puis elles vont passer l'été à Hannencourt (environ 50 kms à l'ouest de Paris) où habite le grand pianiste Raoul Pugno. Certes il donne des leçons, mais il reçoit aussi de nombreux amis artistes, musiciens, peintres, poètes. Des fêtes, des concerts, jeux, déguisements s'organisent sous sa direction, animent tout le village, réjouissent les propriétaires des environs, et,

4

A l'orgue, Rue Ballu - 1913

LILI BOULANGER
GABRIEL FAURÉ
LILI BOULANGER "CLAIRIÈRE DANS LE CIEL" PAROLES FRANCIS JAMMES
GABRIEL FAURÉ 9 MÉLODIES

5

DESIGNER: Henry Sene Yee,
*New York, New York* TYPO-
GRAPHIC SOURCE: In-house
STUDIO: St. Martin's Press
CLIENT: St. Martin's Press PRIN-
CIPAL TYPES: Orator and Trixie
DIMENSIONS: 5³⁄₁₆ x 8½ in. (13.2
x 21.6 cm)

book cover

101

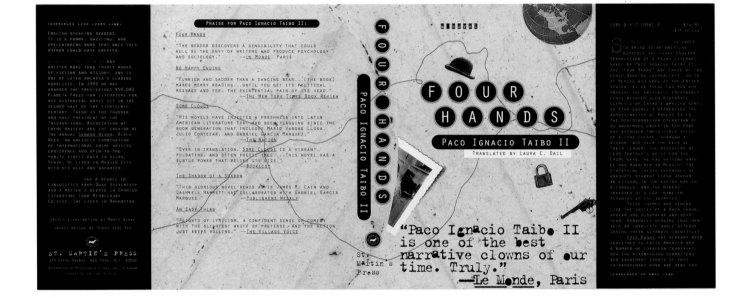

DESIGNER: Uwe Loesch, *Düsseldorf, Germany* LETTERER: Uwe Loesch TYPOGRAPHIC SOURCE: In-house STUDIO: Uwe Loesch CLIENT: International Poster Biennial Lahti, Finland PRINCIPAL TYPE: Frutiger DIMENSIONS: 33 1/16 x 46 7/8 in. (84 x 119 cm)

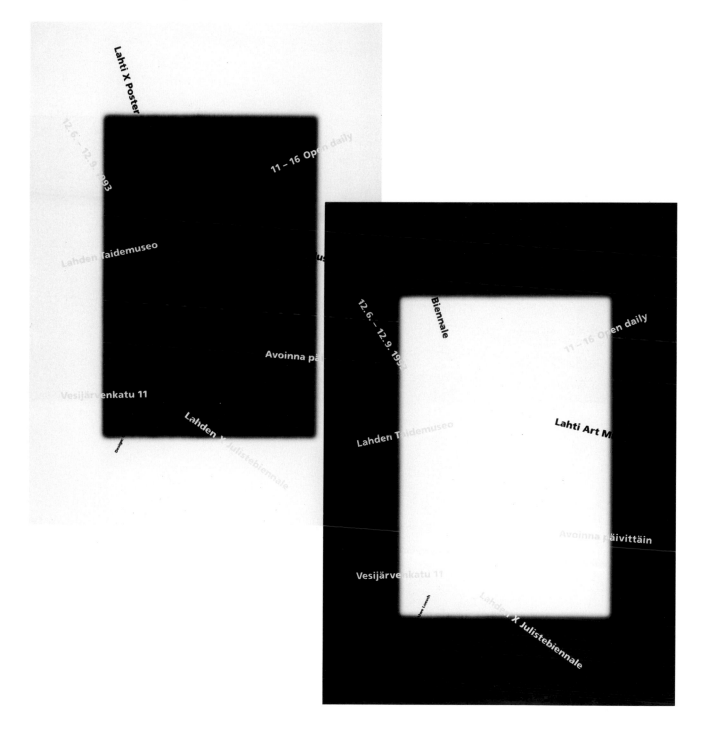

DESIGNERS: Barbara and Gerd Baumann, *Schwabisch Gmund, Germany* TYPOGRAPHIC SOURCE: In-house STUDIO: Baumann & Baumann CLIENT: Robundo Evolution Press, Tokyo PRINCIPAL TYPES: Palatino, Univers, and Garamond DIMENSIONS: 23⁵⁄₁₆ x 33¹⁄₁₆ in. (59.2 x 84.1 cm)

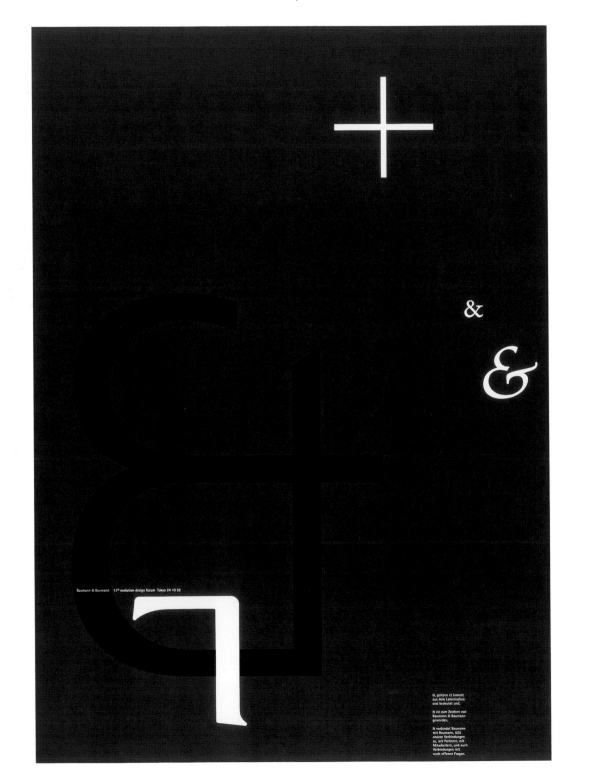

DESIGNER: Prof. Helmut M. Schmitt-Siegel and Jochen Härtel, *Düsseldorf, Germany* TYPOGRAPHIC SOURCE: In-house STUDIO: Institut für Kommunikation and Prof. Schmitt-Siegel & Partner CLIENT: Digital Equipment GmbH, München PRINCIPAL TYPES: ITC Officina Sans and ITC Officina Serif DIMENSIONS: 11¹¹⁄₁₆ x 7⅞ in. (29.7 x 20 cm)

newsletter

## VisionLetter 92.0

Eine Arbeitsunterlage
für Unternehmen
und Organisationen

**Wie wir arbeiten**

**Der Szenario-Teil jedes VisionLetters ist folgendermaßen gegliedert:**

Einführung – Eingrenzung des Gebietes, Definition des Schlagwortes und Fragen, die das Szenario beantworten soll.

▪ Faktensammlung
▪ Kräfteanalyse im Gegenwarts-Szenario
▪ Annahmen über die Zukunft
▪ Stellungnahme zur Zukunft
▪ Gebrauchs-Szenarien der Zukunft

Die Arbeitsschritte des Redaktionsteams verlaufen ähnlich:

**Kräfte im betrachteten Bereich:**

● *Leitkräfte sind heute die wesentlichen „Treiber" und entscheiden über die zukünftige Entwicklung*

● *Beschleuniger. Die Leitkräfte werden durch diese Kräfte beschleunigt.*

● *Verzögerer sind Beharrungskräfte, die direkt gegen Leitkräfte oder auf die Situation wirken.*

● *Störgrößen sind Ereignisse, die man spekulativ erwartet, deren Zeitpunkt des Eintretens man noch nicht kennt. Sie beeinflussen eine oder mehrere Leitkräfte und können den gesamten Bereich völlig verändern.*

● *Vernetzungen zu gänzlich anderen Bereichen können die Situation nachhaltig beeinflussen.*

▪ Sichtung von Unmengen Material, Studien, Ergebnisse von Datenbankzugriffen etc.
▪ Unstrukturiertes Faktensammeln
▪ Telefoninterviews führen
▪ Ein erstes Dossier mit Analysen und Annahmen
▪ Workshop mit Experten
▪ Redaktionsarbeit

Störgrößen

Beschleuniger  Verzögerer

Vernetzungen  Leitkräfte

VisionLetter 92.0
Intro Seite 6

Intro 6

DESIGNERS: Adam McIsaac and Jerry Ketel, *Portland, Oregon* TYPOGRAPHIC SOURCE: In-house STUDIO: The Felt Hat CLIENT: Northwest Film and Video Center PRINCIPAL TYPE: Bodoni DIMENSIONS: 14 x 11⅜ in. (35.5 x 29 cm)

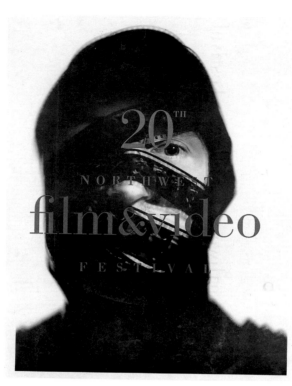

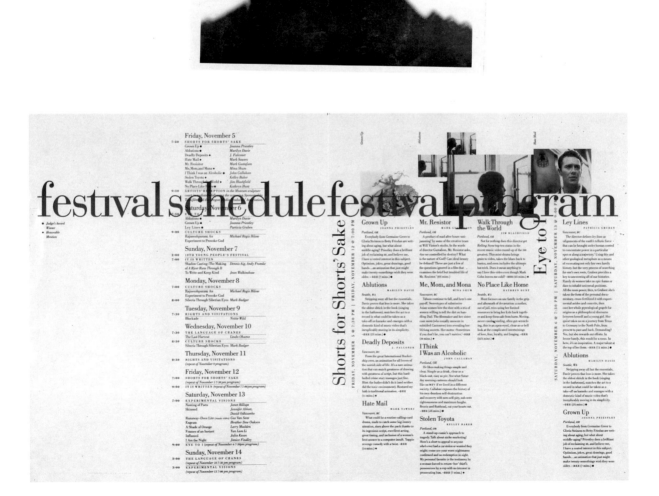

DESIGNERS: Gordon Tan, Mondrey Sin and Yang Qiang, *Singapore* CALLIGRAPHERS: Yang Qiang and Mondrey Sin AGENCY: The Fotosetter Singapore PRINCIPAL TYPE: Chinese Bodoni

typeface

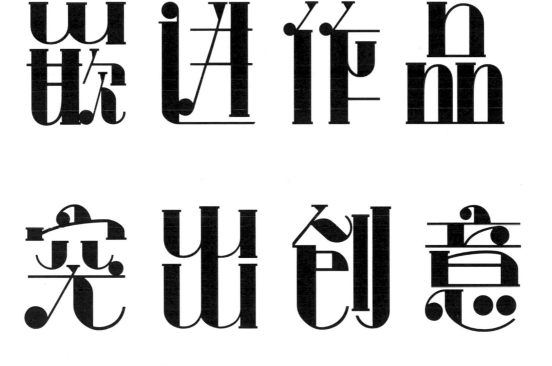

DESIGNER: Fred Machuca, *Long Beach, California* STUDIO: Machuca Design CLIENT: Machuca Design PRINCIPAL TYPE: Roppongi

# Roppongi Thin

a b c d e f g h i j k l m
n o p q r s t u v w x y z

! # $ % & ✳ ∗ ( ) ' ' " " ¢ ▪ • ; " ' , . ?

A B C D E F G H I J K L M
N O P Q R S T U V W X Y Z

0 1 2 3 4 5 6 7 8 9

# Rr

What's that buzzing?
This is a showing of the font Roppongi Thin.
It was selected by the TDC40 jury as
an outstanding achievement in font design.

DESIGNER: Graham Clifford, *New York, New York* TYPO-GRAPHIC SOURCE: In-house CLIENTS: Graham Clifford and Lynda Walsh PRINCIPAL TYPES: Adobe Garamond and Futura DIMENSIONS: 4 ½ x 6 ½ in. (11.4 x 16.5 cm)

invitation

YoU are cordially invited to the marriage of Lynda Walsh and Graham Clifford They will be brought together at 4.30pm Sunday 27th June Covenant Church 310 East 42nd Street between 1st and 2nd Avenues in New York City Reception 6pm at Capsouto Frères 451 Washington Street on the corner of Watts Street 1 block south of Canal Street and 1 block east of the West Side Highway RSVP by 1st June

DESIGNER: Crit Warren, *Columbus, Ohio*  TYPOGRAPHIC SOURCE: In-house and The Electric Typographer  STUDIO: Schmeltz + Warren  CLIENT: John Strange & Associates  PRINCIPAL TYPE: Leonardo  DIMENSIONS: 14½ x 22 in. (36.8 x 55.9 cm)

direct mail                    109

DESIGNERS: Allison Muench
and J. Phillips Williams, *New
York, New York* TYPOGRAPHIC
SOURCE: In-house   STUDIO:
m/w design inc.   CLIENT:
Takashimaya New York PRINCI-
PAL TYPES: Joanna, Perpetua,
Engravers Gothic, Linoscript,
Caslon F, Copperplate, and
Nicolas Cochin   DIMENSIONS:
6 x 9 in. (15.2 x 22.9 cm)

110

catalog

DESIGNER: Bill Thorburn, *Minneapolis, Minnesota* LETTERER: Jack A. Molloy TYPOGRAPHIC SOURCE: In-house STUDIO: The Kuester Group CLIENT: Potlatch Paper Company PRINCIPAL TYPES: Bodoni and hand-lettering DIMENSIONS: 9 x 12 in. (22.9 x 30.5 cm)

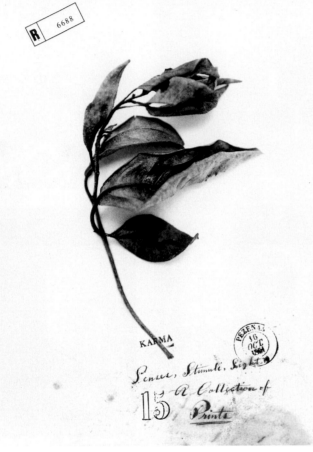

DESIGNER: Andreas Stötzner, *Leipzig, Germany* LOCATION: Hochschule für Grafik und Buchkunst, Leipzig PHOTOGRA-PHERS: Matthias Hoch and Matthias Knoch TYPOGRAPHIC SOURCE: Characters cut by hand on site STUDIO: Andreas Stötzner CLIENT: Self-commissioned project PRINCIPAL TYPE: Specially designed handmade capital characters

spatial installation

112

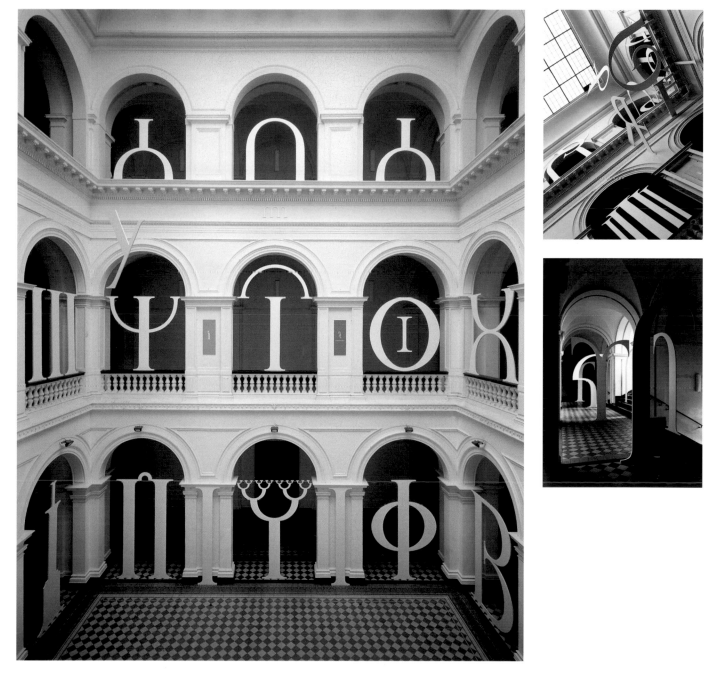

DESIGNER: Geraldine Hessler, *New York, New York* CREATIVE DIRECTOR: Fred Woodward TYPOGRAPHIC SOURCE: In-house STUDIO: Rolling Stone CLIENT: Rolling Stone PRINCIPAL TYPE: Bauer Bodoni DIMENSIONS: 17 x 10¾ in. (43.2 x 27.3 cm)

magazine spread

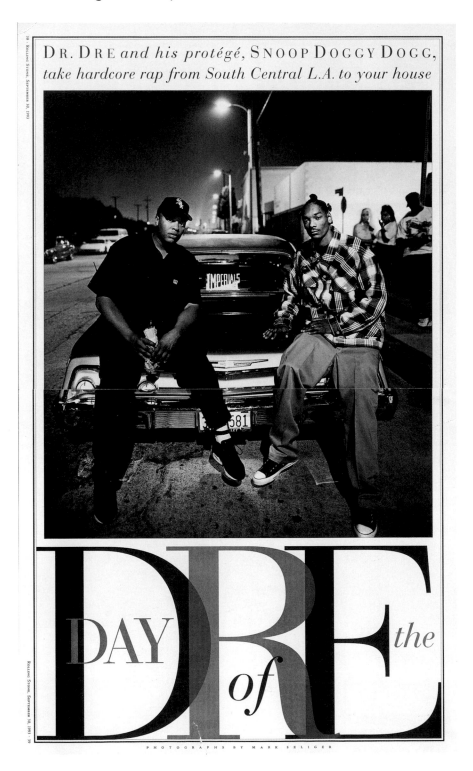

DESIGNER: Rick Cusick, *Lenexa, Kansas* TYPOGRAPHIC SOURCE: In-house STUDIO: Rick Cusick Design CLIENT: *Calligraphy Review* magazine PRINCIPAL TYPES: Block Condensed and Palatino DIMENSIONS: 11 x 17 in. (27.9 x 43.2 cm)

Ten years is a good reason for celebrating, and so we decided to have a little fun with our readers. Inside our Winter edition we randomly inserted a TOP TEN SURVEY – some of you received one, and others didn't – but we can all share the results. Because the response rate was less than 100% we cannot consider those that were returned to be a true random sample, nevertheless we hope the answers will pique your interest – perhaps you will learn about a book your library is lacking, discover a tip you could put to good use, or hear about a teacher with whom you would like to study. You might take this opportunity to review the books on your shelves, the ones you might like to return to – or really read for the first time – or maybe it will conjure up some of your memories about your calligraphic experiences during the past ten years.

DESIGNERS: Fred Woodward
and Gail Anderson, *New York,
New York* ART DIRECTOR:
Fred Woodward TYPOGRAPHIC
SOURCE: In-house STUDIO:
Rolling Stone CLIENT: Rolling
Stone PRINCIPAL TYPE: Grecian
Extended Bold DIMENSIONS:
17 x 10¾ in. (43.2 x 27.3 cm)

DESIGNER: Debra Bishop, *New York, New York* ART DIRECTOR: Fred Woodward TYPOGRAPHIC SOURCE: In-house STUDIO: Rolling Stone CLIENT: Rolling Stone PRINCIPAL TYPE: Hand-lettering DIMENSIONS: 17 x 10¾ in. (43.2 x 27.3 cm)

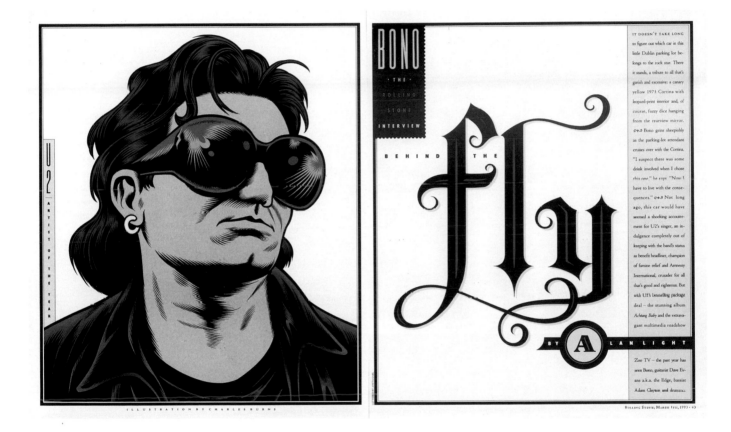

DESIGNER: Debra Bishop, *New York, New York* LETTERER: Anita Karl ART DIRECTOR: Fred Woodward TYPOGRAPHIC SOURCE: In-house STUDIO: Rolling Stone CLIENT: Rolling Stone PRINCIPAL TYPE: Various DIMENSIONS: 17 x 10¾ in. (43.2 x 27.3 cm)

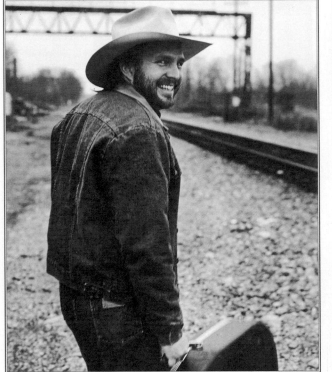

PHOTOGRAPHS BY KURT MARKUS

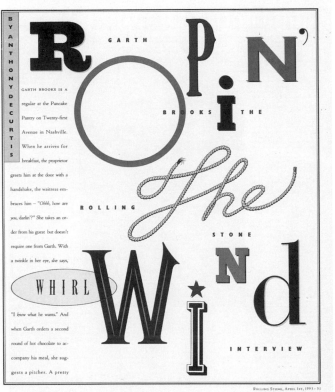

DESIGNERS: Fred Woodward
and Gail Anderson, *New York,
New York* ART DIRECTOR:
Fred Woodward TYPOGRAPHIC
SOURCE: In-house STUDIO:
Rolling Stone CLIENT: Rolling
Stone PRINCIPAL TYPE: Empire
DIMENSIONS: 17 x 10¾ in. (43.2
x 27.3 cm)

magazine spread

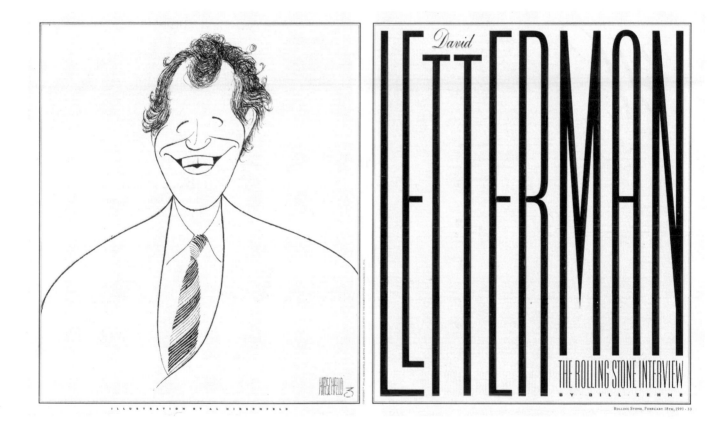

DESIGNER: Debra Bishop, *New York, New York* ART DIRECTOR: Fred Woodward TYPOGRAPHIC SOURCE: In-house STUDIO: Rolling Stone CLIENT: Rolling Stone PRINCIPAL TYPE: Plumber Sans DIMENSIONS: 8 x 10¾ in. (20.3 x 27.3 cm)

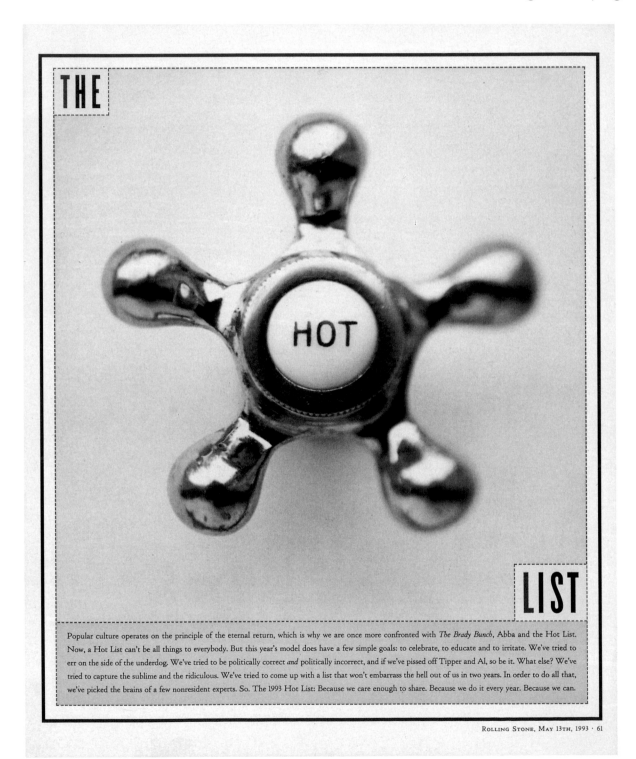

Popular culture operates on the principle of the eternal return, which is why we are once more confronted with *The Brady Bunch*, Abba and the Hot List. Now, a Hot List can't be all things to everybody. But this year's model does have a few simple goals: to celebrate, to educate and to irritate. We've tried to err on the side of the underdog. We've tried to be politically correct *and* politically incorrect, and if we've pissed off Tipper and Al, so be it. What else? We've tried to capture the sublime and the ridiculous. We've tried to come up with a list that won't embarrass the hell out of us in two years. In order to do all that, we've picked the brains of a few nonresident experts. So. The 1993 Hot List: Because we care enough to share. Because we do it every year. Because we can.

ROLLING STONE, MAY 13TH, 1993 · 61

DESIGNER: Michel Mallard,
*Paris, France* TYPOGRAPHIC
SOURCE: In-house STUDIO:
Michel Mallard Studio/Paris
CLIENT: *L'Autre Journal* PRINCI-
PAL TYPES: OCR-B, Times, and
Shannon DIMENSIONS: 11¼ x
16⅛ in. (28.5 x 41 cm)

MERCREDI 28 AVRIL.

**Déontologie.** Examen du procès contre PPDA et Régis Faucon, intenté par une association de téléspectateurs suite à l'interview truquée de Fidel Castro.
Le présentateur vedette s'explique : « J'ai été victime d'une imposture, je croyais qu'il s'agissait de *Surprise sur prise !* »

**Tribunes.** Les magistrats rendent leur arrêt dans l'affaire du stade de Furiani.
Les experts sont formels, il ne s'agissait pas d'une erreur humaine, mais d'une secousse sismique.

DIMANCHE 2 MAI

**Constipation.** 40ᵉ anniversaire de l'arrivée du roi Hussein de Jordanie sur le trône.
Le record n'est toujours pas homologué.

SAMEDI 8 MAI

**Tourisme. Visite de Jean-Paul II en Sicile.**
Le Saint-Père explique sa venue : « Le Vatican a toujours entretenu des relations privilégiées avec les habitants de cette région. »

SAMEDI 15 MAI

**Irlande. Concours Eurovision de la chanson.**
Eric et Johana, les interprètes de la chanson qui représentera la France – *Laisse toi aller d'amour avec moi* –, ont été reçus par le nouveau ministre de la Culture, Jacques Toubon.

DIMANCHE 16 MAI

**Hommage.** 40ᵉ anniversaire de la mort de Django Reinhardt.
Invité à *Sacrée Soirée*, le nouveau ministre de la Culture, Jacques Toubon, a déclaré, très ému : « C'est vrai qu'il était parfois vulgaire, mais j'avoue que ses sketches me faisaient mourir de rire. »

ça (s'est
passé )
le mois prochain
L'agenda de Diastème

JEUDI 29 AVRIL

**France. Journée de la mode.**
Pour participer à cette grande fête, le nouveau ministre de la Culture, Jacques Toubon, effectue une visite surprise au C&A de la Défense.

SAMEDI 1ᴱᴿ MAI

**Chôme. Fête du travail.**
Le nouveau ministre du Travail, Michel Giraud, déclare : « Pour lutter efficacement et sans délai contre le chômage, le gouvernement a décidé qu'à partir de cette année le 1ᵉʳ Mai tomberait un samedi. »

**Brasse coulée. Traversée de Paris à la nage.**
« Voilà enfin la preuve que la Seine est parfaitement propre, a déclaré Jacques Chirac, maire de Paris. D'ailleurs, a-t-il ajouté, sans cette satanée grippe, j'y allais ! »

JEUDI 13 MAI

**Cannes. Ouverture du 46ᵉ Festival du cinéma.**
Dans son discours d'ouverture, le nouveau ministre de la Culture, Jacques Toubon, a rendu un vibrant hommage à l'œuvre de son prédécesseur, François Léotard.

VENDREDI 14 MAI

**Ile-de-France. Nouvelles Assises de l'enseignement catholique en région parisienne.**
A leur sortie, les participants s'avouent satisfaits : « Les chaises étaient beaucoup plus confortables que l'année dernière. »

MERCREDI 19 MAI

**Opéra-Bastille.** Concert de Charles Trénet pour son 80ᵉ anniversaire.
Après avoir réussi à pénétrer dans l'enceinte en se faisant passer pour le ministre de la Culture, Jacques Toubon a été refoulé au contrôle.

LUNDI 24 MAI

**Tennis.** Premier jour du tournoi de Roland-Garros.
Après avoir assisté à la première rencontre, Simone Veil, le nouveau ministre de la Santé, a déclaré : « Tous ces jeunes gens qui jouent des heures entières sous le soleil sans mettre un chapeau, ce n'est pas bien raisonnable ! »

L'AUTRE JOURNAL 1993 / n° 4

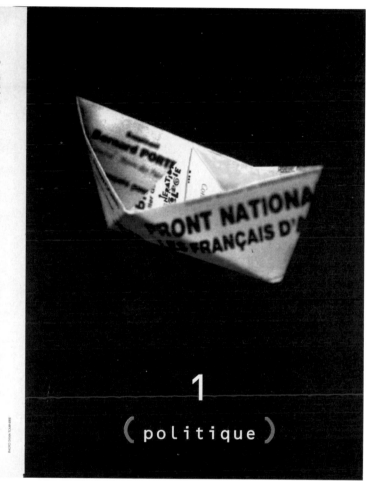

1
( politique )

DESIGNER: Michel Mallard,
*Paris, France* TYPOGRAPHIC
SOURCE: In-house STUDIO:
Michel Mallard Studio/Paris
CLIENT: Diplopie PRINCIPAL
TYPE: Triplex DIMENSIONS: 8¼
x 10¼ in. (21 x 26 cm)

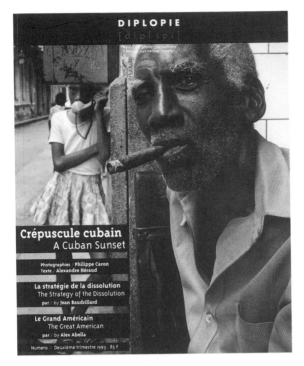

DESIGNERS: Hal Wolverton, Alicia Johnson, Kat Saito, Jerome Schiller, and Chris King, *Portland, Oregon* TYPO-GRAPHIC SOURCE: In-house AGENCY: Johnson & Wolverton CLIENT: Amnesty International USA PRINCIPAL TYPE: Various DIMENSIONS: 8½ x 11 in. (21.6 x 27.9 cm)

magazine

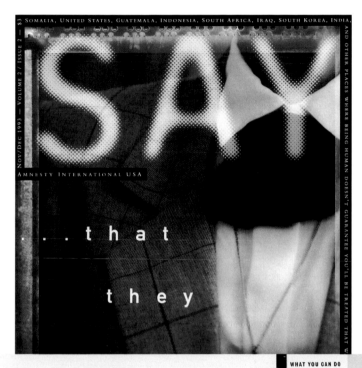

SOMALIA, UNITED STATES, GUATEMALA, INDONESIA, SOUTH AFRICA, IRAQ, SOUTH KOREA, INDIA,

NOV/DEC 1993 · VOLUME 2 / ISSUE 2 · $3

# SAY

AMNESTY INTERNATIONAL USA

...that

they

AND OTHER PLACES WHERE BEING HUMAN DOESN'T GUARANTEE YOU'LL BE TREATED THAT W

# MURDER BY ANY OTHER NAME

BY DIANA QUICK

"The great mass murderers of our time have accounted for no more than a few hundred

Jabbar Rashid Shfki was just 15 years old when he was arrested by the Iraqi Army in 1983. He was one of 8,000 members of the Barzani clan who were rounded up by Iraqi forces during a raid on a resettlement camp in northern Iraq. Their "crime?" They belonged to the "wrong" ethnic group; they were Kurds, believed by the Iraqi Government to be helping Iran in the Iran/Iraq War. Ten years later, the fate and whereabouts of the men and boys, ranging in age from eight to 80, are still unknown.

The relatives of the victims of such "disappearances" suffer a particularly cruel fate. They do not know if their husband or wife, brother or sister, child or parent is dead or alive, and many spend years in a fruitless search, unable to rest because they have no definite information about the fate of their loved ones. Their inquiries run up against endless denials from officials. Their difficulties can be made worse by the climate of fear surrounding "disappearances." Witnesses may be too frightened to come forward and give evidence openly. If they do come forward, they may receive threats or "disappear" themselves.

Amnesty International's 1992 Annual Report recorded political killings in some 45 countries, and reported that at least 1,270 people in 20 countries "disappeared" after arrest by security forces in 1991. It also reported that in at least 29 countries people who were earlier reported to have "disappeared" have yet to be accounted for sufficiently.

Millions of men, women and children have been killed or "disappeared" by their own governments since the 1960s because of their political views or their ethnic origin, because of where they lived, or simply because they were poor.

In Indonesia, half a million people were killed in the 1960s in an "anti-Communist" drive. In the 1970s hundreds of thousands were murdered by the Khmer Rouge in the "killing fields" of Pol Pot's "Democratic" Kampuchea (Cambodia) and thousands of people "disappeared" under Argentina's military juntas in the late 1970s. Things did not improve in the 1980s: up to two percent of the population of El Salvador is estimated to have been wiped out by the government; tens of thousands have "disappeared" in Sri Lanka.

And the end of the Cold War, with democratically-elected governments replacing military juntas and totalitarian regimes, has not meant the end of the killings and suffering. Tens of thousands of people are still being murdered each year or "disappear" without trace at the hands of government agents. In countries around the world, people live in fear of death or wait to hear about the fate of friends and relatives who have "disappeared."

The "disappeared," a term coined in 1966 in Guatemala, are people who have been taken into custody, yet whose whereabouts and fate are unknown. Witnesses have usually seen them being detained, but the authorities deny holding them. The safeguards that normally guarantee their safety in custody are suspended. The prisoner is cut off from the outside world and has no protection. At best, he or she may simply be in unacknowledged detention, unharmed, and may "reappear" in time. Other "disappeared" prisoners are less fortunate; they are tortured, killed, and their bodies disposed of secretly.

Marta Crisóstomo García, a 22-year-old nurse, was a witness to one of the worst massacres in Peru in recent memory. In May 1988 some 30 Indian peasants were killed by the army in the small town of Cayara in revenge for an ambush on a military convoy by the Communist Party of Peru-Shining Path. The military then hunted down and killed witnesses who could testify against them. Marta Crisóstomo gave evidence to the official inquiry, then began to receive death threats, and in September 1989 was shot dead in her home by an army "death squad."

victims in contrast, states that have chosen to murder their own citizens can usually count

their victims by the carload. As for motive, the state has no peers, for it will kill for a careless word, a fleeting thought, or even a poem."

— Dr. Clyde Snow, a forensic anthropologist who analyzed skeletal remains to expose atrocities by state officials in several Latin American countries.

AMNESTY INTERNATIONAL LAUNCHED A YEAR-LONG, WORLDWIDE CAMPAIGN ON "DISAPPEARANCES" AND POLITICAL KILLINGS IN OCTOBER. IT IS DIFFICULT FOR THE PUBLIC TO UNDERSTAND THESE ISSUES AND BE SYMPATHETIC TO SOMEONE WHO HAS "DISAPPEARED" OR DIED. SO IT'S IMPORTANT FOR US TO GET INVOLVED. IF YOUR GROUP HAS NOT YET SIGNED UP AND WOULD LIKE TO, PLEASE WRITE TO: AIUSA, NATIONAL STUDENT PROGRAM, 1118 22ND STREET, NW, WASHINGTON, DC 20037.

## WHAT YOU CAN DO

Harjit Singh, a 22-year-old father of two, was arrested on April 29, 1992 in Punjab, India while he was standing at a bus stop. He was held at Ghagar Bhanar police station and then transferred to Melha police station and then taken to Mal Mandi interrogation Center, a well-known torture center in Amritsar.

Police claim Harjit Singh was arrested on May 11 after an armed encounter with police and killed by

a group of men attacking the police. However, his father, Kashmir Singh, saw him alive twice in police custody.

Punjab is a state in India where armed Sikh insurgents are fighting for independence from India. Hundreds of people have "disappeared" and been killed since 1990.

WRITE TO:

The Prime Minister of India. Urge the government to order an independent and impartial inquiry into the "disappearance" of Harjit Singh and to ensure that its findings are made public. Request that the government ensures protection for

Harjit Singh's family against harassment and intimidation by the police during the investigation. Urge the government to make every effort to establish the whereabouts of Harjit Singh as an immediate priority and to ensure that his family be immediately informed as to his whereabouts.

MR. P.V. NARASIMHA RAO
PRIME MINISTER OF INDIA
PRIME MINISTER'S OFFICE
SOUTH BLOCK
NEW DELHI 110 011
INDIA.

## RESOURCES

There are several films available on video that you might like to watch alone or with your group which deal with the issues discussed here.

MISSING. About American journalists who "disappears" during the military coup in Chile in 1973, and his wife's and father's attempts to find him.

PIXOTE. About a street child in one of Brazil's major cities.

THE OFFICIAL VERSION. About "disappearances" and political killings during the military dictatorship in Argentina.

THE KILLING FIELDS. Set during the period of Khmer Reuge administration in Cambodia. this film tells the story of a Cambodian journalist caught up in the political upheavals. "disappearances" and political killings.

If you want to learn more about "Disappearances" and Political Killings, you can order Amnesty International's new report, "Getting Away With Murder" from AIUSA, Publications, 322 Eighth Avenue, New York, NY 10001. It costs $6.00 plus $1.75 shipping and handling. Groups that sign up for the campaign will get this report as part of the campaign materials.

Amnesty International defines "political killings" as unlawful and deliberate killings, carried out by order of a government or with its complicity. Sometimes they are reprisal killings, with civilians killed in retaliation for the killing of a security forces officer. Sometimes individual opponents or critics of the government, such as trade union members, human rights activists or religious leaders, are assassinated. Sometimes the killings are public and blatant, as when peaceful demonstrators are killed, as happened in Tiananmen Square, China, in 1989. Sometimes the killings are committed by uniformed officers, in other cases by members of paramilitary forces or of plainclothes "death squads." If security forces are involved, they often try to hide their role by operating in plain clothes and using unmarked vehicles. They may blame the opposition for killings they themselves committed or may claim that the victims were killed in shoot-outs or while trying to escape. They may try to legitimize their actions by claiming that the victims were "terrorists."

"Disappearances" and political killings are arguably the greatest threat to human rights today—the preferred methods by which governments get rid of individuals regarded as inconveniences for whatever reason.

Governments often resort to "disappearances" and political killings for reasons of political expediency. They believe that their aims can be more easily achieved by such methods than by using peaceful or lawful means, or that they are the only way they think they can maintain their position of privilege and power. When the government condones or orders the murder, there is no recourse for the victims or their families. The people who carry out the crimes are immune from prosecution or punishment. In some countries, such as Burma and Iraq, the government goes on butchering its armed forces to kill with impunity. In other cases, such as El Salvador, amnesties are granted to human rights violators when a new government comes into power, in a misguided attempt at reconciliation. And many governments are reluctant to undertake investigations into past human rights abuses.

Other countries are also generally reluctant to use their influence to change the situation, continuing to trade arms, implements of torture and provide financial aid, even in the face of evidence of appalling human rights abuses. Until the climate of impunity changes, political killings and "disappearances" will continue.

If "disappearances" and political killings are to stop, it will be as a result of governments sending a clear message that they will not be tolerated, and that any instances will be promptly investigated and punished. Take action! Write letters on the case above, and take a step toward pressuring governments to bring an end to "disappearances" and political killings.

DESIGNER: Michel Mallard, *Paris, France* TYPOGRAPHIC SOURCE: In-house STUDIO: Michel Mallard Studio/Paris CLIENT: *L'Autre Journal* PRINCIPAL TYPES: OCR-B and Times DIMENSIONS: 11¼ x 8¹/₁₆ in. (28.5 x 20.5 cm)

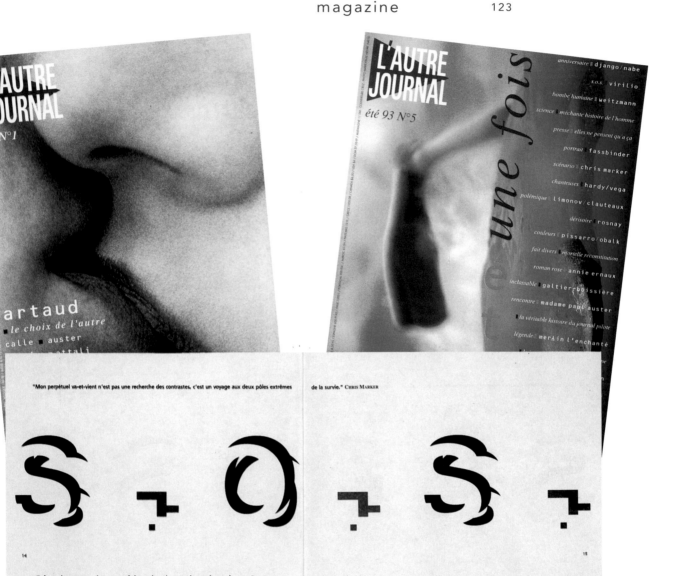

DESIGNERS: Joe Parisi and Tim Thompson, *Baltimore, Maryland* LETTERER: Joe Parisi TYPOGRAPHIC SOURCE: In-house STUDIO: Graffito CLIENT: American Red Cross PRINCIPAL TYPES: Garamond and Meta DIMENSIONS: 11 x 17 in. (27.9 x 43.2 cm)

annual report 124

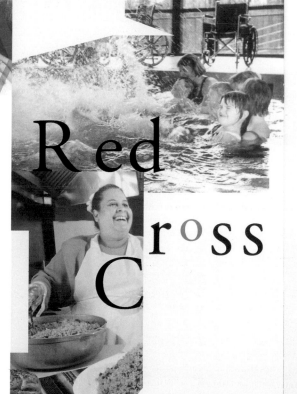

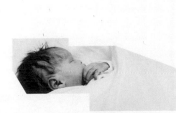

DESIGNERS: Paul and Carolyn Montie, *Boston, Massachusetts* TYPOGRAPHIC SOURCE: In-house STUDIO: Fahrenheit Design CLIENT: The Nora Theatre Company PRINCIPAL TYPES: OCR-B, Meta, Typo-Upright, Copperplate, Torino, and Franklin Gothic DIMENSIONS: Various

campaign

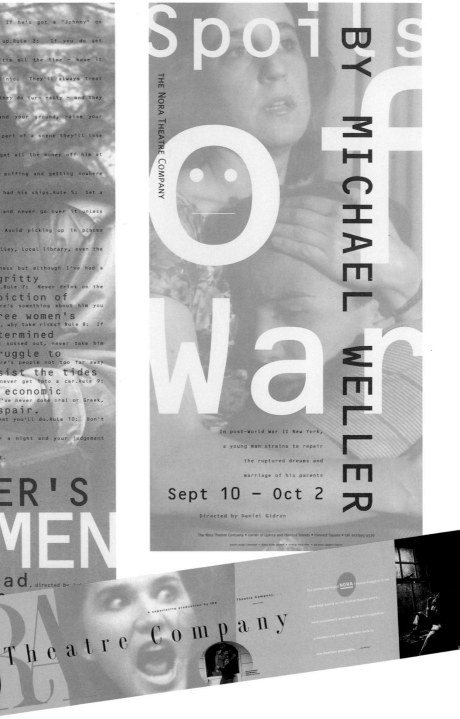

DESIGNER: Robert Bergman-Ungar, *New York, New York*
TYPOGRAPHIC SOURCE: In-house
AGENCY: Art w/o Borders Co.
New York   CLIENT: *Blindspøt*
magazine   PRINCIPAL TYPE:
Bauer Bodoni DIMENSIONS: 9 x
11 in. (22.9 x 27.9 cm)

DESIGNER: Mirko Ilić, *New York, New York* LETTERER: Sam Reep
TYPOGRAPHIC SOURCE: In-house
CLIENT: *The New York Times*
PRINCIPAL TYPES: Franklin Gothic, Bookman Ludlow, and Imperial   DIMENSIONS: 13½ x 22½ in. (34.3 x 57.2 cm)

DESIGNER: David Carson, *Del Mar, California* TYPOGRAPHIC SOURCE: In-house AGENCY: BBDO New York STUDIO: David Carson Design CLIENT: Pepsi PRINCIPAL TYPES: Degenerate, Monotype Grotesk, Futile, and Radiant DIMENSIONS: 8 x 10¾ in. (20.3 x 27.3 cm)

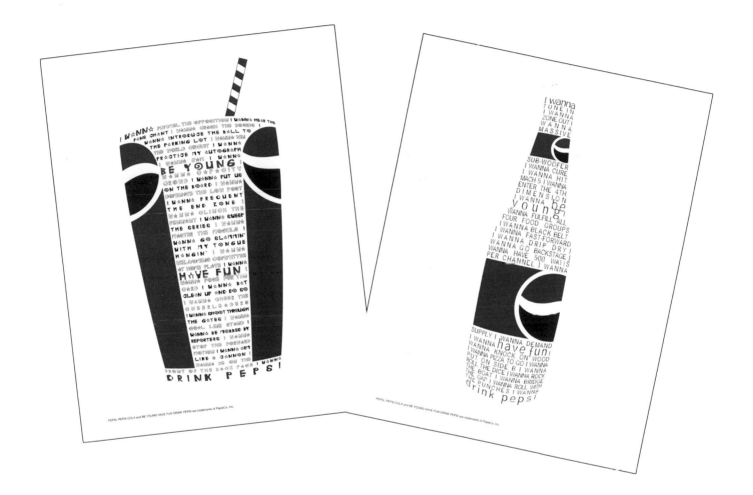

DESIGNER: Paula Scher, *New York, New York* TYPOGRAPHIC SOURCE: NYNEX Telephone Directory 1993 STUDIO: Pentagram Design CLIENT: Ambassador Arts and Champion International Corp. PRINCIPAL TYPES: Bell Centennial and Louie X-Acto DIMENSIONS: 23 x 35 in. (58.4 x 88.9 cm)

poster

DESIGNERS: Hjalti Karlsson and
Grace Kang, *New York, New
York* TYPOGRAPHIC SOURCE:
Oddi Printing Corp. STUDIO:
KarlssonKang graphicdesign
CLIENT: Oddi Printing Corp.
PRINCIPAL TYPE: Helvetica Black
DIMENSIONS: 17 x 5 in. (43.2 x
12.7 cm)

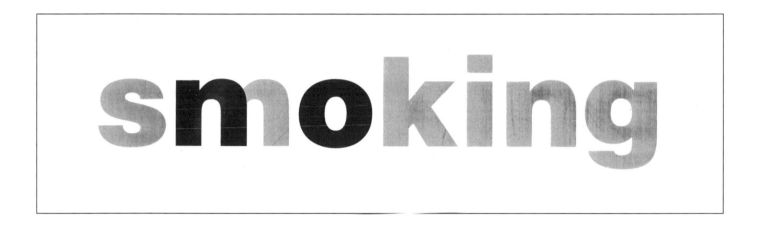

DESIGNERS: Theseus Chan and Jim Aitchison, *Republic of Singapore* TYPOGRAPHIC SOURCE: In-house AGENCY: Chan/Aitchison Partnership CLIENT: D Corner PRINCIPAL TYPES: Gothic 13 and Franklin Gothic DIMENSIONS: 15 x 10⁷⁄₁₆ in. (38 x 26.5 cm)

advertisement

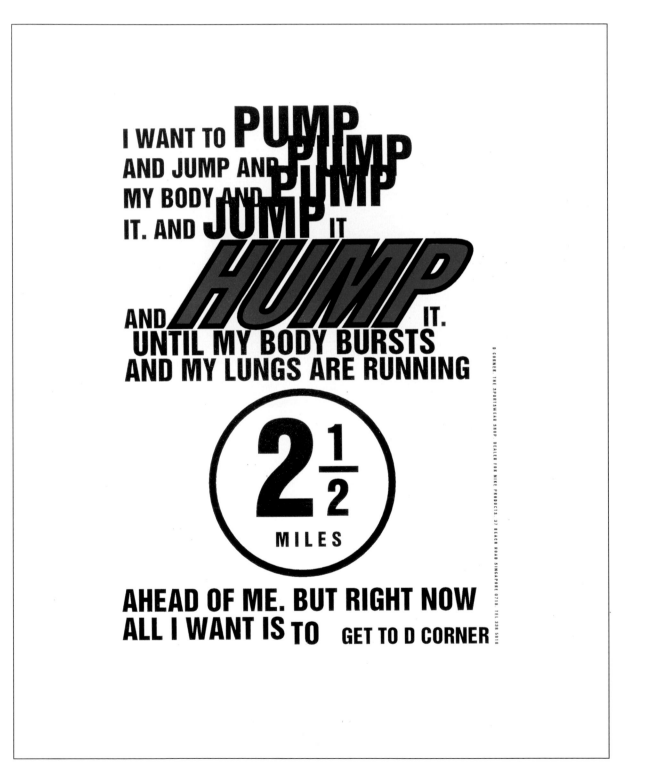

DESIGNER: Michael Accordino, *New York, New York* TYPOGRAPHIC SOURCE: Linoprint Composition Co., Inc. STUDIO: St. Martin's Press CLIENT: St. Martin's Press PRINCIPAL TYPES: Neuzeit Book Heavy and Bodoni DIMENSIONS: 6¼ x 9½ in. (15.9 x 24.1 cm)

book cover

132

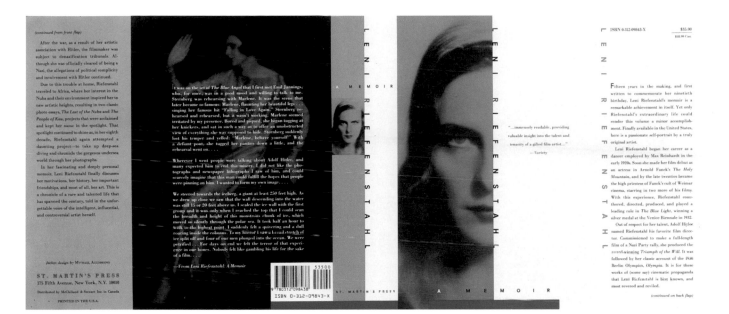

DESIGNER: Angela Skouras, *New York, New York* LETTERER: Henry Sene Yee TYPOGRAPHIC SOURCE: In-house STUDIO: Skouras Design CLIENT: St. Martin's Press PRINCIPAL TYPES: Futura Condensed and hand-lettering DIMENSIONS: 6⅛ x 9¼ in. (15.5 x 23.5 cm)

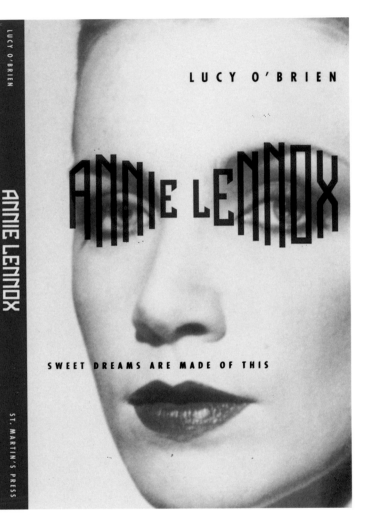

$13.95

Annie Lennox is modern music's most talented, original, and beautiful pop icon. Her appeal is broad ranging, her voice and image immediately distinctive. Always trend-setting and instantly identifiable, this Grammy-winning icon predated Madonna's sex-toy teasing and androgynous attitude, and influenced the look of music videos throughout the '80s...and beyond.

*Annie Lennox: Sweet Dreams Are Made of This* is the first full-scale biography of the Eurythmics' star. Lucy O'Brien traces her life story—from working-class origins in the far north of Scotland, to her arrival in London in the early '70s as a student at The Royal Academy of Music, to her relationship with fellow iconoclastic musician Dave Stewart. O'Brien charts Lennox's career from the early troubled days of The Tourists through the monumental success of Eurythmics to the recent startling decision to take a pop sabbatical at the height of her career to work with the homeless.

Including fascinating interviews with friends, associates, and Lennox herself, O'Brien explores every aspect of this colorful superstar's life, loves, beliefs, and music. She looks at her often outrageous onstage image, her fearless androgyny, her exploration of New Age religion, and the challenges of pop coupledom. Acclaimed and definitive, *Annie Lennox* finally gets to the heart of one of pop's most provocative and fascinating women.

Cover design by Angela Skouras
Cover photograph by Lewis Ziolek / Retna

ST. MARTIN'S PRESS
175 Fifth Avenue, New York, N.Y. 10010

PRINTED IN THE U.S.A.

51395

ISBN 0-312-09740-9

LUCY O'BRIEN

ANNIE LENNOX

S T. M A R T I N ' S  P R E S S

LUCY O'BRIEN

ANNIE LENNOX

SWEET DREAMS ARE MADE OF THIS

DESIGNER: Michael Ian Kaye,
*New York, New York* TYPO-
GRAPHIC SOURCE: In-house
CLIENT: Penguin USA PRINCIPAL
TYPE: Gill Sans DIMENSIONS:
12⅝ x 8¾ in. (32.1 x 22.2 cm)

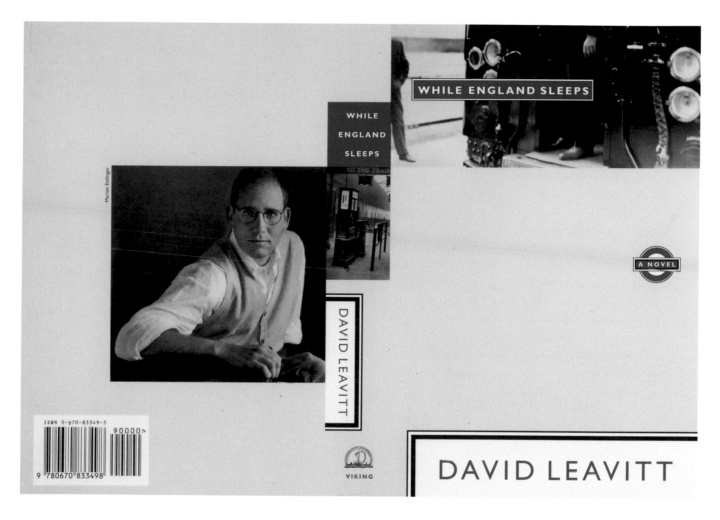

DESIGNER: Michael Ian Kaye, *New York, New York* TYPO-GRAPHIC SOURCE: In-house CLIENT: Farrar, Straus & Giroux PRINCIPAL TYPES: Trajan and Avenir DIMENSIONS: 5¾ x 9 in. (14.6 x 22.7 cm)

DESIGNER: Zempaku Suzuki, *Shintomi, Tokyo, Japan* TYPO-GRAPHIC SOURCE: In house STUDIO: B·BI Studio Inc. CLIENT: Daini Biwakogakuen Hospital for Severely Disabled Persons PRINCIPAL TYPE: Franklin Gothic DIMENSIONS: 28¹¹⁄₁₆ x 40⁹⁄₁₆ in. (72.8 x 103 cm)

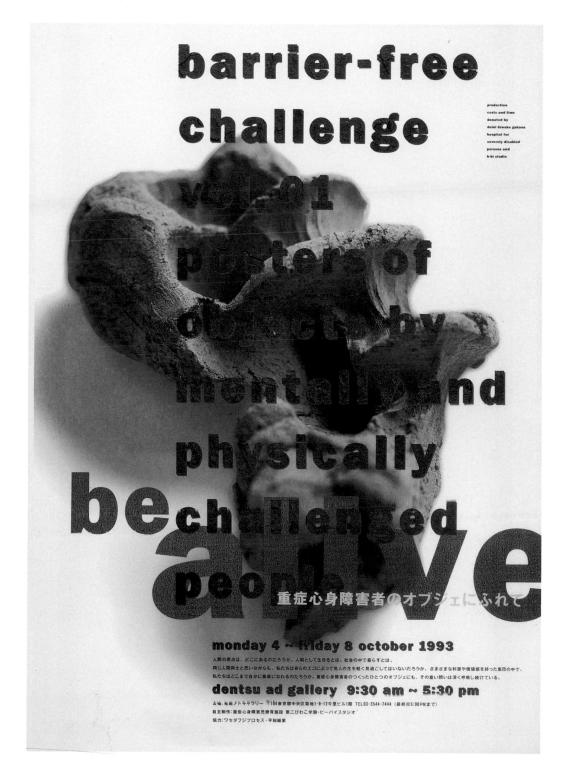

DESIGNERS: Johannes Erler and
Olaf Stein, *Hamburg, Germany*
TYPOGRAPHIC SOURCE: In-house
STUDIO: Factor Design CLIENT:
Font Shop International PRIN-
CIPAL TYPES: FF Dingbats and
FF Meta DIMENSIONS: 5¹³⁄₁₆ x
8¼ in. (14.8 x 21 cm)

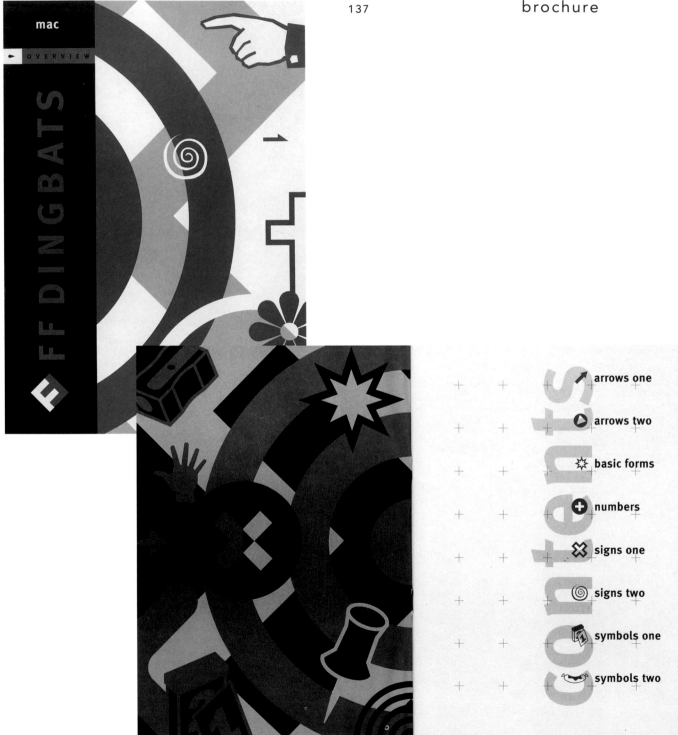

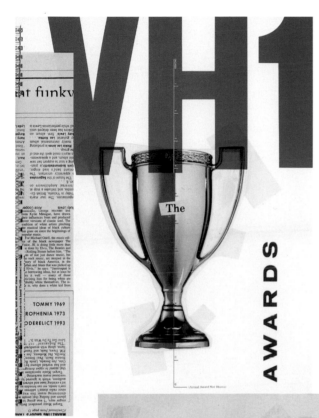

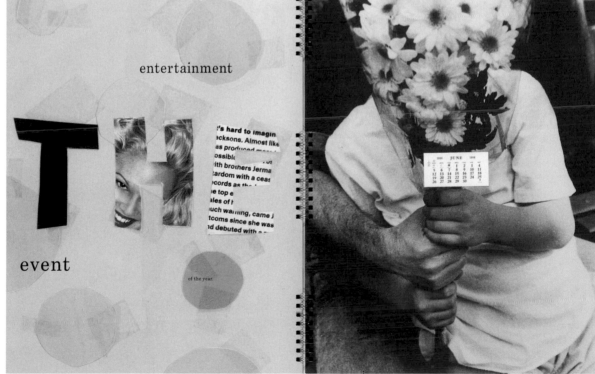

DESIGNERS: Sharon Werner and Amy Quinlivan, *Minneapolis, Minnesota* ART DIRECTOR: Cheri Dorr TYPOGRAPHIC SOURCE: Great Faces Inc. STUDIO: Werner DesignWerks, Inc. CLIENT: VH-1/MTV Networks PRINCIPAL TYPES: Venus Bold Extended, News Gothic, and Clarendon DIMENSIONS: 11 x 14¾ in. (27.9 x 17.3 cm)

brochure          138

DESIGNER: Andréas Nett-
hoevel, *Biel, Switzerland*
ACCOUNT EXECUTIVE: Kathrin
Kiener CREATIVE DIRECTOR:
Juerg C. Zysset TYPOGRAPHIC
SOURCE: second floor south
AGENCY: PUSH 'n' PULL Com-
munication, Berne, Switzerland
CLIENT: Alexandra Moden
PRINCIPAL TYPES: Syntax Roman
and Futura Book DIMENSIONS:
23 x 17 in. (58.3 x 43 cm)

direct mail

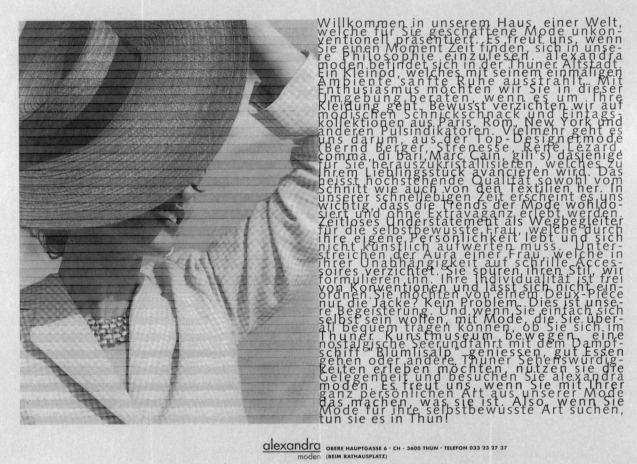

DESIGNERS: Michel Mallard and Alain Paul Mallard, *Paris, France* TYPOGRAPHIC SOURCE: In-house STUDIO: Michel Mallard Studio/Paris CLIENT: Lyon Biennial of Contemporary Art 1993 PRINCIPAL TYPE: OCR-B

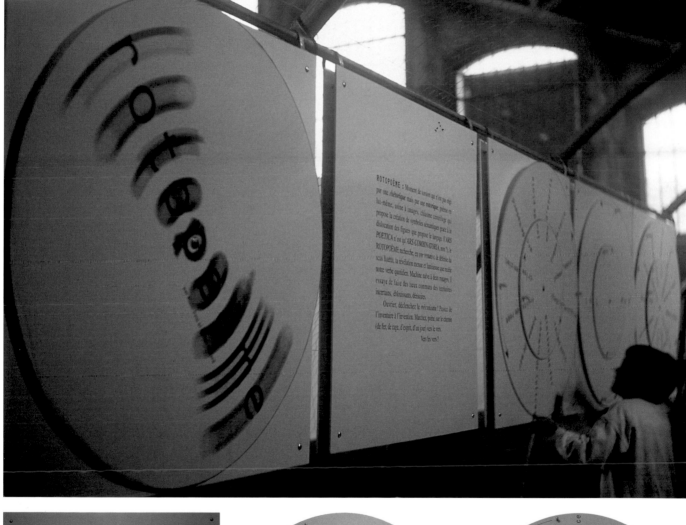

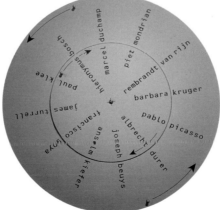

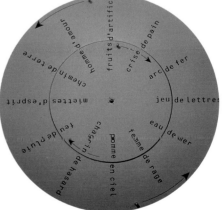

DESIGNERS: Michel Mallard and
Alain Paul Mallard, *Paris,
France* TYPOGRAPHIC SOURCE:
In-house STUDIO: Michel Mal-
lard Studio/Paris CLIENT:
*L'Autre Journal* PRINCIPAL
TYPES: OCR-B and Times
DIMENSIONS: 11¼ x 16⅛ in.
(28.5 x 41 cm)

le vain cri de l'écrivain

# rotopoème

par Alain-Paul et Michel Mallard

Moments de torsion qui n'est pas régi par une rhétorique mais
une rotorique, poème en lui-même, usine à images, chiasme cen-
trifuge qui propose la création de symboles sémantiques grâce à
la dislocation des figures que propose le langage (l'Ars poetica
n'est qu'Ars combinatoria, non ?), le rotopoème recherche en une
tentative de défense du sens littéral, la révélation menue et lumi-
neuse que recèle notre verbe quotidien. Machine naïve à deux
rouages, il essaie de faire des lieux communs des territoires in-
certains, éblouissants, dérisoires.

Ouvrier, déclenchez le mécanisme. Passez de l'inventaire à l'in-
vention. Marchez, poète, sur le chemin (de fer, de rage, d'esprit,
d'un jour) vers le vers.

Vers les vers ?

66

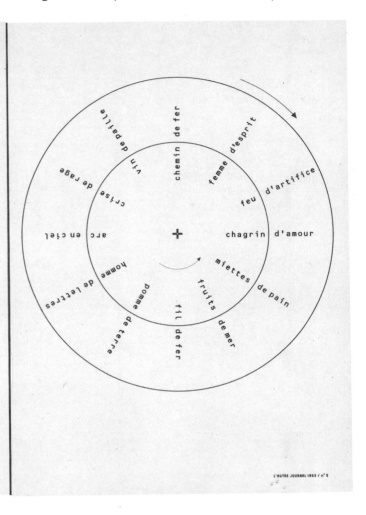

DESIGNER: Nan Goggin, *Champaign, Illinois* ASSISTANT DESIGNER: Paula J. Curran TYPOGRAPHIC SOURCE: In-house STUDIO: redhead design CLIENT: Krannert Art Museum and Kinkead Pavilion, University of Illinois at Urbana-Champaign PRINCIPAL TYPES: Prestige Elite and Helvetica DIMENSIONS: 9 x 12 in. (22.9 x 30.5 cm)

book

OUT OF TOWN:
the Williamsburg Paradigm

an exhibition curated by
Jonathan Fineberg

Krannert Art Museum
and Kinkead Pavilion
University of Illinois
at Urbana-Champaign

DAVID JON LINDBERG

ARTIST'S STATEMENT

"...plus one chromosome" refers to the "extra" chromosome that causes

Down's Syndrome. There are various patterns to the basic structures

making up people. The commonest pattern is not the correct pattern.

There are no good, bad or correct patterns.

David Lindberg was born January 20,

1964 in Des Moines, Iowa. He studied
Often I find new functionings for consumer objects, other than those
Fine Arts at the University of
intended by the manufacturer and the public. Hopefully these breaches
Minnesota and Environmental Design at
are alluring enougy that people will be drawn to register the way I
the Parsons School of Design in New
assemble objects (differences) as normalities; as normal processes; as
York. He recently assisted Tadashi
some of the endless ways of reality. Depowering "normal."
Kawamata with the *Smallpox Hospital*

*Installation* on Roosevelt Island in
"...plus one chromosome" is also a kit. A "kit" refers to a set which
New York, and exhibits at the Herron
an operation is performed on. The set may be the TRIX cereal package
Test Site in Williamsburg.
that is sold in the store - not necessarily only the cereal that is in

the box, but that type of cereal nugget, that type of stay fresh liner

bag and that type of graphic on the box. The set can be that box, a

nugget, or it can encompass a larger mass within the phylum. This TRIX

set is determined for and provided by marketing and manufacturing. But,

after the corporations determine what can be brought home then the

individual applies any perception upon it - introduces it to their own

environment and wishes. To eat the cereal is only a suggestion. I build

objects from these kits.

Kidn kap, Plus One Chromosome Series, 1992, general installation view, #1, foam, bolts, thread, resin, 6 x 9 x 3", #2, steel joint, sandpaper and resin, 3"diam. x 7", #3, steel, five way conti, sculpted in plaster in resin 9 x 4 x 3", #4, plastic ball, paper towel, plastic bag, 8 x 11 x 3", #5, thickened resin dome with gray resin splotch, white foam, ochre foam, 5" diam. x 9", #6, 9" diam. x 3", #7, clear plastic bowl squished in yellow towel, 4 1/2" diameter x 6 1/2" deep, #8, paper towel, scope with carbon fibered textile, 7 x 10 x 6", photo by Seth Rubin.

Plus One Chromosome Series, 1992, #4, photo by Seth Rubin.

Plus One Chromosome Series, 1992, #8, photo by Seth Rubin.

Plus One Chromosome Series, 1992, #2 and #5, photo by Seth Rubin.

DESIGNER: Darren Namaye,
*Pasadena, California* TYPO-
GRAPHIC SOURCE: In-house
STUDIO: Art Center College of
Design, Design Office CLIENT:
Art Center College of Design
PRINCIPAL TYPES: Gill Sans and
Baskerville No. 2 DIMENSIONS:
10 x 15½ in. (25.4 x 39.4 cm)

DESIGNER: Akio Okumura, *Osaka, Japan* LETTERER: Akio Okumura TYPOGRAPHIC SOURCE: In-house STUDIO: Packaging Create Inc. CLIENT: Japan Graphic Designers Association Inc. PRINCIPAL TYPE: Helvetica Regular DIMENSIONS: 28¹¹⁄₁₆ x 40½ in. (72.8 x 103 cm)

144 poster

DESIGNER: Susan Silton, *Los Angeles, California* TYPOGRAPHIC SOURCE: In-house STUDIO: SOS, Los Angeles CLIENT: Fine Arts Gallery, University of California, Irvine PRINCIPAL TYPES: Bureau Agency and Adobe Garamond DIMENSIONS: 8½ x 11 in. (21.6 x 27.9 cm)

the theater of refusal**black art and mainstream criticism**

PARTICIPANTS

HILTON ALS

CHARLES GAINES

THELMA GOLDEN

LIZZETTA LEFALLE-COLLINS

CATHERINE LORD

BEN PATTERSON

SANDRA ROWE

GARY SIMMONS

PAT WARD WILLIAMS

**CATHERINE LORD:** We're going to start by asking each artist to talk about their relation to issues in the show. Charles Gaines—much of whose work deals with numerical formulas—has developed an order.

**CHARLES GAINES:** It's a very complex system. We'll start from center left and move out, and then we'll go to center right and move out.

**LIZZETTA LEFALLE-COLLINS:** When I was asked to participate—and of course we were all sent Charles' essay—I tried to tie it in with what I'm doing as an independent curator, with what I had done in the past as curator of the Afro-American Museum in Los Angeles [1985-92], as an advocate for exposing the work of African-American artists to a wider public, and for getting my African-American audience to move beyond seeing the works of African-American artists in a very, very narrow tunnel.

I received my M.F.A. in painting and drawing in 1974, and moved into curating because of the need to have more voices supporting work by black people. I put my artistic career on hold, so that I could concentrate on curating and writing. I went back to school, to an art history program. When I was working as an artist and then in teaching I always steered clear of these programs because there was not much there helping me in terms of my African-American mix. I don't think much has changed, to my dismay and frustration. So my thoughts today are informed by my past history as an artist, and as a curator, and as a graduate student in an art history program.

I am inclined to agree with Henry Louis Gates that it sometimes seems blacks are doing better in college curricula than on the streets—meaning that even though now we might see more African-American professors on college campuses (it's truly not a whole lot of them—we might see more of them in terms of art programs and in literature programs) the giant has still not been defeated. In fact, in the streets, African-Americans seem to have fallen further behind than when I was in school.

ROUNDTABLE

A lot of scholars went into art theory or literary theory because they noticed that, in terms of criticism, they lacked a voice for what they were doing. That is one reason that brought me back to school. I wanted to find out what was going on, why we still found ourselves on the margins. In a course I'm presently enrolled in at UC Berkeley—a course on American art that is completely void of any voices except white—there seems to be a nervousness on the part of my professor as she approaches in an ever-so-brief discussion the matter of blacks in paintings. And that is as far as she gets. I say all this to say it doesn't seem like a lot has changed since I received my M.F.A. in 1974.

So I went back to school, realizing fully (for some time) that a sign of scholarship to the establishment is mastering white culture, language, literature and art. I find that my professors—my white professors and colleagues—remain most impressed by this. Some of us being black, in our uninitiated state, as young scholars, followed this path. However, we came of age. Age does things for you: you realize to master their culture can mean the negation of your own. Is one willing to make this grand sacrifice for life?

I see this as the dilemma of a lot of black intellectuals. The study of art history as it is taught in most institutions of higher education took some time for me to get used to. I find a real dangerous resistance in some art historical circles as well—and these are the training grounds for museum professionals. This is why I are such a danger. On the other hand, I can speak the language well. I can learn to become completely enthralled in their artistic culture. I can buy into the psychoanalytic theorizing, grappling with linguistic jargon, produces gross generalizations of culture. I have been torn about the language to use: stubbornly resisting the insidious discourse jargon that talks *around* the theory, rather than just coming out with it, the attempts to mask a simplistic theory, so as to make it inaccessible to those who are not part of the fray. I don't like the exercise. I have more pressing things to do in the real world.

Finally, and I'm not afraid to admit this, at one time, as many of us were, I was an idealist, a universalist. But I have for some time (even then) known of differences. Of course there are shared experiences—but there is joy in being different, and there are many manifestations of that difference. I must help out people (and I'm talking about black people) to realize that to be different is not negative, especially given what is found on the other side. I also ask what is this "other" that everyone is talking about? Are black people really the other? Does not having power make us the other? We must participate in the present structure, if only to change it in anyway we can, without being compromised.

**SANDRA ROWE:** I graduated from UC Irvine in 1980, and in my last year, I went to the school psychologist to figure how to get through as the only black student at Irvine in art. I was trying to maintain my unity as an African-American woman, and also buying into what was being talked about as formalist concerns, and making work that was hiding my will and tension. The notion of refusal has affected me greatly. When I was at Irvine it was an indicator of success if your work as an artist was written about—particularly in a positive way.

My first *Los Angeles Times* review in 1980 was as if some one had chewed me up and spit me out. It was not a very pleasant experience. Finally, I realized—who cares? Walking down the street in Riverside, California, no one in this world knew who I was. Most often, we are written about in major publications by white critics, if they remember to include us. In the past, and too often in the present, they place us, they put us, they describe us, and they do all of this according to mainstream standards. They use mainstream measurements to talk about us. There is always this notion of the other, by which we are measured. Now has that affected me?

Particularly when I was at Irvine, and when I was at Cal State Fresno, I had to seek information about artists of color because I was not told about African American artists. I was not told about Asian artists. I was not told about Latin American artists. I sought this information for myself.

I realize that vision is an individual thing. I do believe that strong work is strong work. But if we are considered to be the other, and then ghettoized by that notion of the other, the language used to describe our work is not inclusive. The idea of ghettoization precludes accurate comments about our art.

I still happen to have a 1988 review of my work. I usually toss all the bad reviews but this one I find particularly interesting because this woman got it wrong in 1988 and she got it wrong in 1992. There is a National Black Arts Festival that has been organized in the last few years—and it is a big, big thing in Atlanta.

56 + 57

DESIGNER: Haley Johnson, *Minneapolis, Minnesota* TYPOGRAPHIC SOURCE: In-house STUDIO: Olson Johnson Design Co. CLIENT: Jane Jenni Representative PRINCIPAL TYPES: Frutiger and Times Roman DIMENSIONS: 7¼ x 10 in. (18.4 x 25.4 cm)

brochure

DESIGNER: Joy Panos Stauber, *Chicago, Illinois* TYPOGRAPHIC SOURCE: In-house CLIENTS: Joy Panos and James Stauber PRINCIPAL TYPES: Franklin Gothic and Futura DIMENSIONS: 4⅝ x 6¼ in. (11.7 x 15.9 cm)

announcement

DESIGNERS: Steven Tolleson
and Mark Winn, *San Fran-
cisco, California* TYPOGRAPHIC
SOURCE: In-house STUDIO:
Tolleson Design CLIENT: Cot-
tong & Taniguchi PRINCIPAL
TYPES: Liberty and Rotis Sans
Serif DIMENSIONS: 3 x 5 in. (7.6
x 12.7 cm)

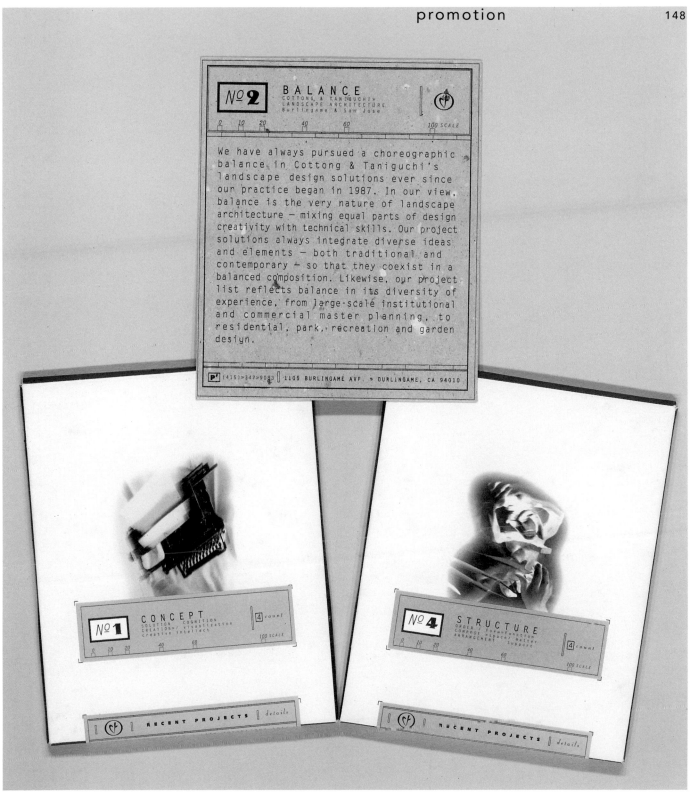

poster

DESIGNER: Anita Meyer, *Boston, Massachusetts* POSTER SILKSCREEN: Arabesque Studio Ltd. TAG OFFSET OVERPRINT: Alpha Press POSTER ASSEMBLY: Daniels Printing Company PRODUCTION COORDINATOR: Susan McNally LECTURE COORDINATOR: Peter Rose TYPOGRAPHIC SOURCE: In-house STUDIO: plus design inc. CLIENT: Alcan Aluminum Ltd. PRINCIPAL TYPES: Antique Typewriter and antique stencils DIMENSIONS: 7 x 14 in. (17.8 x 35.6 cm)

149

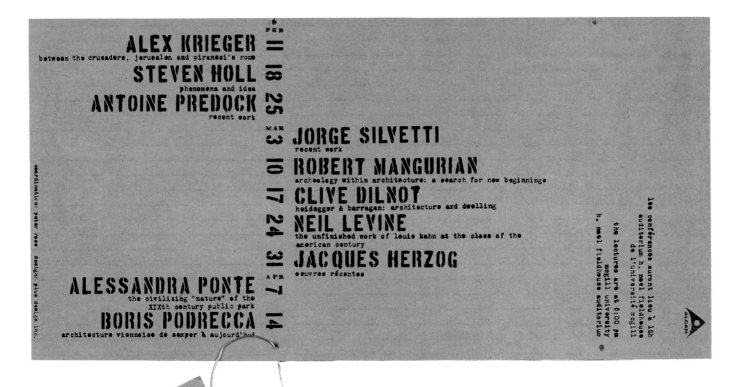

DESIGNERS: Neil Powell and
Kobe, *Minneapolis, Minnesota*
TYPOGRAPHIC SOURCE: P & H
Colorwork STUDIO: Duffy Inc.
CLIENT: Duffy Inc. PRINCIPAL
TYPES: Prestige Elite, Trade
Gothic, and Letter Gothic
DIMENSIONS: Various

DESIGNER: Hartmut Schaar-
schmidt, *Hennef, Germany*
TYPOGRAPHIC SOURCE: In-house
STUDIO: Hartmut Schaar-
schmidt CLIENT: Hartmut
Schaarschmidt PRINCIPAL TYPE:
Avenir DIMENSIONS: 4⅛ x 5¹³⁄₁₆
in. (10.5 x 14.8 cm)

DESIGNERS: Jeffrey Keyton,
Stacy Drummond, and Stephen
Byram, *New York, New York*
TYPOGRAPHIC SOURCE: In-house
STUDIO: MTV: Music Television
CLIENT: MTV: Music Television
PRINCIPAL TYPE: Trade Gothic
DIMENSIONS: 10 x 13 in. (25.4 x
33 cm)

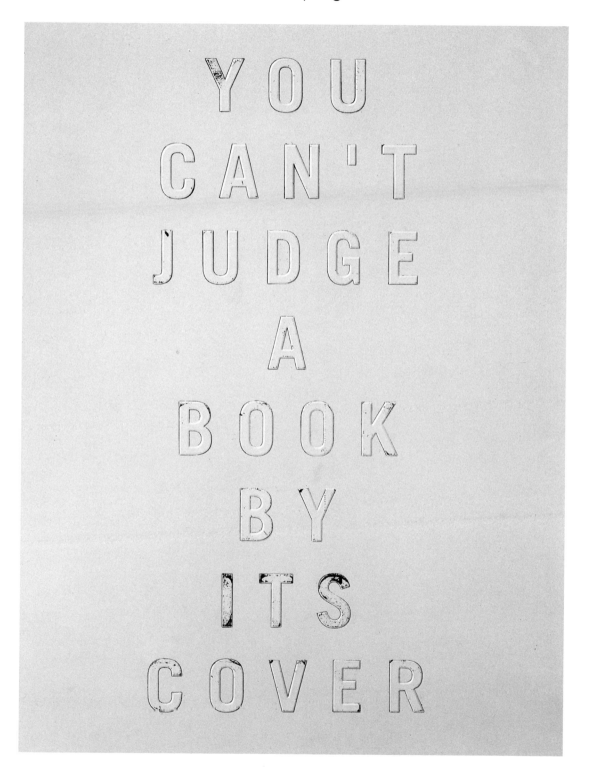

DESIGNER: Darin Beaman, *Pasadena, California* TYPOGRAPHIC SOURCE: In-house STUDIO: Art Center College of Design, Design Office CLIENT: Art Center College of Design PRINCIPAL TYPE: Franklin Gothic DIMENSIONS: 12¼ x 8½ in. (31.1 x 21.6 cm)

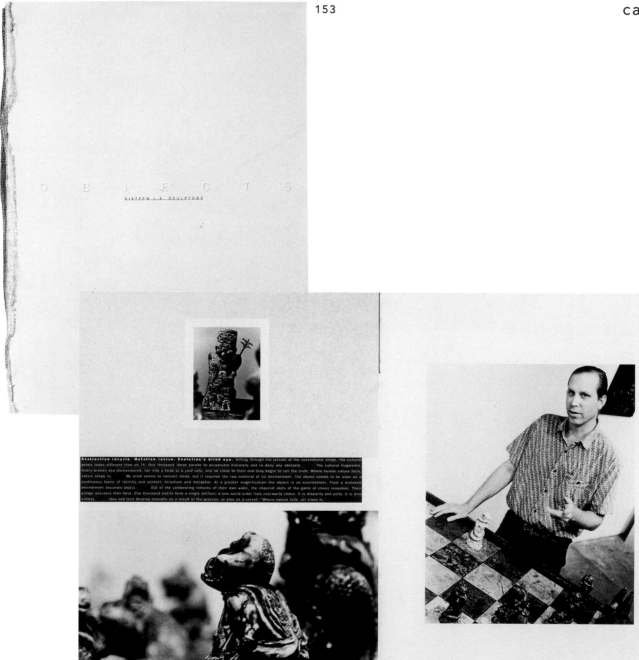

DESIGNERS: Fritz Gottschalk and Andreas Gossweiler, *Zürich, Switzerland* TYPO-GRAPHIC SOURCE: BuchDruck-erei Richterswil AG STUDIO: Gottschalk + Ash International CLIENT: ProLitteris PRINCIPAL TYPE: Bodoni DIMENSIONS: 9¹⁄₁₆ x 12⅝ in. (23 x 32 cm)

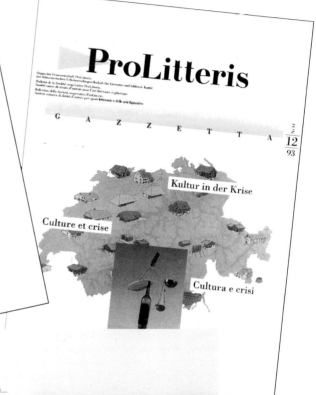

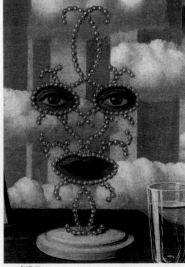

DESIGNER: Rebeca Méndez, *Pasadena, California* TYPO-GRAPHIC SOURCE: In-house, Japan Graphics, and Toyo Printing Company STUDIO: Art Center College of Design, Design Office CLIENT: Art Center College of Design PRINCIPAL TYPE: Univers DIMENSIONS: 6 x 9 in. (15.2 x 22.9 cm)

DESIGNER: Joseph D.R. O'Leary, *Minneapolis, Minnesota* TYPOGRAPHIC SOURCE: In-house STUDIO: Veto Design CLIENT: Minneapolis College of Art and Design PRINCIPAL TYPES: OCR-B, Glypha, and Cochin DIMENSIONS: 10⅜ x 16 in. (26.3 x 40.6 cm)

catalog 160

DESIGNER: Martin Venezky, *San Francisco, California* LETTERER: Martin Venezky TYPOGRAPHIC SOURCE: In-house STUDIO: Cranbrook Academy of Art CLIENT: Martin Venezky PRINCIPAL TYPES: Trade Gothic and handlettering DIMENSIONS: 11 x 17 in. (27.9 x 43.2 cm)

promotion

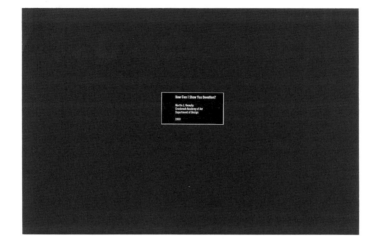

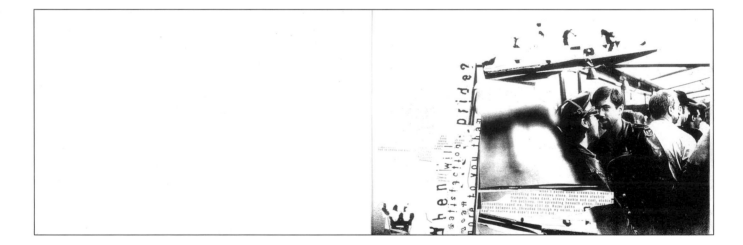

DESIGNERS: Robert Petrick, Laura Ress, and Michael Golec, *Chicago, Illinois* TYPOGRAPHIC SOURCE: In-house AGENCY: Petrick Design CLIENT: Design Industry Foundation for AIDS (DIFFA) PRINCIPAL TYPES: OCR-B and Futura Bold Condensed DIMENSIONS: 6 x 6 in. (15.2 x 15.2 cm)

# DIFFA/Chicago...

From then to now...

**1989** Co-chairs of the Chicago Steering Committee - Larry Deutsch and Gita Gidwani... Our first major event *Brazil* chaired by Dan DuBay and held at Holly Hunt's estate netted $167,000... DIFFA/Chicago opens its office in space donated by The Merchandise Mart... HeartStrings is presented at the Chicago Theater starring Sandy Duncan and Bill Cobbs, co-chaired by Linda Bartlett and Joe McElroy, netted $72,000.
**1990** Chair of the Chicago Steering Committee - Lois Mills... Nena Ivon and Dan DuBay co-chair *The Carnival Ball* and net $212,000... An opening party at the new Crate & Barrel store raises $10,000.
**1991** Co-chairs of the Chicago Steering Committee - Kim Winzeler and Dan DuBay... The 18th Floor Showrooms at The Mart sponsor *Celebreighteen* and raise $7,500....*Venice-A Masked Ball* nets $294,000 under the direction of co-chairs Nena Ivon and Michael V. Hasten... DIFFA/Chicago becomes an official chapter and elects its first Board of Trustees, chaired by Linda Bartlett... Claire Holland and Terri D'Ancona plan *Oak Street on Location* which raises $20,000... Mike and Donna Bell and Claire Holland organize a preview showing of the new Cole Haan store on Michigan Avenue and raise $20,000.
**1992** The DIFFA/Chicago Fellowship at Northwestern Memorial Hospital is established... *Designers Garage Sale* organized by John Cannon raises $75,000... *Tout Francais*, chaired by Trudy Schwartz and Richar nets $283,000... *Barneys New York* comes to Oak Street and its opening party raises $47,000.
**1993** Joe McElroy and Neiman Marcus host *Giorgio Armani Le Collezioni* and raise $5,000... And now *An All American Ball*... and to come *Designers Garage Sale II.*

## Grants

DIFFA/Chicago is a not-for-profit fundraising and grantmaking foundation that distributes funds to Chicago's AIDS service agencies who provide assistance to men, women and children affected by AIDS and HIV-related illnesses. Since 1987, DIFFA/Chicago has awarded grants in excess of $900,000.

We are pleased to have awarded grants to the following:

AIDS Alternative Health Project, AIDS Legal Council of Chicago, AIDS Pastoral Care Network, Better Existence with HIV (BE-HIV), Bonaventure House, Chicago House, Chicago Women's AIDS Project, Children's Memorial Hospital, Children's Place Association, Community Response, Families' and Children's AIDS Network, Gateway Foundation, Genesis House, Harbor Home Support Services, HealthWorks Theatre, Hektoen Institute, Horizon Hospice, Inc., Horizons Community Services, Inc., Howard Brown Memorial Clinic, Illinois Masonic Hospital, Michael Reese Hospital, Northwestern Memorial Hospital, Open Hand Chicago, Roger Baldwin Foundation of ACLU, Inc., St. Catherine of Genoa, STOP AIDS Chicago, Test Positive Aware Network

In addition, we have established The DIFFA/Chicago Fellowship at Northwestern Memorial Hospital for the support of a board-certified physician to provide treatment to patients with AIDS and HIV at NMH's clinical facilities. The first recipient of this fellowship is Dr. Peter F. Bornstein.

DESIGNER: Uwe Loesch, *Düssel-
dorf, Germany* LETTERER: Uwe
Loesch TYPOGRAPHIC SOURCE:
In-house STUDIO: Uwe Loesch
CLIENT: Ruhrlandmuseum
Essen PRINCIPAL TYPE: Franklin
Gothic DIMENSIONS: 33$\frac{1}{16}$ x
46$\frac{7}{8}$ in. (84 x 119 cm)

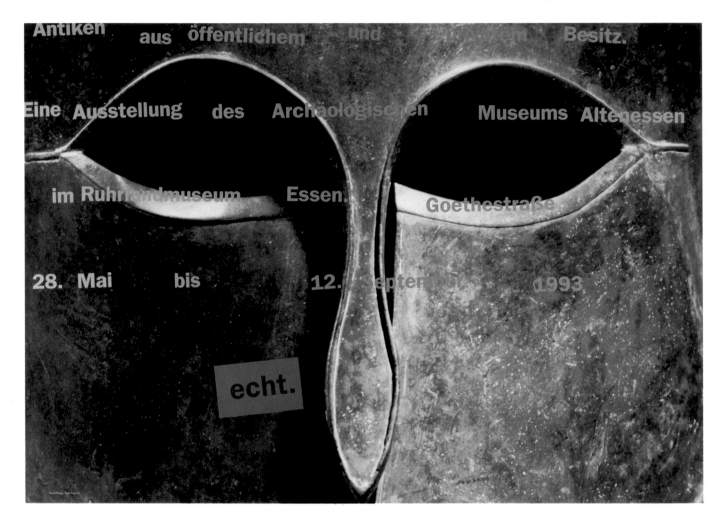

DESIGNER: Helfried Hagen-
berg, *Düsseldorf, Germany*
TYPOGRAPHIC SOURCE: Jöschli
STUDIO: Helfried Hagenberg
CLIENT: Fachbereich Design,
Fachhochschule Düsseldorf
PRINCIPAL TYPES: Futura and
Garamond DIMENSIONS: 33¹⁄₁₆
x 23²⁄₅ in. (84 x 59.4 cm)

DESIGNERS: Dann De Witt, David Cecchi, and Kevin Grady, *Northampton, Massachusetts* TYPOGRAPHIC SOURCE: In-house STUDIO: De Witt Anthony Inc. CLIENT: Reebok International Ltd. PRINCIPAL TYPE: Bastardville DIMENSIONS: 11 x 14 in. (27.9 x 35.6 cm)

brochure

DESIGNERS: Bruce Mau and Nigel Smith, *Toronto, Canada* TYPOGRAPHIC SOURCE: Archetype STUDIO: Bruce Mau Design Inc. CLIENT: The Getty Center for the History of Art and the Humanities PRINCIPAL TYPES: Baskerline and Alpha Gothic Extended DIMENSIONS: 7½ x 10¼ in. (19.1 x 26 cm)

DESIGNER: Haley Johnson, *Min-neapolis, Minnesota* TYPO-GRAPHIC SOURCE: In-house STUDIO: Olson Johnson Design Co. CLIENT: Haley Johnson PRINCIPAL TYPE: Monaco DIMENSIONS: Left: 3⅞ x 3 in. (9.8 x 7.6 cm) Right: 3⅞ x 9 in. (9.8 x 22.9 cm)

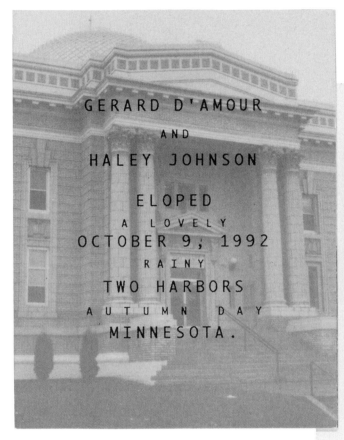

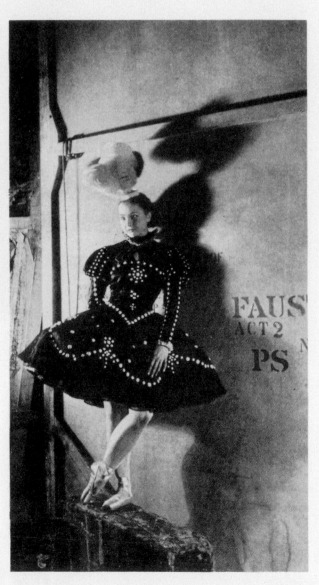

DESIGNER: Todd Waterbury, *Portland, Oregon* TYPO-GRAPHIC SOURCE: Personal collection STUDIO: Bloomingdale's CLIENT: Bloomingdale's PRINCIPAL TYPES: Alternate Gothic No. 51 and Remington typewriter DIMENSIONS: 21 x 27 in. (53.4 x 68.6 cm)

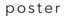 

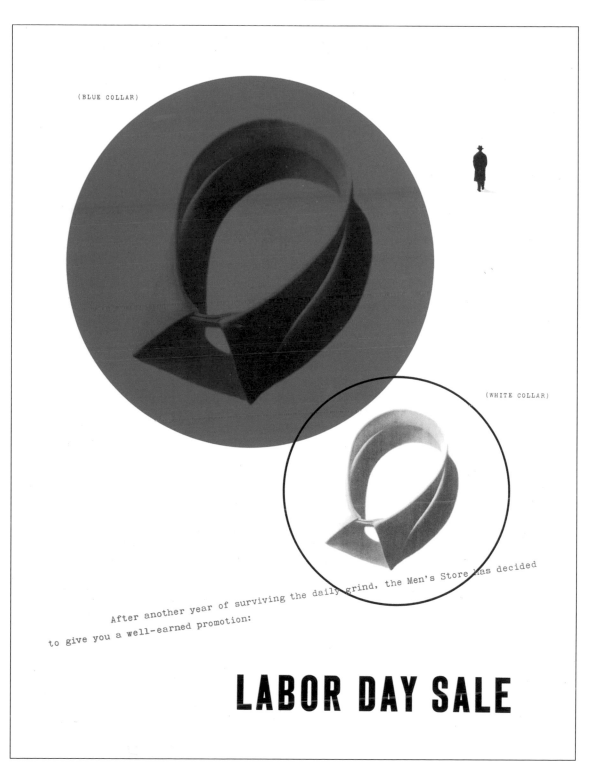

DESIGNERS: Yoichirou Fujii and Hiroyuki Suzuki, *Tokyo, Japan* LETTERER: Yoichirou Fujii AGENCY: Slow Hand Corp. STUDIO: Yoichirou Fujii Design Studio CLIENT: Slow Hand Corp. PRINCIPAL TYPE: Franklin Gothic DIMENSIONS: 23⅜ x 16½ in. (59.4 x 42 cm)

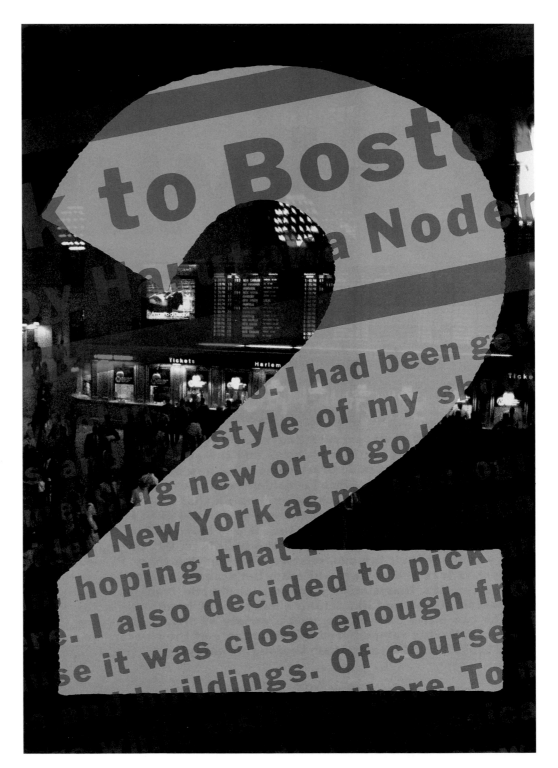

DESIGNER: Dino Paul, *Phoenix,*
*Arizona* LETTERER: Dino Paul
TYPOGRAPHIC SOURCE: In-house
STUDIO: After Hours CLIENT:
After Hours PRINCIPAL TYPE:
Futura Bold DIMENSIONS: 8½ x
11 in. (21.6 x 27.9 cm)

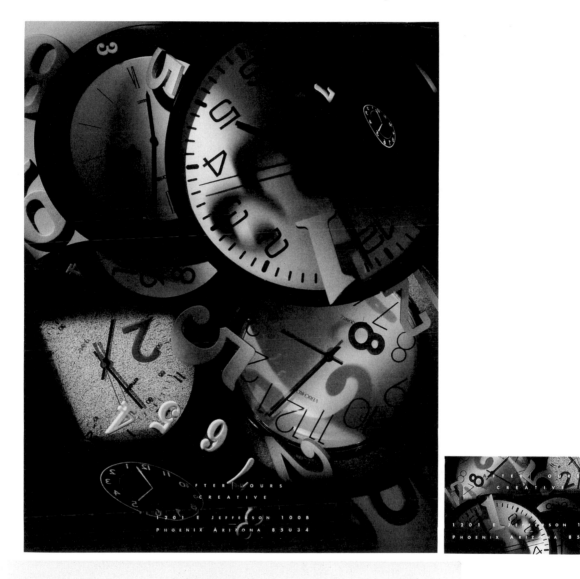

DESIGNERS: Steven Tolleson and Jennifer Sterling, *San Francisco, California* TYPOGRAPHIC SOURCE: In-house STUDIO: Tolleson Design CLIENT: Confetti by Fox Paper Company PRINCIPAL TYPES: Serifa, Cochin, Snell Roundhand, and Memphis DIMENSIONS: 7 x 9 in. (17.8 x 22.9 cm)

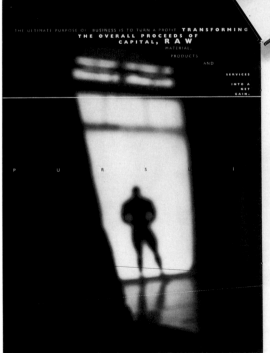

DESIGNER: Andreas Com-
büchen, *New York, New York*
JUNIOR DESIGNER: Hans Neu-
bert CREATIVE DIRECTORS:
Aubrey Balkind and Kent
Hunter TYPOGRAPHIC SOURCE:
In-house AGENCY: Frankfurt
Balkind Partners CLIENT:
EG&G, Inc. PRINCIPAL TYPES:
Courier, Monaco, and Univers
DIMENSIONS: 9 x 11¼ in. (22.9 x
28.6 cm)

172 annual report

Annual Report 1992

EG&G

data blitz p. 30

p. 20 stage 3

p. 36 smart

clean up p. 40

p. 32 zero

# noise

More than nine million Americans are exposed to hazardous levels of
noise on the job, according to the Environmental Protection Agency.
Another 90 million are adversely affected by neighborhood noises.
The consequences of excessive noise were recently enumerated by New York
magazine. In addition to causing impaired hearing, the magazine reported
that noise can trigger increases in heart rate, blood pressure, adrena-
line flow, respiration and, above all, stress. In one Manhattan school,
students in classrooms that looked out on an elevated railroad had lower
reading skills than students on the quiet side of the building.

| Source of Noise | Decibels |
|---|---|
| Rocket launching pad | 180 |
| Jet plane take-off | 140 |
| Gunshot blast | 140 |
| Jackhammer, chainsaw | 130 |
| Firecracker (at 15 feet) | 130 |
| Automobile horn | 120 |
| Rock band | 120 |
| Sandblasting | 112 |
| Woodworking shop | 100 |
| Pneumatic drill | 100 |
| Subway | 90 |
| Food blender | 90 |
| Hair dryer | 80 |
| Conversational speech | 66 |
| Soft whisper | 30 |
| Leaves rustling | 10 |

Noises over 140 decibels
cause pain.

Long exposure to noises over
90 decibels may eventually cause
some loss of hearing.

## stage 3

According to Technology Review, a Dutch study in the mid-1970s revealed
that people who lived near Amsterdam's Schiphol Airport used sleeping
medications and drugs for cardiovascular disorders at a rate far above
normal. Since then, airports have become much quieter -- but not as
quiet as they will be by the end of the decade.
Planes built without any noise constraints, known as Stage 1 aircraft,
have been phased out completely by the Federal Aviation Administration.
Stage 2 aircraft, which were certified after 1975, were the first gen-
eration of planes with noise controls; they represent the bulk of
today's civil fleets. Stage 3 planes satisfy the most stringent noise
standards currently in force. By the year 2000, all planes will have to
meet Stage 3 standards. This will mean either scrapping Stage 2 planes,
re-engining them, or fitting their engines with hush kits -- a
multibillion-dollar endeavor.

-20-

For the past ten years, EG&G KT Aerofab has been the sole manufacturer of the jet-engine
exhaust systems (above) for the 737 series airliners, which meet Stage 3 noise levels.
EG&G is currently developing a number of sound-abating devices for an even quieter engine.

DESIGNERS: Peterhans Pfaff-
mann and Michael Schmidt,
*Stuttgart, Germany* TYPO-
GRAPHIC SOURCE: In-house
STUDIO: DesignWorX CLIENTS:
Stuttgarter Ballett and
Noverre Gesellschaft PRINCI-
PAL TYPES: Letter Gothic and
Frutiger DIMENSIONS: 11⅞ x
11⅞ in. (30 x 30 cm)

book

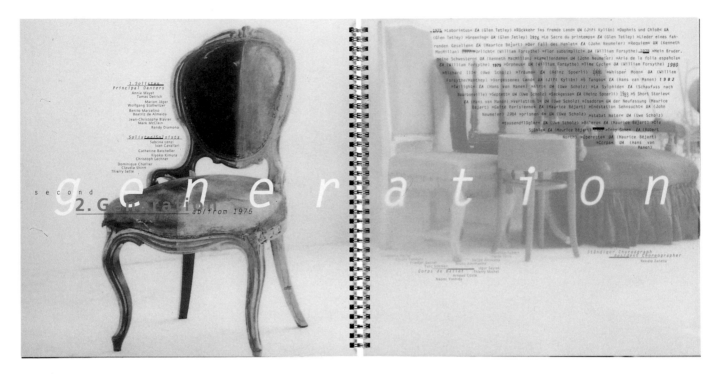

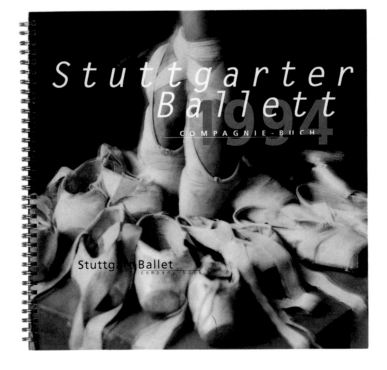

DESIGNER: Daniel Michael Flynn, *Albuquerque, New Mexico* TYPOGRAPHIC SOURCE: In-house STUDIO: Vaughn Wedeen Creative CLIENT: National Institutional Pharmacy Services, Inc. PRINCIPAL TYPES: Trade Gothic Bold, Futura Extra Bold, and Bodoni DIMENSIONS: 8½ x 11 in. (21.6 x 27.9 cm)

DESIGNER: David Covell, *Burlington, Vermont* CREATIVE DIRECTOR: Michael Jager TYPOGRAPHIC SOURCE: In-house STUDIO: Jager DiPaola Kemp Design CLIENT: Jager Di Paola Kemp Design PRINCIPAL TYPES: Din and News Gothic DIMENSIONS: 8½ x 11 in. (21.6 x 27.9 cm)

stationery

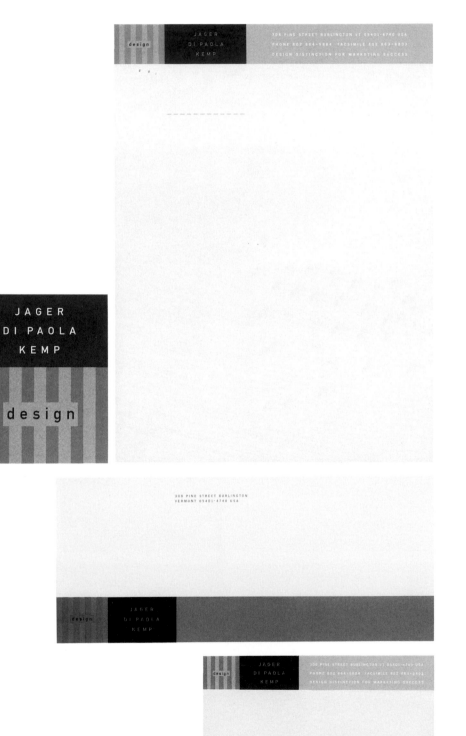

DESIGNERS: Jack Anderson, Leo Raymundo, and Scott Eggers, *Seattle, Washington*
TYPOGRAPHIC SOURCE: In-house
STUDIO: Hornall Anderson Design Works CLIENT: Mahlum & Nordfors McKinley Gordon
PRINCIPAL TYPE: Gill Sans
DIMENSIONS: 8½ x 11 in. (21.6 x 27.9 cm)

stationery

DESIGNER: Todd Waterbury, *Portland, Oregon* TYPOGRAPHIC SOURCE: In-house STUDIO: Bloomingdale's CLIENT: Bloomingdale's PRINCIPAL TYPE: Engraver's Gothic DIMENSIONS: 8½ x 11 in. (21.6 x 27.9 cm)

## stationery

DESIGNER: Uwe Loesch, *Düsseldorf, Germany* LETTERER: Uwe Loesch TYPOGRAPHIC SOURCE: In-house STUDIO: Uwe Loesch CLIENT: Centre d'art contemporain de Quimper PRINCIPAL TYPE: Futura DIMENSIONS: 8¼ x 11¹¹⁄₁₆ in. (21 x 29.7 cm)

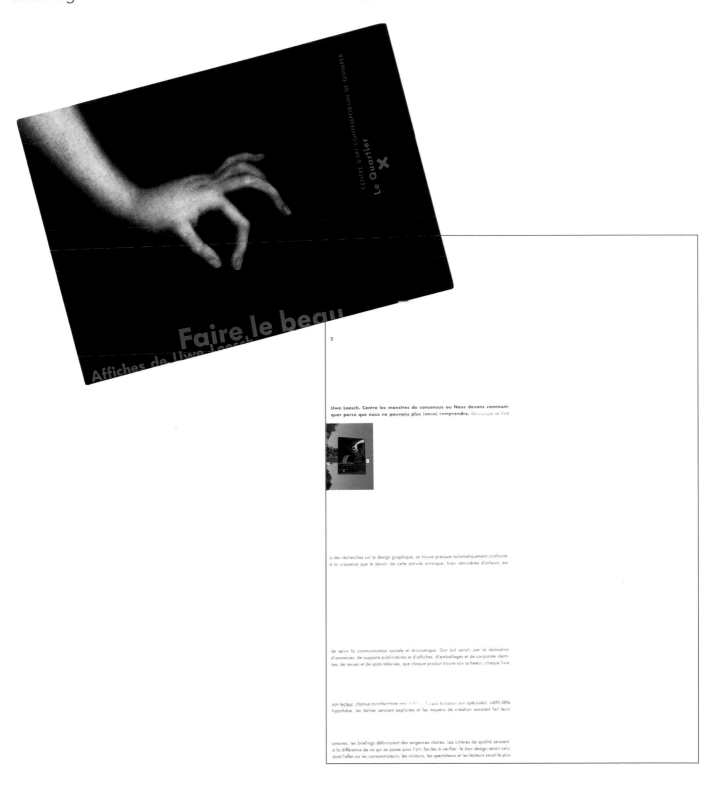

DESIGNERS: Jilly Simons and
Susan Carlson, *Chicago, Illinois*
TYPOGRAPHIC SOURCE: In-house
STUDIO: **Concrete** CLIENT:
**Hinge** PRINCIPAL TYPE: **Letter
Gothic** DIMENSIONS: 8½ x 11
in. (21.6 x 27.9 cm)

179

**stationery**

DESIGNERS: Clifford Stoltze,
Peter Farrell, and Rebecca
Fagan, *Boston, Massachusetts*
TYPOGRAPHIC SOURCE: In-house
STUDIO: Stoltze Design CLIENT:
Stoltze Design PRINCIPAL
TYPES: New Baskerville, 'uck-n-
pretty, Shelley Script, Lino-
script, Fette Fraktur, and
Cooper Black DIMENSIONS: 6 x
4¼ in. each (15.2 x 10.8 cm)

DESIGNER: Marcus Dorau, *Düsseldorf, Germany* ART DIRECTOR: Klaus Hesse TYPOGRAPHIC SOURCE: In-house AGENCY: Hesse Designagentur CLIENT: Immobilienkontor PRINCIPAL TYPES: Frutiger and Walbaum DIMENSIONS: 11⅛ x 6⅛ in. (28.4 x 15.6 cm)

**Standort und Standpunkt**
**Das Immobilienkontor im großen und ganzen**

**Was das Immobilienkontor für Einkaufs- und Geschäftszentren tun kann**

Centermanagement

Das Immobilienkontor vermietet und verkauft nicht nur Wohnungen und Gewerbeflächen, sondern verwaltet auch ganze Geschäfts- und Einkaufszentren. Schließlich sind auch der beste Standort und das beste Konzept noch keine Garantie für die langfristige Rentabilität eines Objekts. Das Center-Management sorgt deshalb nicht nur für den marktgerechten Branchenmix, kontrolliert Kosten und Erträge, erstellt Abrechnungen und Betriebsstatistiken, sondern dient auch als Ansprechpartner für Mieter, koordiniert Interessen und initiiert Werbegemeinschaften, organisiert Reinigung, Wartung und Bewachung oder regelt Versicherungsfälle und die Zusammenarbeit mit den Behörden.

22
Einkaufszentrum
„Dieterich Karree"
Düsseldorf
Duisburgerstraße
23
Passage
Einkaufszentrum
„Dieterich Karree"
24
Eingangsbereich
Spielwarenmarkt
„Toys'R'Us"

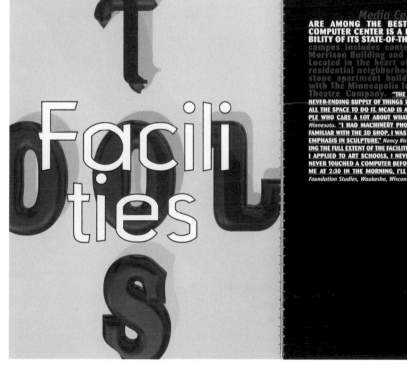

DESIGNER: P. Scott Makela, *Minneapolis, Minnesota* LETTERERS: P. Scott Makela, Alex Tylevich, and Eric Lin TYPOGRAPHIC SOURCE: In-house STUDIO: P. Scott Makela Words and Pictures for Business and Culture CLIENT: Minneapolis College of Art and Design PRINCIPAL TYPES: Barmeno, Calculus, and Tempe DIMENSIONS: 8½ x 11½ in. (21.6 x 29.2 cm)

DESIGNER: Detlef Behr, *Bonn, Germany* ART DIRECTOR: Detlef Behr CREATIVE DIRECTOR: Detlef Behr TYPOGRAPHIC SOURCE: In-house STUDIO: Detlef Behr, Büro für Kommunikationsdesign CLIENTS: PLAKATION Detlef Behr & Germar Wambach PRINCIPAL TYPE: Univers 75 DIMENSIONS: 23⅝ x 31½ in. (60 x 80 cm)

DESIGNER: Koeweiden/Postma,
*Amsterdam,* *Netherlands*
TYPOGRAPHIC SOURCE: In-house
STUDIO: Koeweiden/Postma
CLIENT: **Cineteam** PRINCIPAL
TYPE: KP Din

logotype 184

**cineteam**

DESIGNER: Koeweiden/Postma,
*Amsterdam, Netherlands*
TYPOGRAPHIC SOURCE: In-house
STUDIO: Koeweiden/Postma
CLIENT: Cineteam PRINCIPAL
TYPES: KP Din and Stone Serif
DIMENSIONS: 8¼ x 11¾ in. (21 x
29.8 cm)

DESIGNER: Doc Visser, *Amsterdam, Holland* LETTERER: Doc Visser TYPOGRAPHIC SOURCE: In-house STUDIO: Doc Visser/Harry Poortman Design Works CLIENT: Doc Visser/Harry Poortman Design Works PRINCIPAL TYPES: Schreibmaschinenschrift and Eurostile DIMENSIONS: Various

DESIGNER: Patrick Seymour, *New York, New York* TYPO-GRAPHIC SOURCE: In-house STUDIO: Patrick Seymour Graphic Design CLIENT: The Old Peconic Brewing Company, Ltd. PRINCIPAL TYPE: Syntax DIMENSIONS: 3¾ x 3¾ in. (9.5 x 9.5 cm)

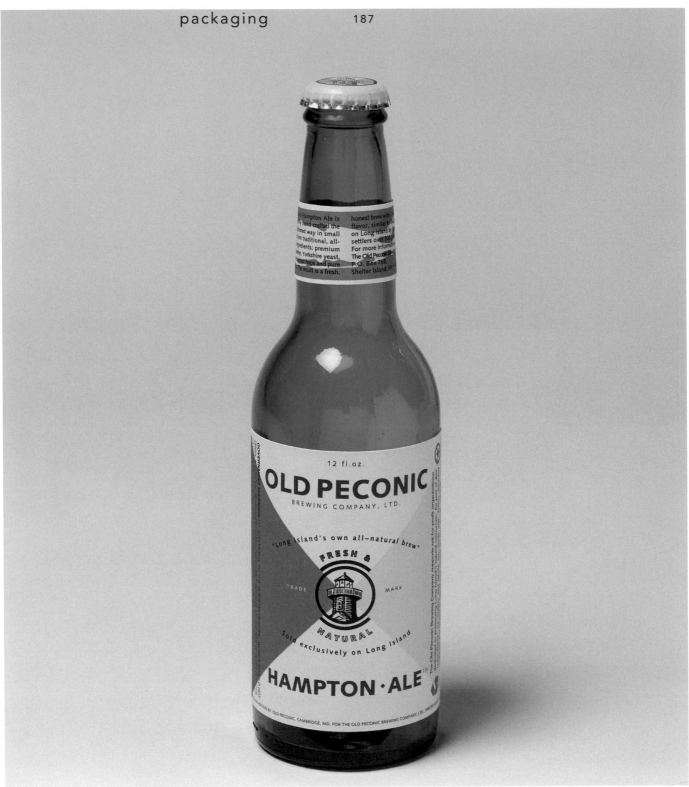

DESIGNER: Renate Gokl,
*Urbana, Illinois* TYPOGRAPHIC
SOURCE: In-house CLIENT:
Krannert Art Museum PRINCI-
PAL TYPE: News Gothic DIMEN-
SIONS: 9 x 12 in. (22.9 x
30.5 cm)

catalog

AL **HELD**

ITALIAN WATERCOLORS

18 · 19

**desegno intendiamo
essere profili et
contorni che nella
cosa se contene***

**Maarten van de Guchte: Talking
about drawing and design in a wider sense: Does the
drawing exist in your mind before you set out on a
new watercolor?**
Al Held: No, no, it doesn't exist in my
mind at all. These drawings evolve the way the paint-
ings evolve. There's a lot of erasure in drawings, but
unlike Piero who used to work with the golden section,
I don't do that at all. Mine is more of an instinctive
approach. I would like to sometime but I don't have
the discipline to do it.
**Within the watercolors you have
clearly visible pencil lines, pentimenti in the Ren-
aissance sense. They are quite unlike your paintings
where you achieve that very smooth and polished
effect. Do you leave these lines there on purpose?**
They are not left on purpose; it's just that, first, it's
impossible to get them out, and secondly, they don't
seem to bother me. Otherwise I would try to do some-
thing about it. Once you put a color down on top or
near these lines, you can't erase it. The colors isolate
the lines.

* PIERO DELLA FRANCESCA, DE PROSPECTIVA PINGENDI, 1459-65

VICTORIA XII
(35) - 26 1/4" BY 30 5/8"

DESIGNER: Scott Clum, *Silverton, Oregon* TYPOGRAPHIC SOURCE: In-house STUDIO: ride CLIENT: Morrow Snowboards PRINCIPAL TYPES: 'uck-n-pretty, Exocet Heavy, State, and hand-lettering DIMENSIONS: 8½ x 11 in. (21.6 x 27.9 cm)

DESIGNERS: Stefan Caesar and Marcus Dorau, *Düsseldorf, Germany* ART DIRECTOR: Klaus Hesse TYPOGRAPHIC SOURCE: In-house AGENCY: Hesse Designagentur CLIENT: Voss TV-Ateliers PRINCIPAL TYPE: Franklin Gothic DIMENSIONS: Various

corporate identity

DESIGNERS: David Richardson
and Tim Schumann, *Minneapo-
lis, Minnesota* TYPOGRAPHIC
SOURCE: In-house AGENCY: Kil-
ter Incorporated CLIENT: Kilter
Incorporated PRINCIPAL TYPE:
Frutiger DIMENSIONS: 8½ x 11
in. (21.6 x 27.9 cm)

stationery

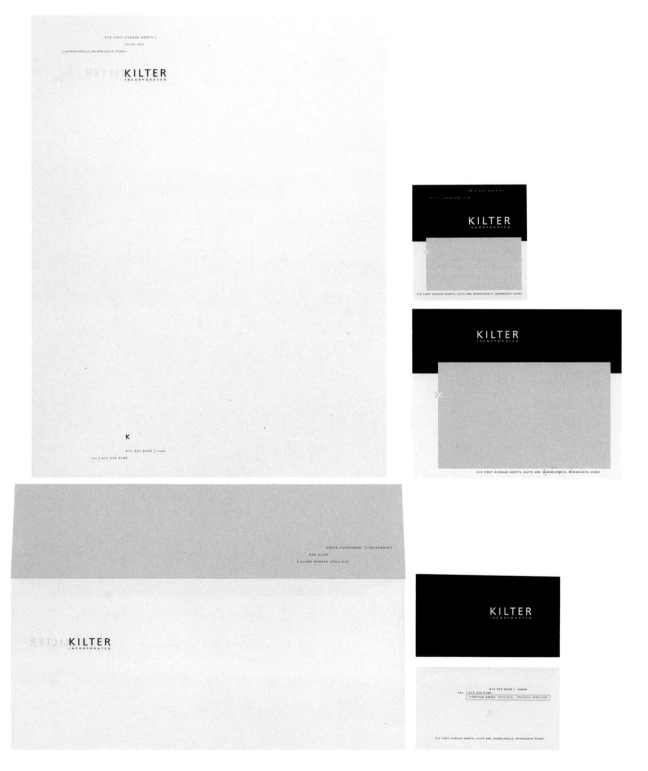

DESIGNER: Ruth Diener, *New York, New York* CALLIGRAPHER: Jeffrey Fisher CREATIVE DIREC-TORS: Aubrey Balkind and Kent Hunter AGENCY: Frankfurt Balkind Partners CLIENT: Comcast Corporation PRINCIPAL TYPE: Fisher Font

# Fisher

---

This is a showing of Fisher Roman.
A B C D E F G H I J K L M N O P Q R S T U V W X Y Z
a b c d e f g h i j k l m n o p q r s t u v w x y z
0 1 2 3 4 5 6 7 8 9
! $ & ' ' " " ; , . ? r g h l e

This is a showing of Fisher Italic.
A B C D E F G H I J K L M N O P Q R S T U V W X Y Z
a b c d e f g h i j k l m n o p q r s t u v w x y z
0 1 2 3 4 5 6 7 8 9
! $ & ' ' " " ; , . ?

This is a showing of Fisher Roman Bold.
A B C D E F G H I J K L M N O P Q R S T U V W X Y Z
a b c d e f g h i j k l m n o p q r s t u v w x y z
0 1 2 3 4 5 6 7 8 9
! $ & ' ' " " ; , . ? r g h l e

DESIGNER: Philip Stanton, *Barcelona, Spain* CALLIGRAPHER: Philip Stanton TYPOGRAPHIC SOURCE: In-house AGENCY: Stanton Studio S.L. CLIENT: City of Barcelona, Municipal Institute of Parks and Gardens PRINCIPAL TYPES: Handlettering and typewriter DIMENSIONS: Various

193

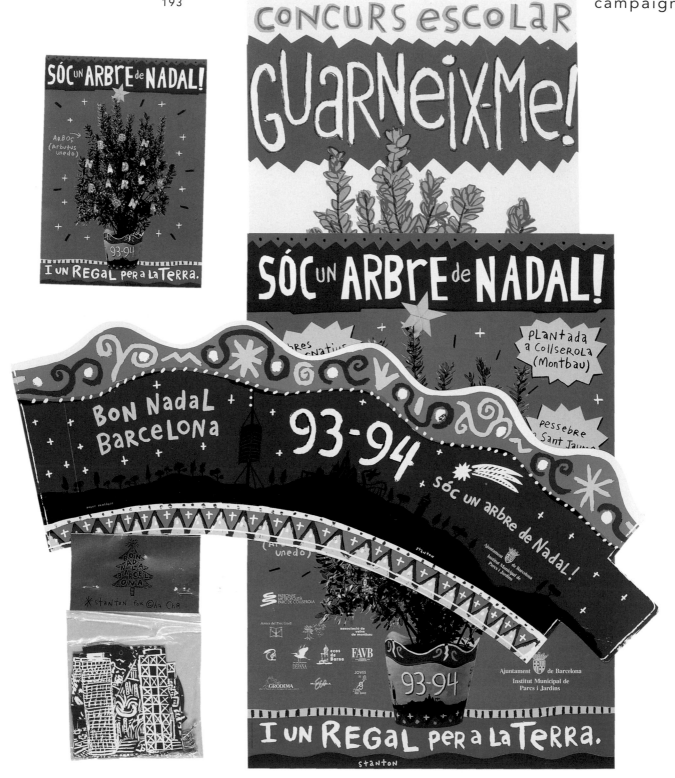

DESIGNERS: John Van Dyke and Ann Kumasaka, *Seattle, Washington* ART DIRECTOR: John Van Dyke TYPOGRAPHIC SOURCE: In-house STUDIO: Van Dyke Company CLIENT: Fox River Paper PRINCIPAL TYPE: Various DIMENSIONS: 6⅜ x 11 in. (16.2 x 27.9 cm)

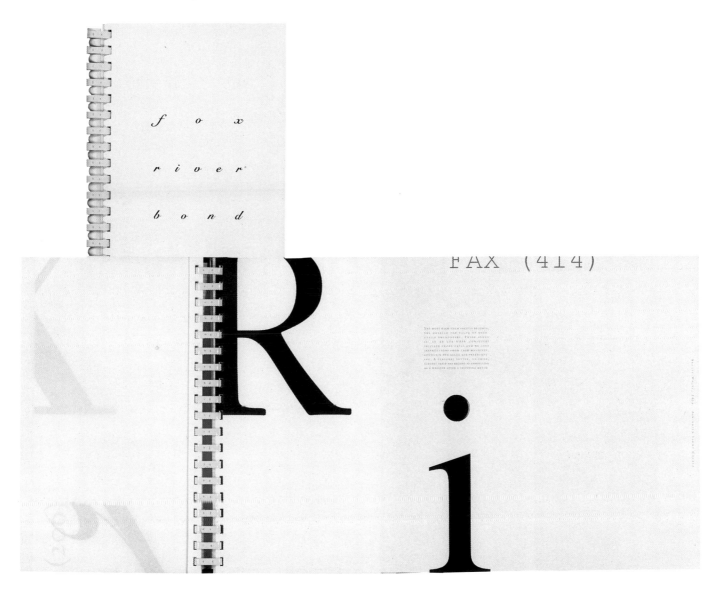

DESIGNERS: Lana Rigsby and
Troy S. Ford, *Houston, Texas*
TYPOGRAPHIC SOURCE: In-house
STUDIO: Rigsby Design, Inc.
CLIENT: The Contemporary
Arts Museum of Houston
PRINCIPAL TYPES: Bernhard
Modern, 45 Helvetica Light, 55
Helvetica Roman, and 95 Hel-
vetica Black DIMENSIONS: 8½ x
12 in. (21.6 x 30.5 cm)

catalog

DESIGNERS: Jim Williams and Eric Tilley, *Knutsford, Cheshire, England* TYPOGRAPHIC SOURCE: Ikon Communications AGENCY: The Consul CLIENT: The Creative Circle PRINCIPAL TYPES: Baskerville and Ad Grotesk DIMENSIONS: 10⁷⁄₁₆ x 9⁷⁄₁₆ in. (26.5 x 24 cm)

Volume **Eight**

*of* the
Creative Circle
Honours

[PRESIDENT'S AWARD]

It's hard trying to make it in advertising. Every obstacle, excuse and prejudice, is employed to grind down the creative mind into a submissive, complacent purveyor of ad pap.

The **Iron** Pen
*in the*
*Velvet*
Glove

To succeed you not only have to be brilliant, you have to be determined.

BARBARA NOKES embodies all of this as well as being a fine ambassador for the business. She made the transition from secretary to copywriter in an era when everything seemed possible during the birth of creative advertising in Britain. Her schooling in the *Doyle Dane Bernbach* and the *BMP* method of intelligent intrusive work brought early accolades.

**Hunky**

When she joined *John Hegarty* to found *BBH* she was very much under the spotlight to prove herself as a writer and leader. Needless to say she shone, with outstanding work for Dr Whites, remember the man dressed in woman's underwear which posed the question would a man understand periods better if he had them, and again an unconnected *Levis* ad where a young hunk strips down to his underwear in a launderette to wash his jeans to the sound of *Marvin Gaye's 'Heard It Through The Grapevine.'*

Now BARBARA is taking on the task of sole Creative Director at *CME.KHBB* where her leadership skills will be put to the test. Her admirers in advertising assume she will not be found wanting, in fact we await eagerly to see what she can do when she's been given her head.

SIX & SEVEN

DESIGNER: Tom Stvan, *New York, New York* TYPOGRAPHIC SOURCE: The Sarabande Press STUDIO: Department of Graphic Design CLIENT: The Museum of Modern Art PRINCIPAL TYPES: Bauer Bodoni and Univers DIMENSIONS: 5 x 7 in. (12.7 x 17.8 cm)

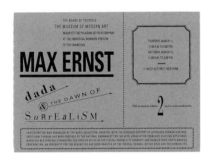 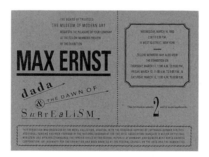 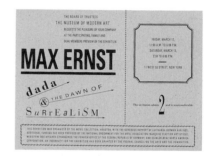

DESIGNERS: Jennifer Morla and Craig Bailey, *San Francisco, California* TYPOGRAPHIC SOURCE: In-house STUDIO: Morla Design CLIENT: San Francisco Airport Commission PRINCIPAL TYPES: Univers Black 75 and OCR-B DIMENSIONS: 9 x 9 in. (22.9 x 22.9 cm)

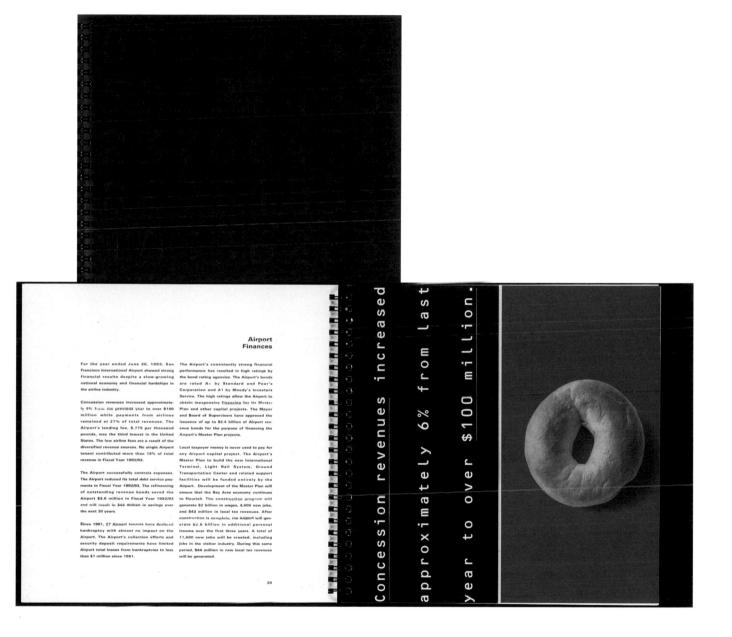

brochure

DESIGNER: Anita Meyer, *Boston, Massachusetts* CALLIGRAPHER: Jan Baker, *Providence, Rhode Island* COLLAGE: Anita Meyer, Nicole Juen, Carolina Senior, Veronica Majluf, Jan Baker, Matthew Monk, Daniels Printing Company, and Stacy Miyagawa PRINTER: Alpha Press SEWING: Elissa Della-Piania PROJECT COORDINATOR: Stacy Miyagawa PROJECT DIRECTOR: Julia Bloomfield TYPOGRAPHIC SOURCE: In-house STUDIO: plus design inc. CLIENT: The Getty Center for the History of Art and the Humanities PRINCIPAL TYPES: Letter Gothic and Emigré 8 DIMENSIONS: Folded: 5½ x 11 in. (14 x 27.9 cm) Unfolded: 11 x 33 in. (27.9 x 83.8 cm)

199

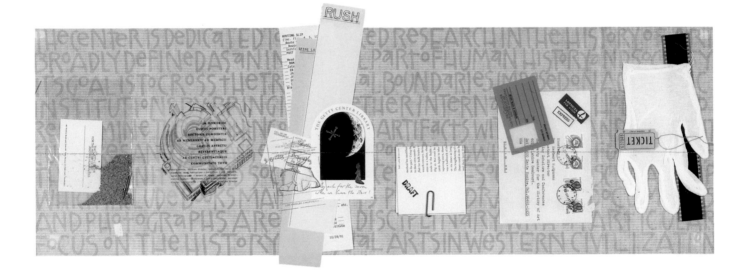

DESIGNER: Brian Schorn, *Bloomfield Hills, Michigan* AGENCY: Cranbrook Academy of Art STUDIO: Cranbrook Academy of Art Design Department CLIENT: Cranbrook Academy of Art PRINCIPAL TYPE: Addmorph

typeface                                    200

# ADDMORPH

---

A B C D E F G H I J K L M
N O P Q R S T U V W X Y Z

! $ % & ' ' " " ; , . ?

0 1 2 3 4 5 6 7 8 9

# WHAT'S THAT BUZZING?

THIS IS A SHOWING OF THE FONT ADDMORPH.
IT WAS SELECTED BY THE TDC40 JURY AS AN
OUTSTANDING ACHIEVEMENT IN FONT DESIGN.

DESIGNER: **Stephen Farrell,** *Chicago, Illinois* STUDIO: **Stephen Farrell Design** PRINCIPAL TYPE: **Missive**

# Missive

---

a b c d e f g h i j k l m

n o p q r s t u v w x y z

0 1 2 3 4 5 6 7 8 9

A B C D E F G H I J K L M

N O P Q R S T U V W X Y Z

! # $ % & * { } ' ' " " ¢ ¶ • ; " ' , . ?

Æ Œ Ø æ fi fl ı ø œ ß ł ¥ ƒ ¿ ¡

Ä Á À Â Å Ã Ç Ë È É Ê Ï Í Ì Î Ñ

Ö Ó Ò Ô Õ Ü Ú Ù Û Ÿ ä á à â å ã ç ë é è ê ï í ì î ñ ö ó ò ô õ ü ú ù û ÿ

ſ ç ð ´ © · ^ Δ ° ¬ µ ¯ π ® ß ‡ ¨ √ Σ ≈ Ω ¡ ™ ∞ § ¶ • a o

What's that buzzing? This is a showing of the font Missive. It was selected by the TDC40 jury as an outstanding achievement in font design.

DESIGNER: Stephen Farrell,
*Chicago, Illinois* STUDIO:
Stephen Farrell Design PRINCI-
PAL TYPE: Osprey

# OSPREY

A B C D E F G H I J K L M
N O P Q R S T U V W X Y Z

0 1 2 3 4 5 6 7 8 9

! # $ % & * { } ' ' " " ¢ ¶ · ; " ' , - ?

© ® ß † ¨ i ™ § Æ Œ œ ß ¥ ¿ ¡
À Á Â Ã Ä Å Ç Ë È É Ê Ï Î Í Ñ
Ò Ó Ô Õ Ö Ù Ú Û Ü

## WHAT'S THAT BUZZING?

THIS IS A SHOWING OF THE FONT OSPREY.
IT WAS SELECTED BY THE TDC 40 JURY AS AN
OUTSTANDING ACHIEVEMENT IN FONT DESIGN.

DESIGNERS: Keisuke Unosawa, Mitsuhiro Kanaya, and Reiko Hada, *Tokyo, Japan* LETTERER: Keisuke Unosawa ART DIRECTOR: Keisuke Unosawa TYPOGRAPHIC SOURCE: In-house STUDIOS: Q-Tec, Inc. and Keisuke Unosawa Design CLIENT: Keisuke Unosawa PRINCIPAL TYPES: Futura Extra Bold and handlettering

203    video message

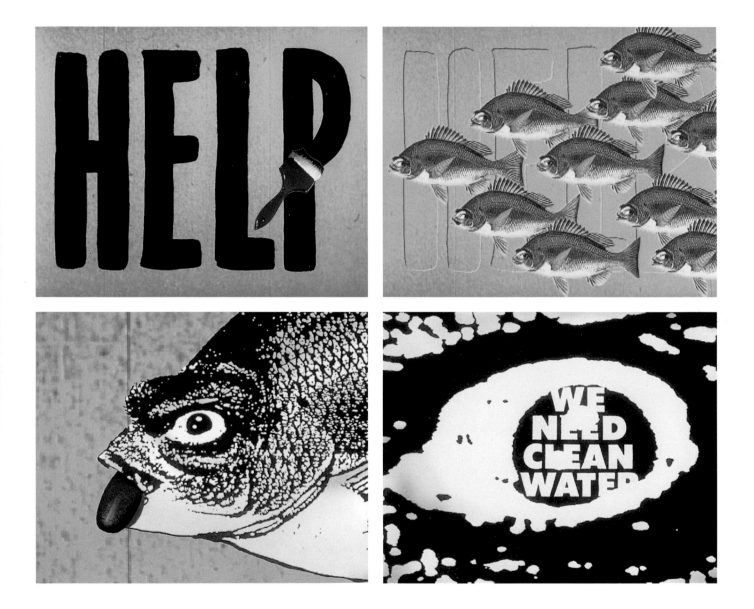

DESIGNER: Claud Cafengiu, *New York, New York* LETTERER: Claud Cafengiu PRINTER: Peder Press TYPOGRAPHIC SOURCE: Robert Wakeman and Luis Dalomba STUDIO: type Wreckognition CLIENT: type Wreckognition PRINCIPAL TYPES: Futura Bold and Univers DIMENSIONS: 8½ x 11 in. (21.6 x 27.9 cm)

DESIGNER: Koeweiden/Postma,
*Amsterdam,      Netherlands*
TYPOGRAPHIC SOURCE: In-house
STUDIO:   Koeweiden/Postma
CLIENT: Gemma Veel PRINCIPAL
TYPES:   Matrix  Script  and
Lunatix DIMENSIONS: 8¼ x 11¾
in. (21 x 29.8 cm)

stationery

DESIGNER: Mark-Steen Adamson, *London, England* ART DIRECTORS: John Sorrell and Frances Newell TYPOGRAPHIC SOURCE: In-house AGENCY: Newell and Sorrell CLIENT: *The Cartoonist* PRINCIPAL TYPE: Wood Block

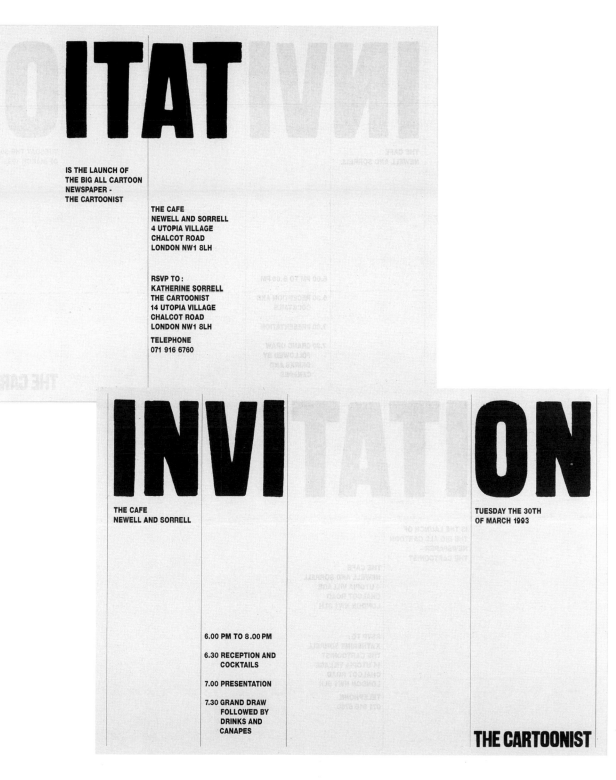

DESIGNERS: Maureen Erbe and
Rita A. Sowins, *Los Angeles,
California* TYPOGRAPHIC
SOURCE: In-house STUDIO:
Maureen Erbe Design CLIENT:
Chronicle Books, San Francisco
PRINCIPAL TYPES: Gill Sans and
Shelley DIMENSIONS: 10 x 9⅝
in. (25.4 x 24.4 cm)

## board of directors 1993/94

| | |
|---|---|
| president | Allan Haley |
| vice president | Kathie Brown |
| secretary/treasurer | B. Martin Pedersen |
| directors-at-large | Ed Colker |
| | Cynthia Hollandsworth |
| | Gerard Huerta |
| | Mara Kurtz |
| | Dirk Rowntree |
| | Mark Solsburg |
| | Ilene Strizver |
| chairperson, board of directors | Ed Benguiat |

## board of directors 1994/95

| | |
|---|---|
| president | B. Martin Pedersen |
| vice president | Mara Kurtz |
| secretary/treasurer | Mark Solsburg |
| directors-at-large | Kathie Brown |
| | Ed Colker |
| | Cynthia Hollandsworth |
| | Gerard Huerta |
| | Daniel Pelavin |
| | Dirk Rowntree |
| | Ilene Strizver |
| chairperson, board of directors | Allan Haley |

## committee for TDC 40

| | | |
|---|---|---|
| chairperson | Dirk Rowntree | |
| designer | ReVerb | |
| coordinator | Carol Wahler | |
| assistant coordinator | Klaus Schmidt | |
| calligrapher | Robert Boyajian | |
| assistants to judges | Peter Bain | Martin Solomon |
| | Adam Greiss | Mark Solsburg |
| | Bonnie Hazelton | Ilene Strizver |
| | Cheryl Miller-Schwartz | Allan R. Wahler |
| | Eric Neuner | Nancy Wahler |
| | Alexa Nosal | Samantha Wahler |
| | Nancy Romano | David Weil |
| | Agatha Sohn | Michelle Winters |

## TDC presidents

Frank Powers 1946 1947
Milton Zudeck 1948
Alfred Dickman 1949
Joseph Weiler 1950
James Secrest 1951 1952 1953
Gustave Saelens 1954 1955
Arthur Lee 1956 1957
Martin Connell 1958
James Secrest 1959 1960
Frank Powers 1961 1962
Milton Zudeck 1963 1964
Gene Ettenberg 1965 1966
Edward Gottschall 1967 1968
Saadyah Maximon 1969
Louis Lepis 1970 1971
Gerard O'Neill 1972 1973
Zoltan Kiss 1974 1975
Roy Zucca 1976 1977
William Streever 1978 1979
Bonnie Hazelton 1980 1981
Jack George Tauss 1982 1983
Klaus F. Schmidt 1984 1985
John Luke 1986 1987
Jack Odette 1988. 1989
Ed Benguiat 1990 1991
Allan Haley 1992 1993
B. Martin Pedersen 1994

## TDC medal recipients

Hermann Zapf 1967
R. Hunter Middleton 1968
Frank Powers 1971
Dr. Robert Leslie 1972
Edward Rondthaler 1975
Arnold Bank 1979
Georg Trump 1982
Paul Standard 1983
Herb Lubalin 1984 (posthumously)
Paul Rand 1984
Aaron Burns 1985
Bradbury Thompson 1986
Adrian Frutiger 1987
Freeman Craw 1988
Ed Benguiat 1989
Gene Federico 1991

## special citations to TDC members

Edward Gottschall 1955
Freeman Craw 1968
James Secrest 1974
Olaf Leu 1984 1990
William Streever 1984
Klaus F. Schmidt 1985
John Luke 1987
Jack Odette 1989

## 1994 scholarship recipients

Tae Chung, Pratt Institute
Jennifer Crupi, The Cooper Union
Heather Dega, School of Visual Arts
Teresa Yeung, Parsons School of Design

## international liaison chairpersons

### ENGLAND
David Quay
Studio 12
10-11 Archer Street
SoHo
London W1V 7HG

### FRANCE
Christopher Dubber
Signum Art
94, Avenue Victor Hugo
94100 Saint Maur Des Fosses

### GERMANY
Bertram Schmidt-Friderichs
Universitatsdruckerei und Verlag
H. Schmidt GmbH & Co.
Robert Koch Strasse 8
Postfach 42 07 28
55129 Mainz Hechtsheim

### JAPAN
Japan Typography Association
C C Center
4-8-15 Yushima
Bunkyo-ku
Tokyo 113

### MEXICO
Prof. Felix Beltran
Apartado de Correos
M 10733 Mexico 06000

### REPUBLIC OF SINGAPORE
Gordon Tan
The Fotosetter
41 Middle Road #40-00
Singapore 0718

### SOUTH AMERICA
Diego Vainesman
160 East 26 Street
New York, New York 10010

### SWEDEN
Ernst Dernehl
Dernehl & Son Designers
Box 8073
S-400 41 Goteborg

The new logo was designed by Gerard Huerta, Gerard Huerta Design, Inc., Southport, Connecticut. A lettering artist and designer as well as a TDC board member, he created the new logo as a modern interpretation of a classic monogram. Because of its simple design and round shape, it can be used in a wide variety of applications with equal facility.

The new logo is representative of the changes in the industry, but reflects the tradition TDC has enjoyed for more than half a century.

The familiar older TDC logo was designed by Freeman (Jerry) Craw in the 1950s for a lecture series. It has held the TDC in good stead since it was first drawn. The TDC Board of Directors had felt for some time that a new logo was needed to symbolize the organization's commitment to the future of typography.

Type Directors Club
60 East 42nd Street
Suite 721
New York, NY 10165
212-983-6042 FAX 212-983-6043

For membership information, please contact the Type Directors Club offices.

Carol Wahler, executive director

## TDC membership

212

Mary Margaret Ahern '83
Jim Aitchison '93
Victor Ang '91
Martyn Anstice '92
Hal Apple '94
Herman Aronson '92
Robin Gill Attaway '93
Peter Bain '86
Bruce Balkin '93
Maria Helena Ferreira Braga
  Barbosa '93s
Clarence Baylis '74
Felix Beltran '88
Ed Benguiat '64
Randall Bennett '94
Jesse Berger '92
Anna Berkenbusch '89
Peter Bertolami '69
Klaus Bietz '93
Roger Black '80
Anthony Bloch '88
Susan Cotler Block '89
Art Boden '77
Karlheinz Boelling '86
Garrett Boge '83
Patricia Bradbury '93
Bud Braman '90
Ed Brodsky '80
Kathie Brown '84
Werner Brudi '66
Bill Bundzak '64
Elizabeth Butler '94s
Jason Calfo '88
Ronn Campisi '88
Cristina Canlas '93
Paul S. Carroll '92s
Matthew Carter '88
Ken Cato '88
Herman Chandra '94s
Len Cheeseman '93
Kai-Yan Choi '90
Alan Christie '77
Andrew Clarke '93
Ed Cleary '89
Travis Cliett '53
Mahlon A. Cline* '48
Elaine Coburn '85
Tom Cocozza '76
Lisa Cohen '93s
Angelo Colella '90
Ed Colker '83
Paul Correia '93s
Freeman Craw* '47

David Cundy '85
Leonard Currie '93
Rick Cusick '89
Susan Darbyshire '87
Ismar David '58
Don Davidson '93
Richard Dawson '93
Carol DeBlasio '94s
Matej Dêcko '93
Robert Defrin '69
Cosmo De Maglie '74
Josanne De Natale '86
Ernst Dernehl '87
Claude Dieterich '84
Ralph Di Meglio '74
Lou Dorfsman '54
John Dreyfus** '68
Christopher Dubber '85
Lutz Dziarnowski '92
Rick Eiber '85
Friedrich Eisenmenger '93
Dr. Elsi Vassdal Ellis '93
Garry Emery '93
Nick Ericson '92
Joseph Michael Essex '78
Leon Ettinger '84
Leslie Evans '92
Florence Everett '89
Peter Fahrni '93
David Farey '93
Gene Federico** '91
Sidney Feinberg** '49
Janice Prescott Fishman '91
Simon Fitton '94
Kristine Fitzgerald '90
Mona Fitzgerald '91
Yvonne Fitzner '87
Norbert Florendo '84
Vincent Fong '93s
Gonçalo Fonseca '93
Tony Forster '88
Thomas Fowler '93
Dean Franklin '80
H. Eugene Freyer '88
Adrian Frutiger** '67
Partick Fultz '87
András Fürész '89
Murray Gaby '93
Fred Gardner '92
Christof Gassner '90
David Gatti '81
Jeremy Gee '92
Stuart Germain '74

Lou Glassheim* '47
Howard Glener '77
Tama Alexandrine Goen '93
Jeff Gold '84
Laurie Goldman '93s
Edward Gottschall '52
Norman Graber '69
Diana Graham '85
Austin Grandjean '59
Kevin Greenblat '93s
Adam Greiss '89
Jeff Griffith '91
Rosanne Guararra '92
Dante B. Guintu '94s
Risa Haddad '94s
Kurt Haiman '82
Allan Haley '78
Mark L. Handler '83
Sherri Harnick '83
John Harrison '91
Knut Hartmann '85
Reinhard Haus '90
Bonnie Hazelton '75
Richard Henderson '92
Elise Hilpert '89
Michael Hodgson '89
Fritz Hofrichter '80
Alyce Hoggan '91
Cynthia Hollandsworth '91
Catherine Hollenbeck '93
Kevin Horvath '87
Gerard Huerta '85
Harvey Hunt '92
Anthony A. Inciong '93s
Elizabeth Irwin '94s
Donald Jackson** '78
John Jamilkowski '89
Jon Jicha '87
R. W. Jones '64
Anita Karl '94
Karen Kassirer '93
Scott Kelly '84
Michael O. Kelly '84
Renée Khatami '90
Hermann Killian '92
Rick King '93
Zoltan Kiss '59
Robert C. Knecht '69
Nana Kobayashi '94s
Myosook Koo '93s
Steve Kopec '74
Andrej Krátky '93
Bernhard J. Kress '63

Madhu Krishna '91
Pat Krugman '91
Ralf Kunz '93
Mara Kurtz '89
Sasha Kurtz '91s
Misook Kwak '93s
Raymond F. Laccetti '87
Jim Laird '69
John Langdon '93
Guenter Gerhard Lange '83
Kyung Sun Lee '92s
Judith Kazdym Leeds '83
Olaf Leu '65
Jeffery Level '88
Mark Lichtenstein '84
Wally Littman '60
Gerry L'Orange '91
John Howland Lord** '47
Alexander Luckow '94
Gregg Lukasiewicz '90
John Luke '78
Burns Magruder '93
Sol Malkoff '63
Marilyn Marcus '79
Stanley Markocki '80
Adolfo Martinez '86
Rogério Martins '91
Deborah Masel '94's
Les Mason '85
Douglas May '92
Roland Mehler '92
Frédéric Metz '85
Douglas Michalek '77
Michael Milley '94s
John Milligan '78
Michael Miranda '84
Oswaldo Miranda (Miran) '78
Nancy Molins '94s
James Montalbano '93
Richard Moore '82
Ronald Morganstein '77
Denis Moriarty '94
Minoru Morita '75
Gerald Moscato '93
Tobias Moss* '47
Richard Mullen '82
Antonio Muñoz '90
Keith Murgatroyd '78
Erik Murphy '85
Jerry King Musser '88
Alexander Musson '93
Louis A. Musto '65
Alexander Nesbitt '50
Robert Norton '92

Alexa Nosal '87
Robert O'Connor '92
Jack Odette '77
Michel Olivier '94
Brian O'Neill '68
Gerard O'Neill* '47
Robert Overholtzer '94
Tony Owen '92
Bob Paganucci '85
Rosina Patti '91a
B. Martin Pedersen '85
Daniel Pelavin '92
Robert Peters '86
Roy Podorson '77
William Porch '94
Will Powers '89
Vittorio Prina '88
Richard Puder '85
David Quay '80
Elissa Querzé '83
Erwin Raith '67
Adeir Rampazzo '85
Paul Rand** '86
Hermann Rapp '87
Jo Anne Redwood '88
Hans Dieter Reichert '92
Bud Renshaw '83
Martha Rhodes '93
Robert Ripp '93s
Susan Rivoir '93
Nancy Romano '93s
Salvadore Romero '94
Edward Rondthaler* '47
Kurt Roscoe '93
Robert M. Rose '75
Dirk Rowntree '86
Joanne Rudden-Barsky '94
Erkki Ruuhinen '86
Michael Rylander '93
Gus Saelens '50
Howard J. Salberg '87
David Saltman '66
Irene Santoso '93s
John Schaedler '63
Jay Schechter '87
Hermann J. Schlieper '87
Hermann Schmidt '83
Klaus Schmidt '59
Markus Schmidt '93
Peter Schmidt '93s
Bertram Schmidt-
   Friderichs '89
Werner Schneider '87
Eileen Hedy Schultz '85

Eckehart Schumacher-
   Gebler '85
Paul Shaw '87
Philip Shore, Jr. '92
Gil A. Silva '92
Mark Simkins '92
Tyler Singer '93
Dwight D.A. Smith '92
Kimberly Smith '93s
Martin Solomon '55
Jan Solpera '85
Mark Solsburg '89
Barbara Sommer '92
Ronnie Tan Soo Chye '88
Bill Sosin '92
Erik Spiekermann '88
Vic Spindler '73
Walter Stanton '58
Rolf Staudt '84
Charles Stewart '92
Sumner Stone '88
William Streever '50
Ilene Strizver '88
Hansjorg Stulle '87
Tony Sutton '93
Zempaku Suzuki '92
Gunnar Swanson '92
Ken Sweeny '78
Paul Sych '93
Gordon Tan '90
Michael Tardif '92
William Taubin '56
Jack Tauss '75
James Taylor '93
Pat Taylor '85
Anthony J. Teano '62
Mark Tenga '93
Grover Tham '93
Bradbury Thompson '58
Paula Thomson '91
Harry Title '93
D. A. Tregidga '85
Susan B. Trowbridge '82
Paul Trummel '89
Lucile Tuttle-Smith '78
Edward Vadala '72
Violeta Valle '94s
Mark van Bronkhorst '93
Jan Van Der Ploeg '52
Diego Vaninesman '91
James Wageman '88
Jurek Wajdowicz '80
Robert Wakeman '85
Garth Walker '92

Tat S. Wan '91
Xu Wang '93
Ewan Warmbath '93
Janet Webb '91
Joy Weeng '93s
Kurt Weidemann '66
Alex White '93
Gail Wiggin '90
Richard Wilde '93
James Williams '88
Conny J. Winter '85
Michelle Winters '93s
Doyald Young '94
Shawn Young '94
Susan Young '93
Hal Zamboni* '47
Hermann Zapf** '52
Roy Zucca '69

214

## sustaining members

Adobe Systems, Inc. '90
Image Technologies '86
International Typeface
Corporation '80
Letraset '91
Linotype-Hell Company '63
Monotype Typography, Inc. '91
PDR/Royal Inc. '76
Sprintout Corporation '88
Toyota Motor Sales '92
TypoVision Plus '80

* charter member
** honorary member
s student member
a associate member

membership as of
May 31, 1994

216

## Collages

## Creative Directors

## Design Director

## Designers

## Font Designer

## Illustrators

## Junior Designers

## Lecture Coordinator

## Letterers

## Output

## Paper Manufacturer

## Photographers

## Photoshop Illustrator

## Poster Assembly

## Principal Types

in remembrance of B. W. Honeycutt

B.W. Honeycutt, art director of *Details* magazine, had enthusiastically agreed to serve as a juror for the 1993 TDC competition. Regrettably, he died before the judging. I had been look-ing forward to working with B.W., being an admirer of the bright, bold, and unexpected work he was doing at *Details*. We at TDC will sadly miss the energy and exceptional sensibility he brought to our field.

—Dirk Rowntree, TDC40 chairperson

## DATE DUE